LOST LAS VEGAS

Acknowledgments
Jeff Burbank would like to thank his daughter and high school thespian Ansley Madison Burbank, born in 1999, for her support and patience during the writing and editing of *Lost Las Vegas*.

Picture credits
University of Nevada, Las Vegas Library: 9, 14, 15, 16, 19, 25, 28, 32, 33 (bottom left and bottom right), 34, 36, 37 (left), 39, 41, 45, 51, 55, 58, 59, 64, 73, 83, 87, 93, 111 (left), 114, 115 (bottom right), 118, 131, 139.

Getty Images: 7, 20, 22 (top right), 26 (top right), 27, 29 (top), 30 (bottom right), 46, 57 (bottom), 60, 61, 63, 68, 75, 78 (left), 86 (top left), 88, 92 (bottom left).

University of Las Vegas: 17 (right), 23, 24, 42, 44 (left), 69 (right), 72, 84, 113, 138 (right), 140 (left), 143.

Library of Congress: 10, 11, 74 (bottom left), 91 (bottom left), 94, 95 (right), 97, 102 (left), 103, 105, 126 (top left), 129, 142 (left).

Corbis: 31, 38 (left), 49, 53 (bottom right), 56, 67, 79, 99, 100, 123, 124.

Barrett Adams: 44 (right), 104 (top), 125 (left), 127, 128, 136.

Simon Clay: 92 (top right), 116, 117, 135.

David Watts: 110, 119 (left), 121.

Alamy: 107, 109.

Michael Boutot (photo by Ann and Harold Boutot): 89 (top).

National Nuclear Security Administration: 48 (middle top).

Kreg Steppe (kregsteppe.com): 125 (right).

Allen Sandquist: 106 (top right).

Karl Mondon: 134 (bottom).

Wes Isbutt: 142 (top right).

Jason Hawkes: 132.

Endpapers show the Las Vegas Strip at night in 1990 (Carol M. Highsmith, Library of Congress).

First published in the United Kingdom in 2014 by
PAVILION BOOKS
10 Southcombe Street, London W14 0RA
An imprint of Anova Books Company Ltd

© Anova Books, 2014

Editor and picture researcher: David Salmo

ISBN: 978-1-90981-503-2

A CIP catalogue record for this book is available from the British Library.

10 9 8 7 6 5 4 3 2 1

Repro by Mission Productions Ltd, Hong Kong
Printed by 1010 Printing International Ltd, China

www.anovabooks.com

LOST LAS VEGAS

Jeff Burbank

PAVILION

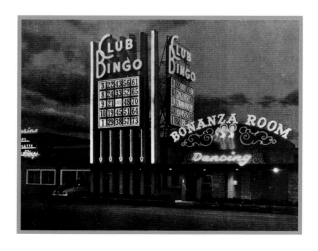
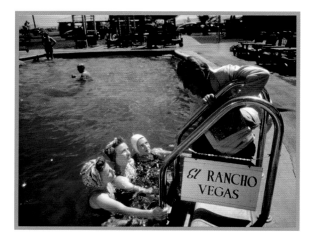
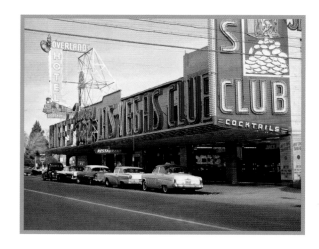

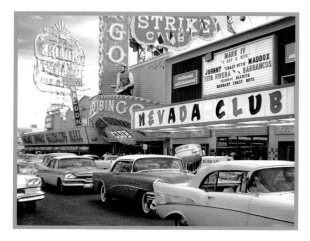
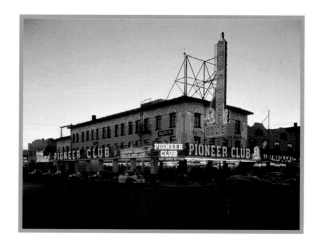

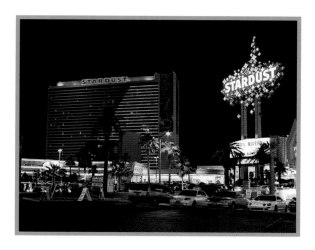

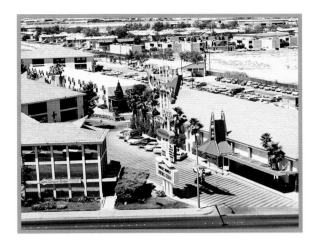

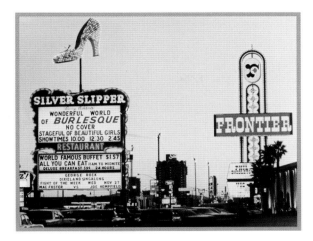

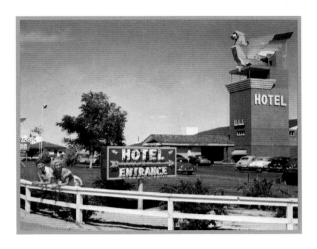

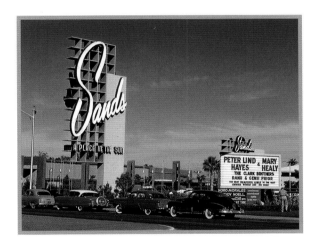

LOST IN THE...

Introduction **page 6**

1940s **page 8**

1950s **page 12**

1960s **page 20**

1970s **page 34**

1980s **page 38**

1990s **page 46**

2000s **page 82**

2010s **page 126**

Index **page 144**

INTRODUCTION

In 1902, Helen Stewart lorded over a livestock and fruit tree ranch in the Las Vegas Valley that she and her husband started as sturdy pioneers in 1882, nearly two decades after Nevada became a state. By 1900, little more than 30 people lived in the desolate valley, almost unbearably hot in the summer and cold in the winter. But the railroad would transform the Las Vegas Valley. Montana Senator William Clark, a mining and railroad baron, was building the San Pedro, Los Angeles and Salt Lake Railroad from Salt Lake City to Los Angeles. In 1902, Clark made a generous offer for most of Stewart's ranch and she accepted, making sure the small Paiute Indian colony was protected.

Clark would use his large section of the Stewart ranch to build a depot and repair yard for the railroad, and a town next to it to boot. He advertised in Los Angeles for a planned auction to sell parcels of property nearby. His resulting land auction on May 15, 1905, at the start of what would be Fremont Street, launched Las Vegas. Buyers of the land plots sought to be among the first to run businesses in the fledgling town despite the harsh desert heat in what was one of the most remote parts of the United States. The town made an early attempt to control vice by permitting liquor sales and prostitution in a red-light area known as Block 16. But Las Vegas, as isolated outpost and brief stop for thirsty and intrepid railroad travelers, soon won a reputation as a center of sin, tolerated for the most part by its residents who welcomed the economic activity. Las Vegas was also associated with gambling, in bars and backrooms.

After surviving the effects of a flood that halted rail service for months, Las Vegas was incorporated as a city in 1911. In 1931, the State Legislature made Nevada the only state in the country to legalize wide-open casino gambling games. Small casinos were approved in the city's legal poker clubs, while slot machines operated in stores and trailer parks. That same year, in another historic boon for Las Vegas, the building of Boulder Dam—later known as Hoover Dam—started on the Colorado River about 25 miles southeast of the city. Legions of tourists streamed into town upon the dam's completion in 1935.

The end of national Prohibition against alcohol sales in 1933 created another attraction for Las Vegas's new all-night casinos. Nevada also made it possible to obtain a divorce after only six weeks' residency, making Las Vegas and Reno the temporary homes for divorcees from across the country. By 1940, Las Vegas was still a relatively small town that benefited from tourism and federal spending. That year, the U.S. Army Air Corps built an airport northeast of town. Military authorities soon convinced city officials to close down the brothels on Block 16 and elsewhere. Fremont Street remained the town's business center with lines of neon signs for gambling clubs and stores lining both sides for several blocks. The low-rise, Western-style El Rancho Vegas hotel, the first casino resort on old Highway 91, opened in 1941, starting what soon become known as the Las Vegas Strip.

By the late 1940s, Highway 91, on Clark County land on the outskirts of Las Vegas, had three more resorts, the Hotel Last Frontier (1942), Flamingo (1945) and the Thunderbird (1948). Fremont Street downtown also had an impressive string of gambling clubs big and small, notably the Golden Nugget (1946) owned by former Los Angeles vice cop Guy McAfee. The iconic moving, speaking neon cowboy sign, nicknamed "Vegas Vic," enhanced the popularity of downtown Las Vegas in 1947. Nuclear weapons testing at the Nevada Test Site, about 50 miles west of Las Vegas, bought in more government dollars and became a tourist attraction. By the mid-1950s, other Strip casinos emerged—the Desert Inn (1950), Sands (1952), Sahara (1952), Riviera (1954), Showboat (1954), Dunes (1955), Moulin Rouge (1955), the Royal Nevada (1955) and Hacienda (1956). In downtown, former Dallas street hoodlum Benny Binion took over the Apache hotel and El Dorado Club to open the Horseshoe Club in 1951. Strip hotel owners engaged in bidding wars to pay thousands of dollars a week to major Hollywood stars and popular singers—from Frank Sinatra and Judy Garland to Marlene Dietrich and Noël Coward—to appear in their showrooms and generate publicity and casino play. So much building on the Strip in the mid-1950s meant more hotel rooms than tourist numbers could fill, and led to near-failure for some hotels. But the lull was brief, as the Strip added the Tropicana in 1957 and the Stardust in 1958.

As the Las Vegas area matured, the Strip entered into an era of corporate-ownership in the 1960s when billionaire Howard Hughes bought up six Strip hotels, starting with the Desert Inn in 1967. The opening of Caesars Palace in 1966, with its Roman statues and fountains, started an era of its own with anything-goes, plush excesses that would transform Las Vegas in the public's mind. The Las Vegas area experienced its first "mega-resort" with Kirk Kerkorian's 1,568-room International Hotel off the Strip in 1969.

By the 1980s, as major Strip resorts refurbished, parts of the venerable Strip, though still famous, were many years old and starting to fade. At the end of the decade, yet a new period began with The Mirage hotel, built in 1989 by Golden Nugget casino owner Steve Wynn for a then-staggering $640 million. It was financed in part by high-interest "junk bonds" sold on Wall Street. The Mirage had 3,400 rooms, an erupting outdoor faux volcano fronting the Strip, an interior jungle forest, an exhibit of white tigers for Wynn's showroom performers Siegfried and Roy, and in the rear a habitat for dolphins. The worldwide publicity accompanying The Mirage brought more attention to Las Vegas than ever and sparked a wave of expensive, new mega-resorts by other owners. Las Vegas's opulent, often outlandish line of major new resorts was a unique phenomenon, an international sensation that had to be seen. Now hotels could charge guests more to stay, and money earned from guest rooms and shopping rivaled profits from the casinos. By the 2000s, the population of Las Vegas's metropolitan area was close to two million people, almost entirely within one century. While the ebbs and flows of the national economy affected it, Las Vegas still drew entrepreneurs with ever-larger ambitions. The latest wave of large high-rise hotels on the Strip came in 2009, with MGM Mirage's $9 billion CityCenter, which cost the lives of six construction workers over three years. Downtown Las Vegas, too, enjoyed a mini-renaissance with the opening of the Smith Center for the Performing Arts and National Museum of Organized Crime and Law Enforcement in 2012.

RIGHT *Fremont from Second Street in 1950 (see page 60).*

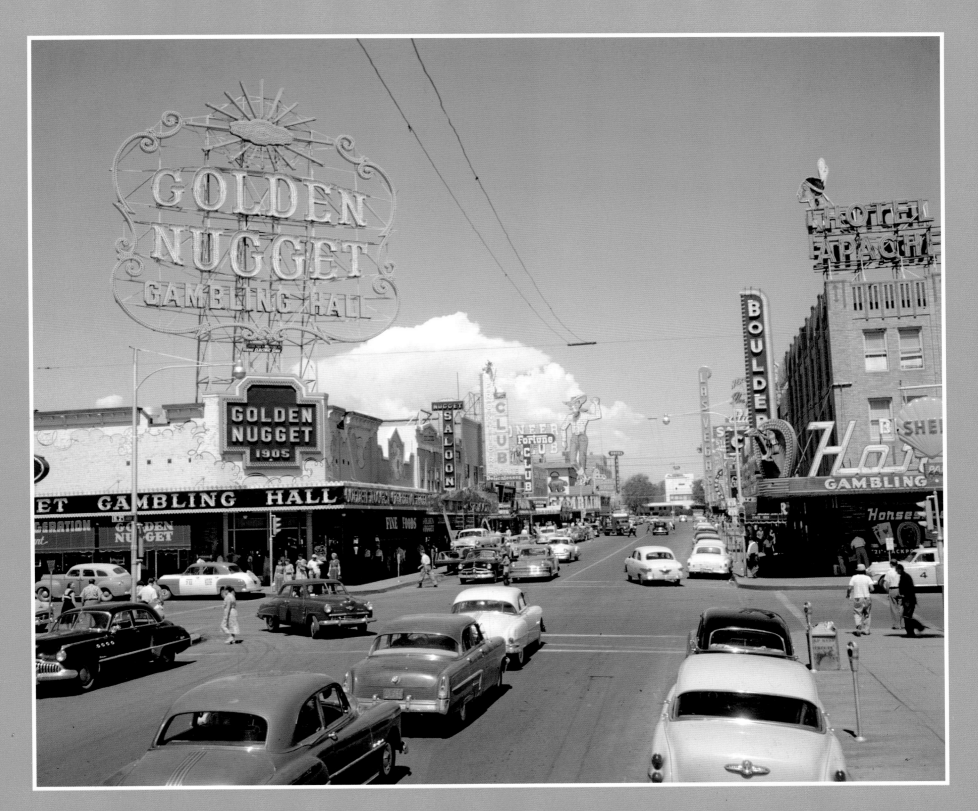

Arizona Club CLOSED 1941

When James McIntosh arrived to buy property at Las Vegas's land auction in 1905, he selected a lot on the so-called Block 16, the only part of town along with the adjacent Block 17 where liquor could be sold. McIntosh's lot was just off the northwest corner, on First Street at East Ogden Street.

McIntosh opened the Arizona Club in 1905 beside his neighbors-in-vice, The Gem and Red Onion clubs, each starting out as little better than wood and canvas shacks. The Arizona Club's facade advertised "beer on draught" and touted it as the "headquarters" for fine whiskey. The Arizona and the other Block 16 clubs in the sparsely populated town quickly advanced Las Vegas's budding reputation as a lure for day-trippers eager to blow money while passing through on the next train.

But McIntosh showed his aplomb as a saloon operator. By early 1906, he rebuilt the club using stone masonry, added a second floor and lined the front with beveled glass and oak paneling. Inside, he put in a grand, 40-foot-long mahogany bar, said to cost a then-fortune of $20,000, that would become the club's trademark. The Arizona Club, a bar with

faro, roulette and other gambling games, quickly became regarded as the classiest entertainment spot for train travelers and locals alike. McIntosh offered drinks on the cheap for 15 cents, or two for 25 cents. The red-light district where the Arizona Club shone was restricted to men only, except for the women employed as prostitutes inside hidden rooms behind some of Block 16's bars.

When McIntosh sold his club in 1912, new owner Al James famously added a bordello on the second floor. Over the next two decades, the Arizona Club operated as other Block 16 clubs, its prostitution tolerated by local officials—as was alcohol service during Prohibition from 1919 to the early 1930s. In the 1920s, when poker games were permitted in Nevada, the city issued a poker license to the Arizona Club's then owner, E.H. Edwards. In the years before and after Nevada legalized casino gambling for good in 1931, the Arizona Club remained in the public's mind as an example of Las Vegas's rough and tumble beginnings in the early 20th century. But after 1931, the newest legal casinos popped up a block west on Fremont Street,

the city's respectable, main thoroughfare that was closer to the railroad depot. While Block 16, with its bars and working girls, remained a tourist attraction throughout the 1930s, as a taste of the bawdy Old West, the Arizona Club and the rest of the block began a decline from which it would not recover.

The club, still very much as McIntosh left it, held on with the other old, somewhat seedy bars until 1941. The U.S. military, housed in bases outside of town, threatened to declare Las Vegas completely off limits to personnel unless the city shut prostitution down at Block 16 and elsewhere, which it did. The Arizona Club finally closed that year as the country stood on the brink of World War II. But important parts of it survived, at least for a time, to live on in the new, emerging Las Vegas several miles southwest on Highway 91. In 1942, William Moore, the owner of an early Las Vegas Strip hotel-casino, the Last Frontier, transplanted the club's oak wood frontage and venerable mahogany bar into his Old West–themed resort, where they remained until the property was rebuilt as the Hotel New Frontier in 1955.

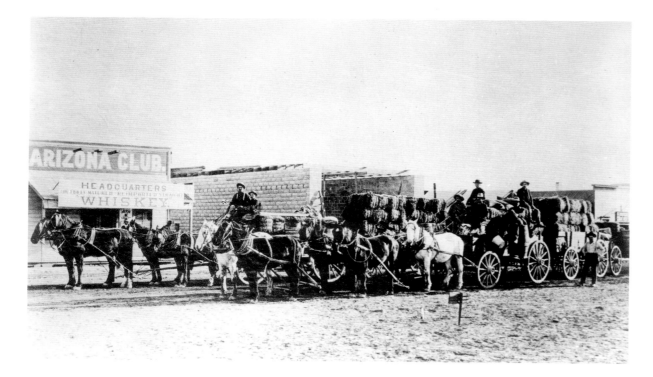

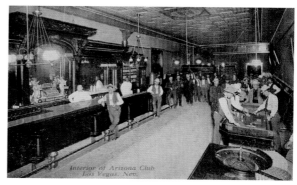

ABOVE *The interior of the Arizona Club, with its 40-foot mahogany bar, spittoons on the floor, roulette wheel and crowded craps table.*

LEFT *Teams of horses and their drivers pose outside the original clapboard wood Arizona Club in about 1905. They were about to embark on trips to cities north of the Las Vegas Valley to deliver bales of hay for horses and mules.*

RIGHT *An exterior view of the revamped Arizona Club, which became the finest saloon in town after owner James McIntosh replaced the old clapboard in 1906 with stone masonry, beveled glass windows and oak panels.*

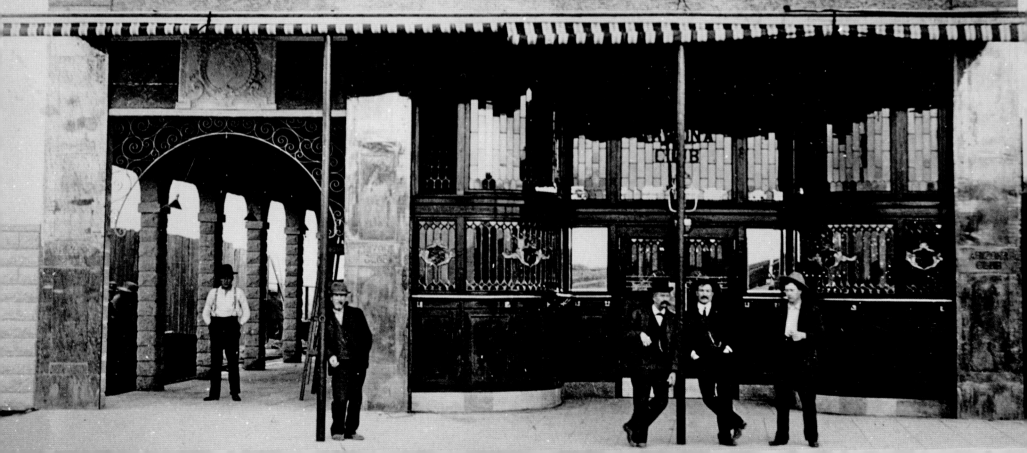

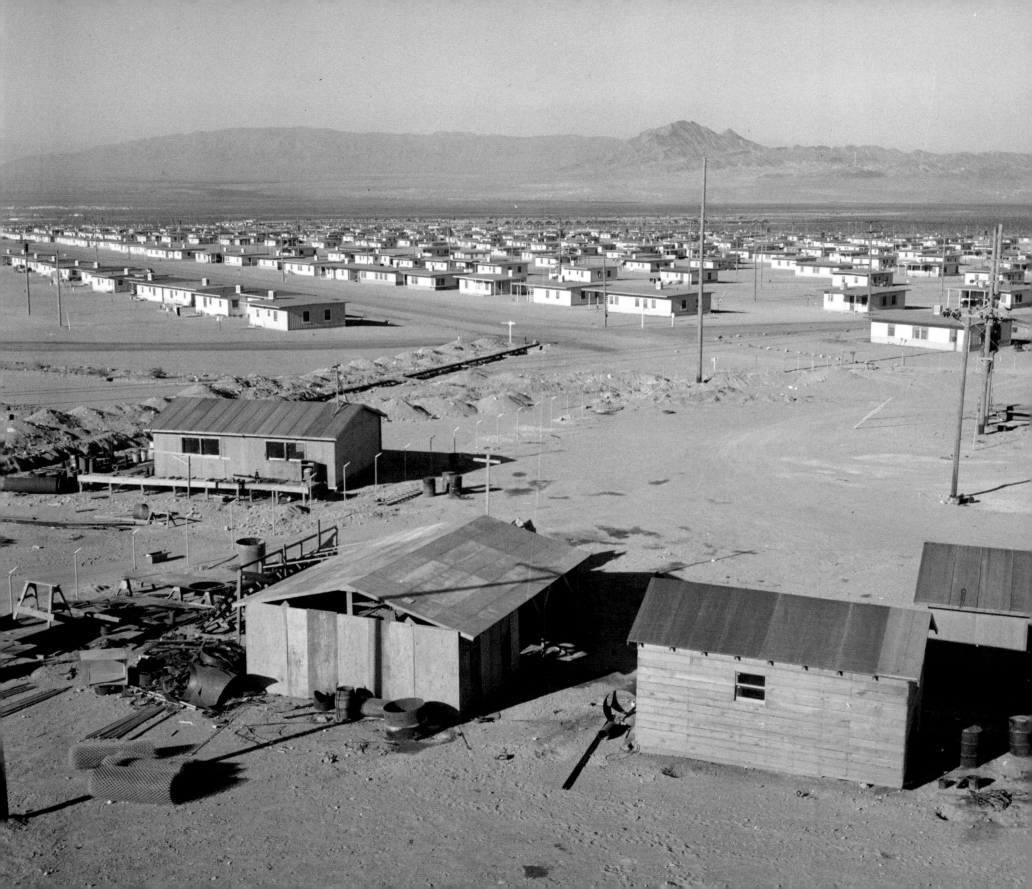

Basic Magnesium Inc. CLOSED 1944

In 1941, as U.S. ally Great Britain struggled against Nazi Germany and its prolific defense industry, American politicians, including Nevada's influential U.S. Senator Pat McCarran, prevailed on President Roosevelt to fund a plant about 15 miles outside Las Vegas to manufacture magnesium, a vital lightweight metal used in the aircraft industry and for ammunition. The industrial plant, overseen by Basic Refractories, a company based in Cleveland, Ohio, would be located in an isolated area far from the danger of German forces. At the time, Germany was a heavy user of magnesium in its war effort, while the allies lagged behind. Magnesium was the lightest of metals and had many uses in war: making bombs, airplane parts, tracer bullets and flares for bombers. The Basic Magnesium Inc. plant, or BMI, was one of a number of magnesium plants in the country for the U.S. War Department. The plant made ingots of magnesium shipped to manufacturers of munitions and airplane parts. Nearby Hoover Dam would supply the plant with inexpensive power needed to cook and extract the metal from ore mined in Gabbs, Nevada, about 300 miles north. The expansive plant, covering 2,800 acres, would supply a quarter of all the magnesium used by the Allies in World War II. At first, most of its 13,600 employees—about 10 percent of Nevada's entire population—housed themselves in a nearby tent city. The federal government later built dozens of cheap homes to house workers beside the plant in an area known as the Basic Townsite. It was renamed Henderson in 1944 after former Nevada Senator Charles Henderson. Three years earlier, Henderson had been the chairman of the Reconstruction Finance Corporation, which under Roosevelt had provided loans to build war production plants.

In 1941, the BMI plant hired the Californian architect Paul Revere Williams—who one day would design the La Concha Motel and other projects in Las Vegas—to draw up plans for the 1,000-unit townsite. Many of the homes were eventually occupied while others remained vacant, as fumes emanating from the plant discouraged some people from living there. Williams, ironically, was black, and the townsite he designed, after it opened, became segregated, with white residents only, as was typical in the United States at the time. In 1943 the plant built a separate neighborhood, Carver Park, out on Boulder Highway, for its black workers.

Many of the workers making ingots, driving forklifts and operating machinery were women, who became known as "Magnesium Maggies." The plant would have lasting benefits for the Las Vegas area. The federal government, in order to run the plant at peak efficiency, installed a vast infrastructure to pipe water in from Lake Mead, which cooled the molten metal, and a generator to draw cheap electrical power from Hoover Dam. Southern Nevada would use both systems to expand in the post-war years.

The plant had produced 166 million pounds of magnesium, but as the need for magnesium for defensive uses waned the plant was closed in 1944. The plant's employees began leaving and the U.S. government's War Asset Administration considered selling the Henderson townsite to raise public funds. But local and Nevada officials stepped in. The state's legislature, which created the Colorado River Commission to manage river water and electricity from Hoover Dam in 1935, passed a law allowing the commission to buy the closed plant property in 1947. The state renamed the plant the Basic Management Industrial Complex, managed by Basic Management Inc., which started selling low-cost power in the region in the 1950s. The Henderson townsite became an incorporated city in 1953. Within four decades, Henderson's population had surpassed Reno as the second largest city in Nevada.

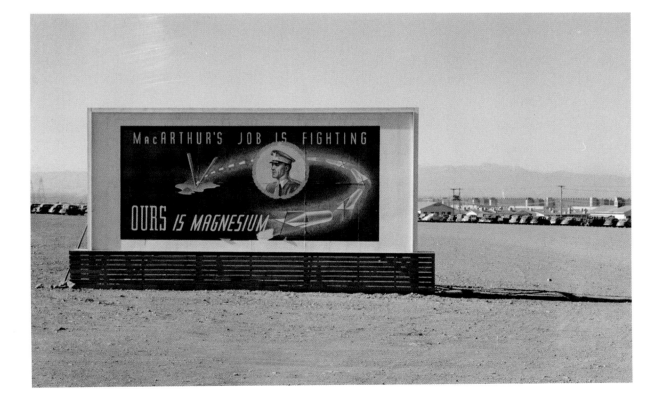

LEFT *A billboard sign outside the Basic Magnesium Inc. factory reminded workers of the importance of their industry to America's military during World War II.*

OPPOSITE *A 1943 view of the Basic Magnesium Inc. townsite and construction sheds.*

Club Bingo CLOSED 1952

Milton Prell, originally from St. Louis, Missouri, grew up in Los Angeles where he started out as a salesman while still in high school, first selling luggage, then cars and jewelry. Prell succeeded in the jewelry business but had ambitions to manage his own nightclub. In 1937, he saw his chance and moved with his wife Debby to Butte, Montana, where he opened a lounge called the 30 Club. But Prell had heard about the greater potential in Las Vegas—closer to his former home of Los Angeles—and the new hotels and clubs cropping up there in the late 1930s and early 1940s.

After taking some trips to scope the budding Las Vegas Strip, he and his wife moved to Las Vegas in 1945. At first, they wanted to build a hotel but Prell started small, with a club like the one he ran in Butte, without hotel rooms. Within only two years, Prell had opened the Club Bingo among the handful of casinos on the Strip. The place had a large neon sign in the shape of a square bingo card that flashed winning numbers. Its anchor was a

300-seat bingo parlor inside a casino with other gambling games. Prell hired Frank Schiro to run the casino and Herb McDonald to manage the bingo and to market the club. McDonald soon hired comedian Stan Irwin to manage entertainment in the club's Bonanza Room. Club Bingo soon became a hot spot for all-night dancing and music and a magnet for visitors at nearby hotels, much to the displeasure of other hotel operators. Stage performers at the hotels headed to the club after getting off work to catch the late-night action in the showroom and casino. The coffee shop served 49-cent breakfasts from midnight to 6 a.m. Irwin had a knack for booking talented music acts, like Dorothy Dandridge and the Will Mastin Trio, into the Bonanza Room that further popularized the club.

But Prell still wanted to build a large, luxury hotel-casino to outdo the likes of the Desert Inn and Last Frontier on the Strip. He divided his time between Los Angeles, where he maintained financial contacts with investors, and Las Vegas,

leaving the running of Club Bingo to his management team. By the early 1950s, Club Bingo was fading as a business. Prell closed it in 1952 in order to integrate the site into his new dream resort project, the Sahara Hotel. The old Club Bingo building was converted into a big coffee shop restaurant for the Sahara when the new resort debuted on October 7, 1952. This time, Prell built 276 guest rooms, realizing his dream to run a hotel. While some locals missed the excitement and casual atmosphere of the old Club Bingo, the $5.5 million Sahara was a smash hit with the public almost right away, and became one of the game changers in Las Vegas casino history with luxury accommodations and high-paid name entertainers.

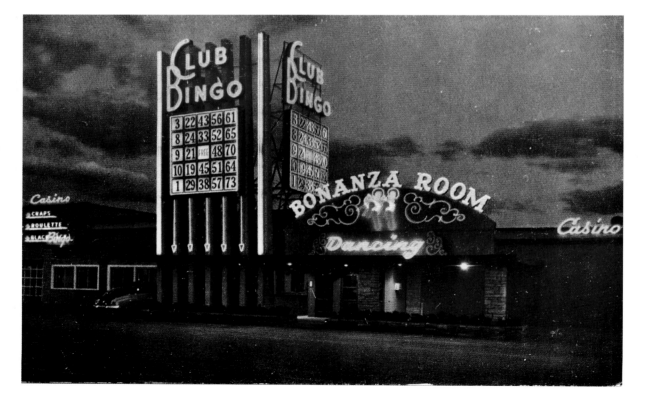

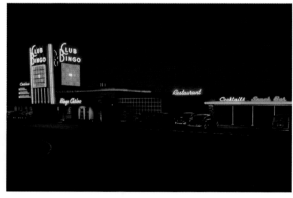

ABOVE As if the casino were asleep for the evening, this photo shows a rare, late-night view of the Club Bingo with soft blue neon.

LEFT A color shot of the Club Bingo at dusk, with neon cancan dancers dressed in red and white on the Bonanza Room's sign.

RIGHT Club Bingo's square tower had a neon bingo card with numbered lights flashing on and off as if drawn during a bingo game, beside a sign for the casino's showroom, the Bonanza Room.

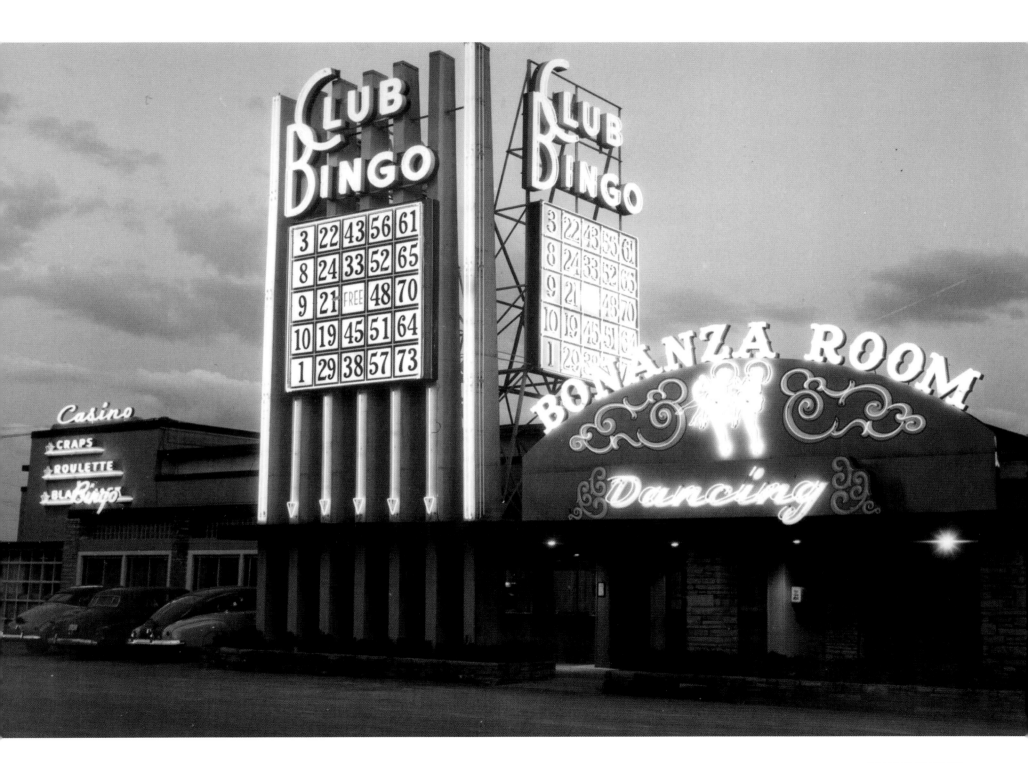

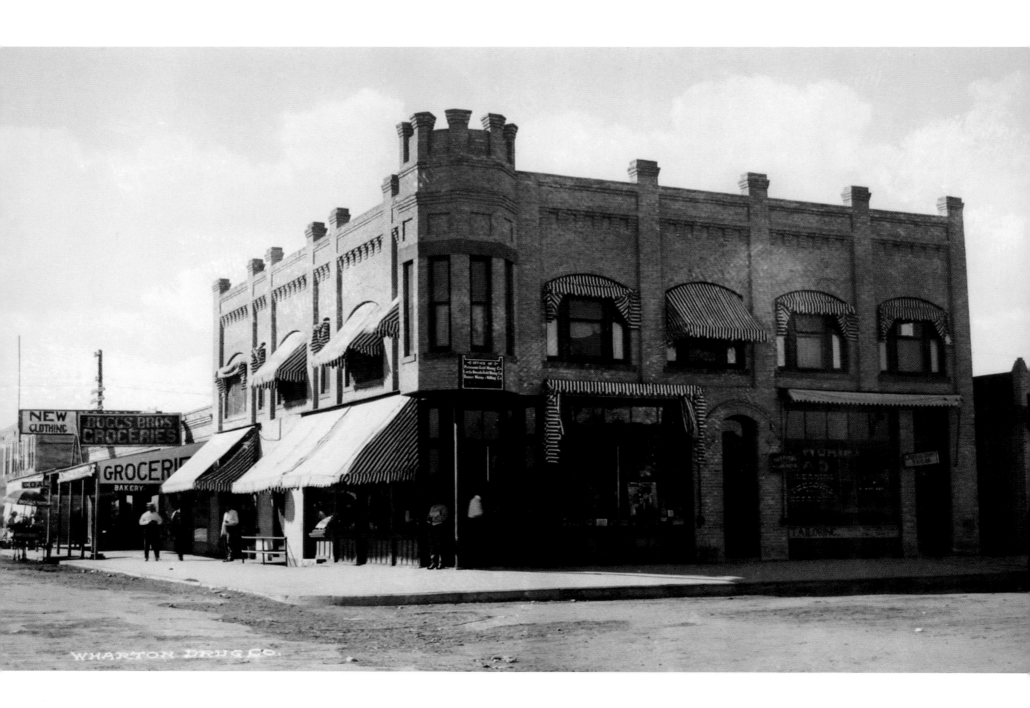

Las Vegas Pharmacy CLOSED 1956

The Las Vegas Pharmacy, with its prime location on First and Fremont streets, was a fixture in downtown Las Vegas for more than 40 years. William E. Ferron, a native of Salt Lake City and graduate of the College of Pharmacy in Philadelphia, came to Las Vegas in 1916, after trying his luck gold mining in South America. Ferron arrived at a time when health care in Las Vegas was expanding. Dr. Roy Martin and two other Las Vegas medical doctors were establishing the city's first modern hospital at the site of the former Palace Hotel on Second and Fremont streets. Shortly after his arrival, Ferron became Martin's partner in the Las Vegas Pharmacy, built at the northwest corner of First and Fremont. In addition to drugs and sundries, Ferron also sold liquor at the pharmacy. The partnership succeeded, and in 1918 Ferron opened a new pharmacy, called White Cross Drugs, at the site of the Jewell Drug Store on Second and Fremont. He later moved White Cross to Fourth and Fremont, and went on to open yet another White Cross, on Las Vegas Boulevard, in 1955 (which stayed open until 2013). During the worldwide flu pandemic of 1918 to 1919, Ferron worked nights filling prescriptions for drugs dispensed to ease the symptoms for local victims of the sickness, which claimed 48 lives in the Las Vegas area when it had a population of only 2,000 people. Ferron was elected mayor of Las Vegas in 1919, serving one term.

In the early 1940s, the Pioneer Club casino opened on the opposite side of Fremont, across from the pharmacy. The Pioneer's operators made a big splash by renting the Las Vegas Pharmacy's roof and installing a neon sign with the face of a cowboy and a cascading neon-lit arrow aiming at the Pioneer with the message "Here It Is! The Famous Pioneer Club." It was the forerunner of the famous standing cowboy sign, the waving Vegas Vic, placed outside the Pioneer in 1947. By the 1950s, the pharmacy's location among Fremont Street's glittering casinos became too valuable to serve as a drugstore. New owners shut it down in 1956 and in its place built the Silver Palace casino.

The Silver Palace linked its second floor casino and a restaurant on the first floor with the first escalator built in Las Vegas. In the 1970s, the old pharmacy location became the Gambler's Hall of Fame, and more famously, in 1979, the site of Sassy Sally's, a slot machine club topped with a large neon blonde cowgirl in a short skirt, sitting cross-legged. The sign, known as Vegas Vicky, became Vegas Vic's female counterpart. While Vegas Vic waved his arm, Vegas Vicky pointed her leg provocatively. The Vegas Vicky sign remained after the club was renamed Mermaids in 2001.

OPPOSITE *William E. Ferron and Dr. Roy Martin became partners in the Las Vegas Pharmacy, shown here, in about 1916, at the corner of Fremont and First streets.*

BELOW *The pharmacy appears at right in a view looking north down Fremont Street toward the Las Vegas railroad depot, with a long trail of smoke from a train engine, in about 1920.*

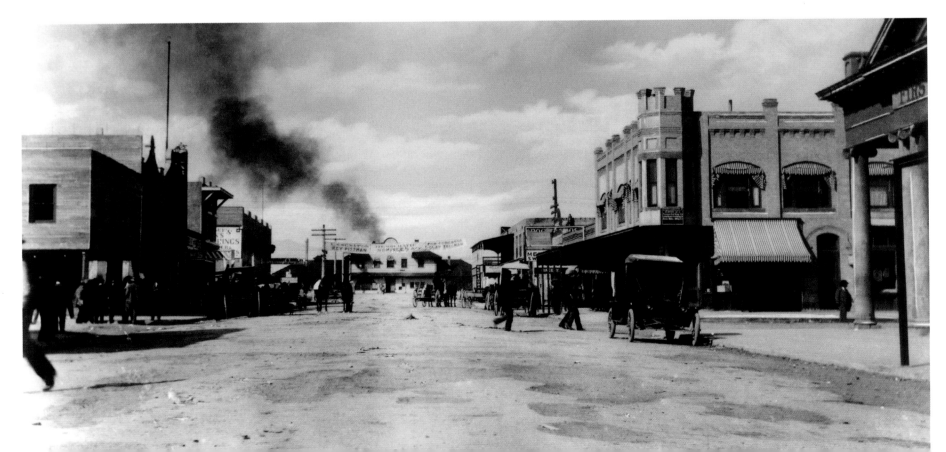

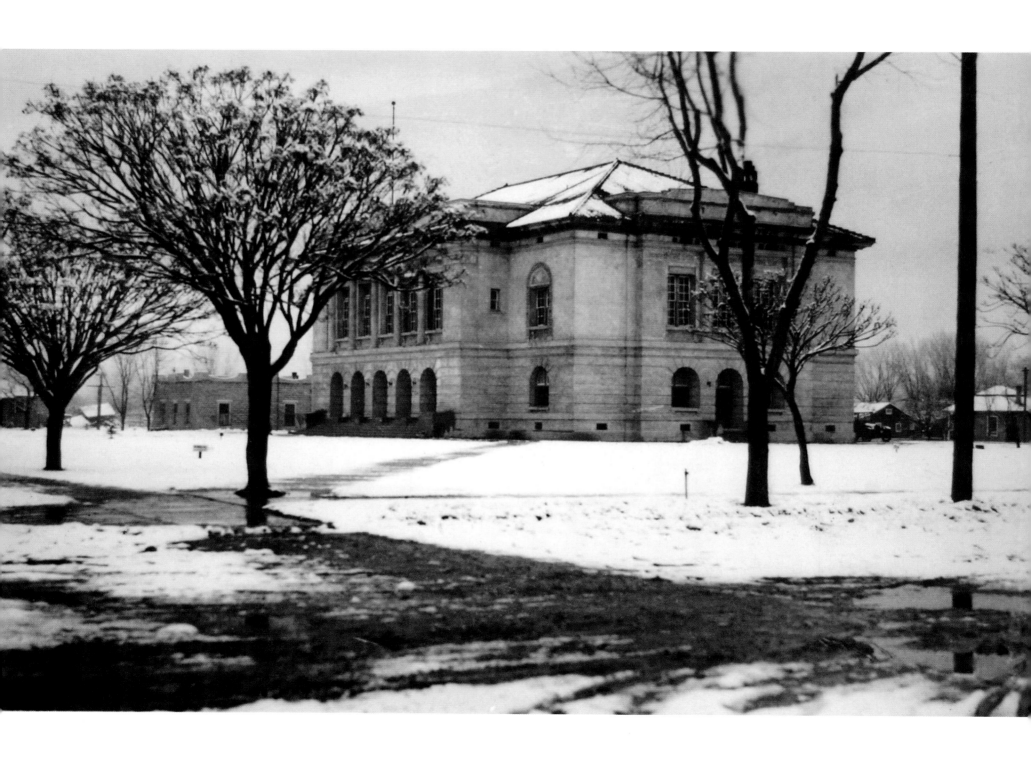

Clark County Courthouse RAZED 1958

The Nevada Legislature created Clark County in 1909 by splitting off the southern part of Lincoln County. That year, the new county quickly set up its first courthouse, a small, boxy, almost makeshift concrete brick structure. The building served the town's needs temporarily until the community sought a more lasting, landmark courthouse for its judges to try criminal and civil cases in Las Vegas. In 1913, the county hired Reno native Frederick DeLongchamps, who at age 31 was already one of the best known architects in Nevada. DeLongchamps had designed Washoe County's courthouse that opened in Reno in 1910 and was considered by many as the finest building in Nevada. DeLongchamps would design a total of nine courthouses built in Nevada and California. For Clark County, he envisioned a large, majestic building based on Spanish Colonial Revival architecture, a Mediterranean style that was all the rage in the United States at the time, with an arched facade and a red tile roof. He mixed in flattened Corinthian columns along the second floor

windows and brick masonry arches on the first floor. DeLongchamps' early influences may have come from new architectural designs being discussed in San Francisco, where he worked in 1906 after the devastating earthquake.

The Clark County Courthouse would be similar to civic structures in San Francisco, such as the rebuilt City Hall that opened in 1915. The courthouse was completed at a cost of about $50,000 in 1914. The public facility housed the county's administrative offices in addition to its courtrooms. Over the years, the courthouse, with is classic design and broad front lawn, provided a contrast to the neon signs and casinos that grew along Fremont Street little more than a block away to the east. By the 1950s, the city used the courthouse building as its City Hall and central

library. But like other growing American cities in the post–World War II era, Las Vegas wanted to modernize and build a new courtroom, and new City Hall, rather than preserve the architectural jewel DeLongchamps bestowed upon it. In 1958, city officials razed the old courthouse in favor of a new one with a purely functional design. That building remains standing in downtown Las Vegas, although it closed in 2005 in favor of yet a newer county courthouse.

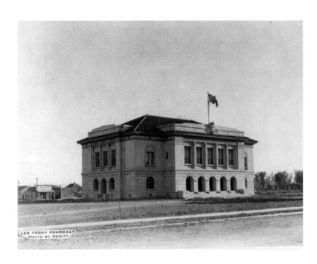

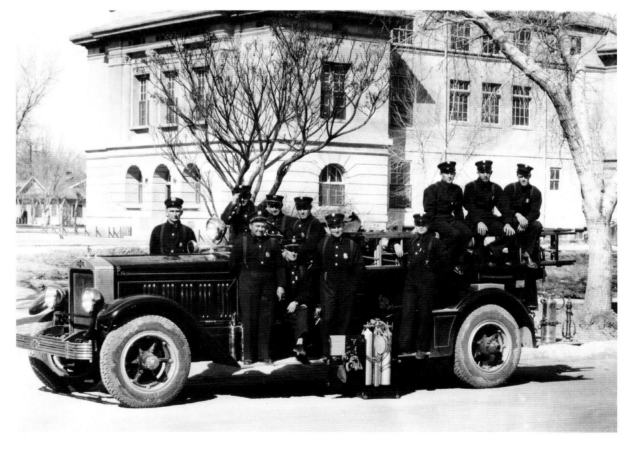

ABOVE *A flag flies over the newly built, if isolated, Clark County Courthouse in downtown Las Vegas in about 1915.*

LEFT *The courthouse as it looked after a rare Las Vegas snowfall, with added trees and sidewalks.*

RIGHT *A Las Vegas fire brigade poses with a fire engine outside the courthouse in the 1930s.*

Royal Nevada **CLOSED 1958**

The well-publicized successful openings of the Sahara and Sands hotels in 1952 inspired others to plan casino resorts along Highway 91, the Las Vegas Strip. One of them was the Royal Nevada, which would quickly become one of the victims of overbuilding on the Strip in the mid-1950s. In 1953, Frank Fishman, a former Miami resident, announced a $5-million hotel project to be built between the Sands and Sahara. Fishman's Royal Nevada, designed by architects Paul Revere Williams (who would later design the La Concha Motel) and John Replogle, took shape by 1955. The Riviera and the Dunes hotels had just opened on the Strip, increasing the competition for a limited stream of visitors. But Fishman was already in hot water with state gaming regulators, who refused to grant him and two of his Las Vegas investors casino licenses. Other partners agreed to buy out Fishman's interest if he and his friends left the project. Fishman, however, remained as landlord. New investors took over the operation to share in its

casino profits. The night before its opening, the Royal's management treated a group of American servicemen, working on atomic bomb tests at the Nevada Test Site, to a private party in the resort. The Royal, with its casino and 250 guest rooms, opened officially on April 19, 1955. Albert Moll, its biggest investor, and Sid Wyman were the operators. Famed former New York Metropolitan Opera singer Helen Traubel, a soprano who specialized in Wagnerian operas, performed on the opening night in the Royal's Crown Room.

Williams made the Royal's distinctive feature two large faux royal crowns, one fashioned into its front neon sign on the Strip, and a much larger one atop its front entrance and porte-cochère. Another attraction was its large swimming pool, said to be Olympic-sized, in the center of the property, surrounded by low-rise hotel buildings. Later in 1955, Fishman leased the hotel to respected Las Vegas casino and entertainment manager Jake Kozloff. At one point, Bill Miller, the successful

entertainment director at the Sahara, came over to run the resort briefly, promoting it for a time as "Bill Miller's Royal Nevada." But in December 1955, the hotel was unable to win enough cash in its casino to pay government licensing fees and back wages owed to a local labor union, and closed on New Year's Day, 1956. It took three months to reopen. That year, licensees from the New Frontier hotel-casino, including Mississippi hotel owner Rich Richardson, Lake Tahoe casino club owner Bucky Harris and hidden Detroit mob associate and skimming expert Maurice Friedman, took control of management. Harris, the general manager, started holding popular Hawaiian luau parties beside the Royal's expansive pool. In its showroom and cabaret lounge, the hotel booked dozens of mostly middle-brow acts compared to the bigger celebrities playing at the Sahara, Sands, Riviera and Dunes. It hosted Italian opera singer Anna Maria Alberghetti, movie actor Robert Alda and many popular Las Vegas acts such as singer-comedienne Rose Marie and the all-black singing group The Treniers.

But the Royal was sinking almost from the day it opened, losing out to larger Strip resorts with superior and much higher-paid entertainment options. The opening of the Tropicana in 1957, at the far southern end of the Strip, made things worse. So would the 1958 debut of the Stardust Hotel, the Royal's new next-door neighbor. The Royal finally closed down that year, after only three years in business. In 1959, Stardust operator Moe Dalitz acquired the shuttered Royal property and refurbished it to serve as a convention center for the Stardust.

RIGHT *The new Royal Nevada, featuring giant royal crowns over its front entrance and a marquee sign that touted the casino's opening-night performer, the famed New York opera singer Helen Traubel.*

LEFT *The left side of the Royal Nevada's front entrance included a unique tiered fountain on a wall next to young palm trees.*

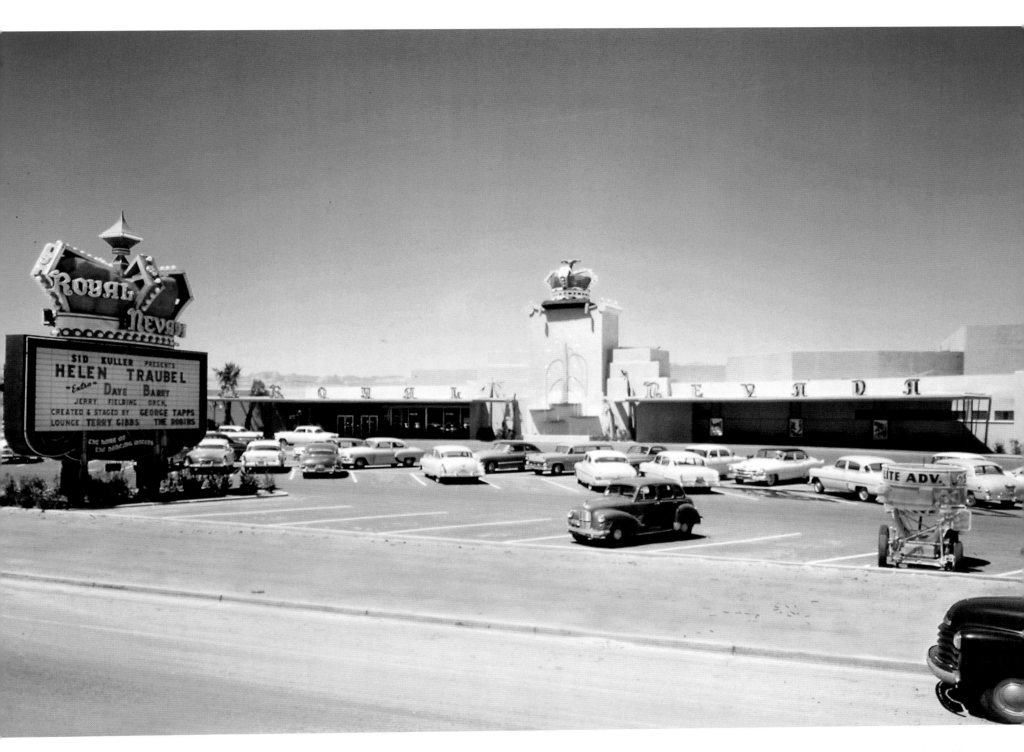

Boulder Club CLOSED 1960

Prosper Jacob "P.J." Goumond would be one of the few gambling club operators in Las Vegas to open before Nevada legalized casinos in 1931 and continue to run a successful gambling business into the 1950s. Goumond moved to Reno with his wife Gertrude in 1906 and, after a stint in Detroit, relocated to Las Vegas in 1928. He started the Boulder Club on Fremont Street in 1929 with three partners, Clyde Hatch, J.V. Murphy and Walter Watson. At the time, Nevada banned casino games and the U.S. government outlawed the sale of alcoholic beverages. The state did permit clubs to offer, with local licenses, some non-bank card games of chance including draw and stud poker, lowball and bridge. Goumond and partners ran card games and advertised soft drinks and tobacco

products, but perhaps more than that—many bars in Las Vegas served alcohol during Prohibition and ran illegal casino games in backrooms while local officials did little to stop it. In April 1931, when Nevada legalized licensed casino gaming, the Boulder Club became one of the first five businesses granted casino licenses by Las Vegas town leaders. Goumond and partners brought in slot machines, tables for craps, blackjack and faro, a keno game and a Big 6 wheel. The repeal of Prohibition two years later meant added prosperity from legal beer and alcohol sales. Goumond invested in a cutting-edge neon sign in 1933—designed by the new Yesco company that would go on to design many of the classic neon signs along Fremont Street and the Las Vegas Strip.

Goumond did well and installed a taller neon sign in the late 1930s. The Boulder Club, along with the Northern, Apache and J. Kell Houssel's Las Vegas Club, was one of the leading gaming clubs in Las Vegas in the 1930s. In 1938, the club and its three rivals expanded after Ria Langham, married to movie actor Clark Gable, filed for divorce in Las Vegas and lived there for the state-required six weeks for the divorce to become final. The national publicity from Mrs. Gable's trip—she was seen dealing casino games at the Apache next to the Boulder Club—started a great influx of thousands of divorcees, mainly from California, to Las Vegas. In 1944, the Boulder Club was licensed for 18 table games and 37 slot machines. Goumond's partners came and went along the way. In 1946, he sold a 3-percent share to a young Jackie Gaughan, a man from Omaha, Nebraska, where his family held shares in a gambling business. Gaughan had been stationed by the military in northern Nevada during World War II and decided to stay on where casinos were legal. Years later, Gaughan, who got his break at the Boulder Club, would become one of Las Vegas's top gaming figures, at one time owning five casinos. Goumond died in 1954 but the Boulder Club continued on until 1960, when a fire gutted its second floor and water damage ruined its tables and machines on the first floor. Unable to operate again, the club's partners sold the space to the Binion family, who used it to expand their Binion's Horseshoe Club next door.

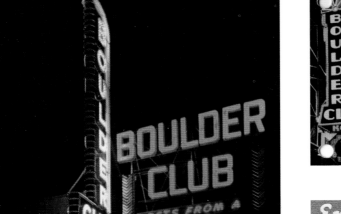

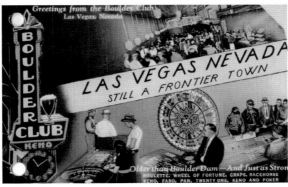

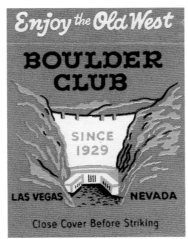

ABOVE LEFT *A postcard from the 1930s advertises the Boulder Club and Las Vegas as "still a frontier town."*

LEFT *A paper matchbook cover from the Boulder Club includes a drawing of Hoover Dam.*

FAR LEFT *The Boulder Club's impressive, colorful front neon sign from the 1940s, inviting guests to "Enjoy the Old West," seeks the attention of patrons from multiple angles on Fremont Street.*

OPPOSITE *This nighttime shot of the Boulder Club was taken on May 15, 1955, the fiftieth anniversary of the foundation of Las Vegas.*

El Rancho Vegas CLOSED 1960

Thomas Hull, a long-time hotel operator in California, agreed to drive to Las Vegas in 1940 at the behest of Las Vegas investors Robert Griffith and James "Big Jim" Cashman to scout a new hotel site near downtown Las Vegas. At that time, casinos in Las Vegas were in the city's downtown except for a few nightclubs on Highway 91, the main route to Los Angeles. Hull, whose car broke down on the highway outside of Las Vegas, looked around and thought how much he wished he could leap into a swimming pool. He liked the potential he saw for a full-fledged casino resort on the almost desolate highway. He convinced Griffith, Cashman

and other investors to build the El Rancho Vegas just outside the city limits. Hull also predicted, accurately as it turned out, that the military munitions industry in Las Vegas would improve the local economy.

Hull needed only $5,000 to buy the 50-acre site for the El Rancho Vegas. He hired architects McAlister and McAlister from Los Angeles to design the resort, based on a combination of Old West and Spanish hacienda themes. The hotel would have a casino, a dinner showroom called the Round-Up Room, a steakhouse, retail stores, stables for horses, 65 guest rooms inside cottages with kitchens, a swimming pool visible from the freeway, and a coffee shop serving a free early morning breakfast. Hull imported a sexy revue of dancing girls called the "El Rancho Starlets" for evening entertainment. A landmark, turning neon windmill stood over the front entrance where cars pulled in from the highway. There was nothing like it in Las Vegas. The El Rancho Vegas opened at a cost of about $500,000 on April 3, 1941 and became the

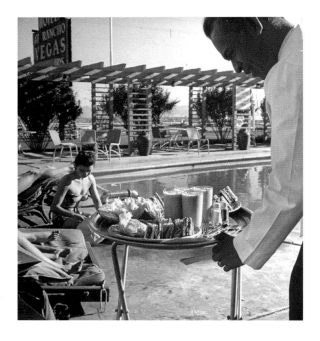

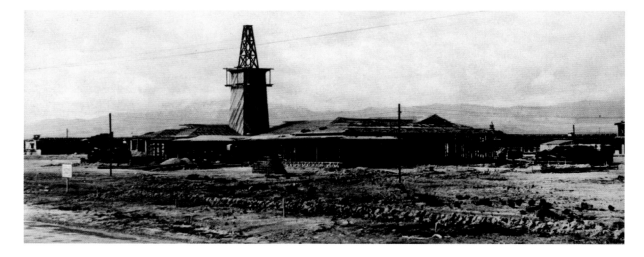

ABOVE *This construction shot of the El Rancho Vegas, regarded as the first Las Vegas Strip resort, shows its partly built windmill tower in early 1941.*

LEFT *A large newspaper advertisement announces the April 3, 1941 opening of the El Rancho Vegas, listing its partners as "podners," inviting customers to its "intimate casino" and describing it as "America's Ideal Western Hotel."*

TOP *A white-jacketed waiter with the El Rancho Vegas delivers drinks and sandwiches poolside. The pool was built out in front of the resort so that passing motorists could see it and be enticed to stop by for a visit.*

RIGHT *Sports cars are parked at the porte-cochère of the El Rancho Vegas, with signs publicizing its Opera House showroom and Stage Door Steakhouse in the late 1950s.*

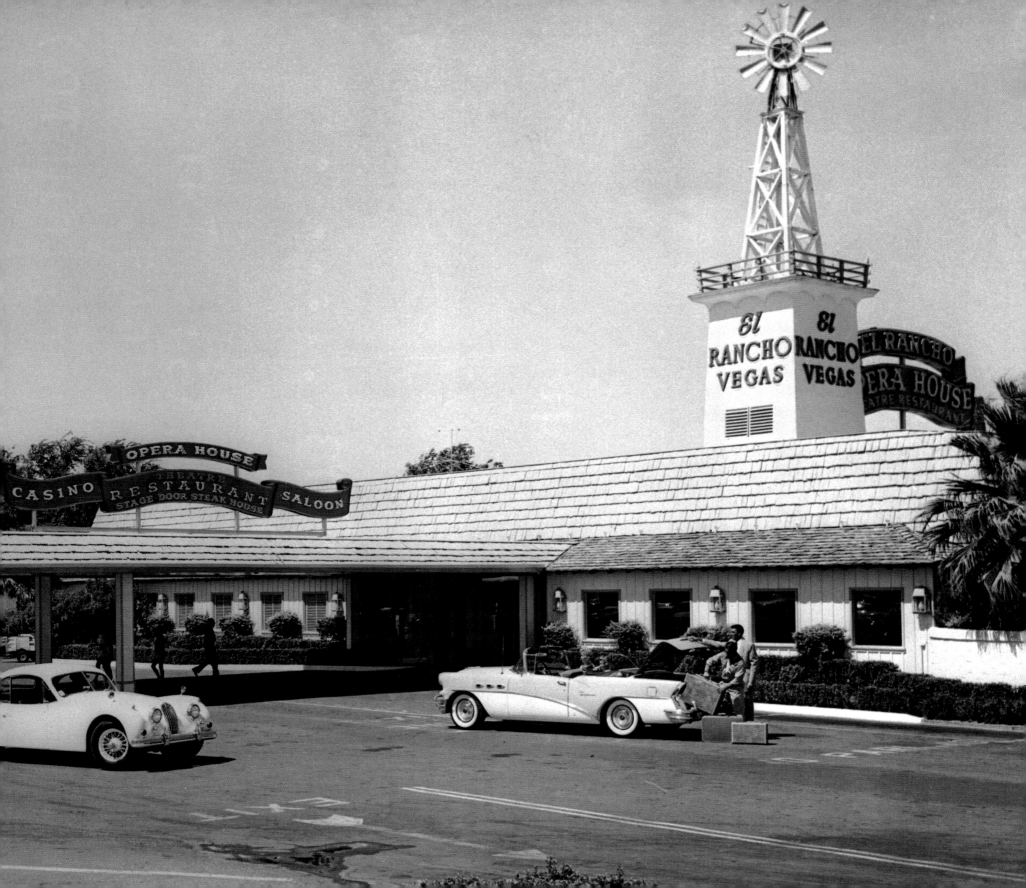

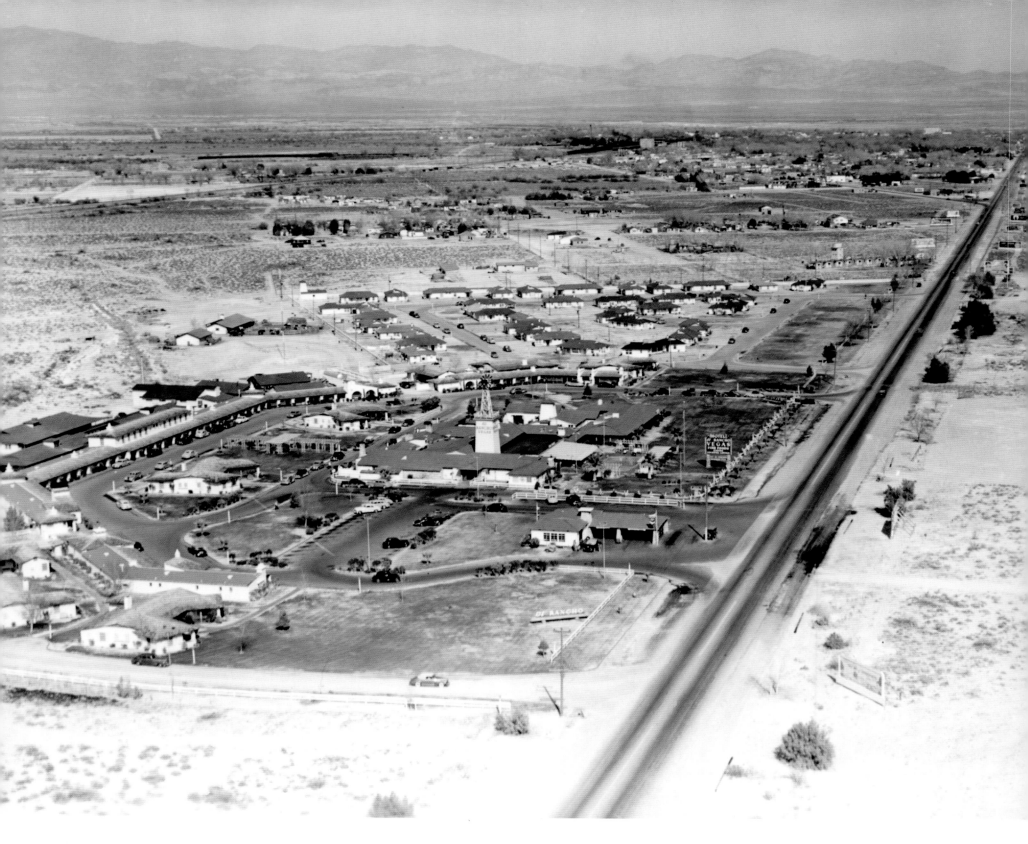

first modern Las Vegas Strip resort. Hull also started an unpretentious policy of welcoming guests and gamblers to dress as informally as they pleased. The El Rancho Vegas was successful with tourists and locals, and others quickly noticed, including investors who built the Last Frontier hotel nearby only a year later.

But the complicated new resort was difficult to manage in an area with fewer than 10,000 people not known for deluxe accommodations. Hull soon grew tired of running the place he built and sold out the following year. Wilbur Clark, who later built the Desert Inn, bought a minority share of the hotel in the mid-1940s. Two new majority owners who had links to organized crime were forced out by government officials. But in 1947, the hotel's prospects changed when Jake Katleman bought it with some partners including his nephew, Beldon. The Katlemans hired capable managers and delivered $750,000 for expansion and refurbishing.

OPPOSITE *A view from the air of the El Rancho's sprawling grounds, including the main hotel-casino building in the center (the swimming pool to the center right), shops and housing to the far left, a gas station to the right and new houses and streets built around it in the Las Vegas Valley.*

BELOW *Sunbathers lounge on the lawn in this 1950s photo taken outside the El Rancho's swimming pool.*

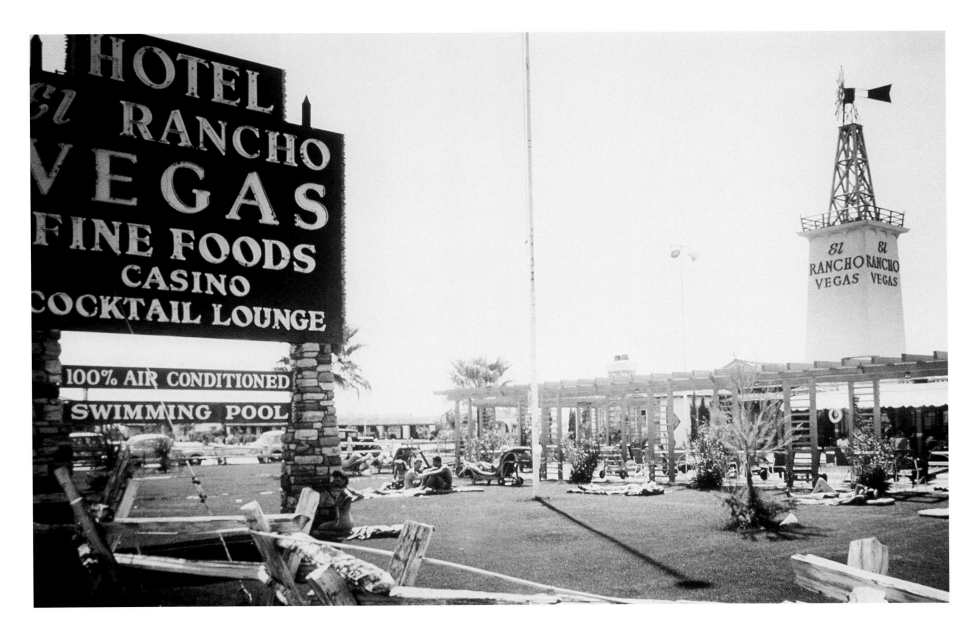

They kept the Western motif on the outside but then remodeled the interior with a fancy French provincial decor containing fewer cowboy relics and far more room for gambling. They added 220 guest rooms, renamed the showroom the Opera House and hired a new revue with girls dressed as casino dice. Beldon took over after Jake died in 1950 and became one of the most highly regarded Las Vegas hotel and casino operators. In the 1950s, he had a reliable and profitable stable of performers in the Opera House, such as major star Milton Berle, singer Eartha Kitt, stand-up comedian Joe E. Lewis and stripper Lili St. Cyr.

Then in the early morning of June 17, 1960, a fire swept the hotel, as guests, including comedian Red Skelton, watched outside. Firefighters were unable to save the mostly wooden structure. Witnesses saw the hotel's emblematic neon windmill collapse into the flames. The fire's cause was never determined. Katleman moved out of town and left the wreckage behind. The site stayed vacant for decades until the Hilton Hotels Corporation built a vacation timeshare high rise on the southern part of the property in 2004.

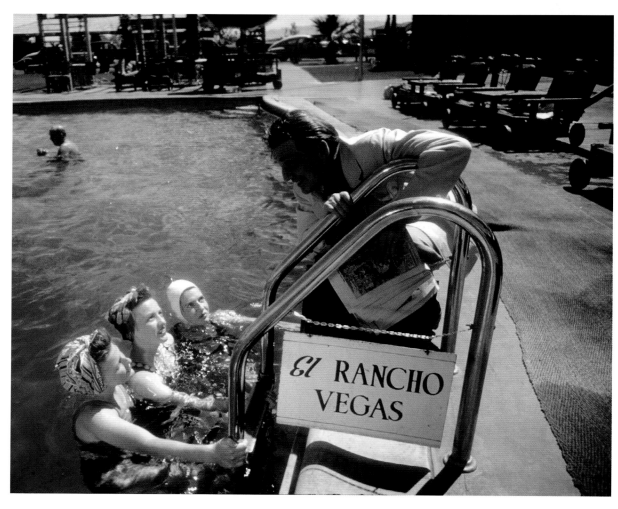

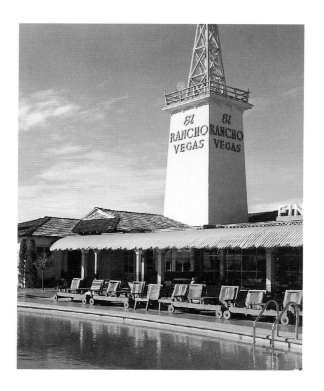

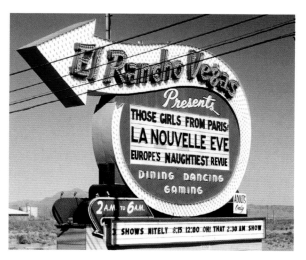

ABOVE *A colorful publicity shot from July 1942 showcases the resort's popular swimming pool.*

RIGHT *A man in U.S. Air Force uniform relaxes with other El Rancho patrons at the casino's mechanical slot machines.*

LEFT *The El Rancho's circled arrow neon sign highlights "Europe's naughtiest" dancers from Paris, with late shows after 2 a.m.*

FAR LEFT *The resort's distinctive windmill tower rises above the swimming pool.*

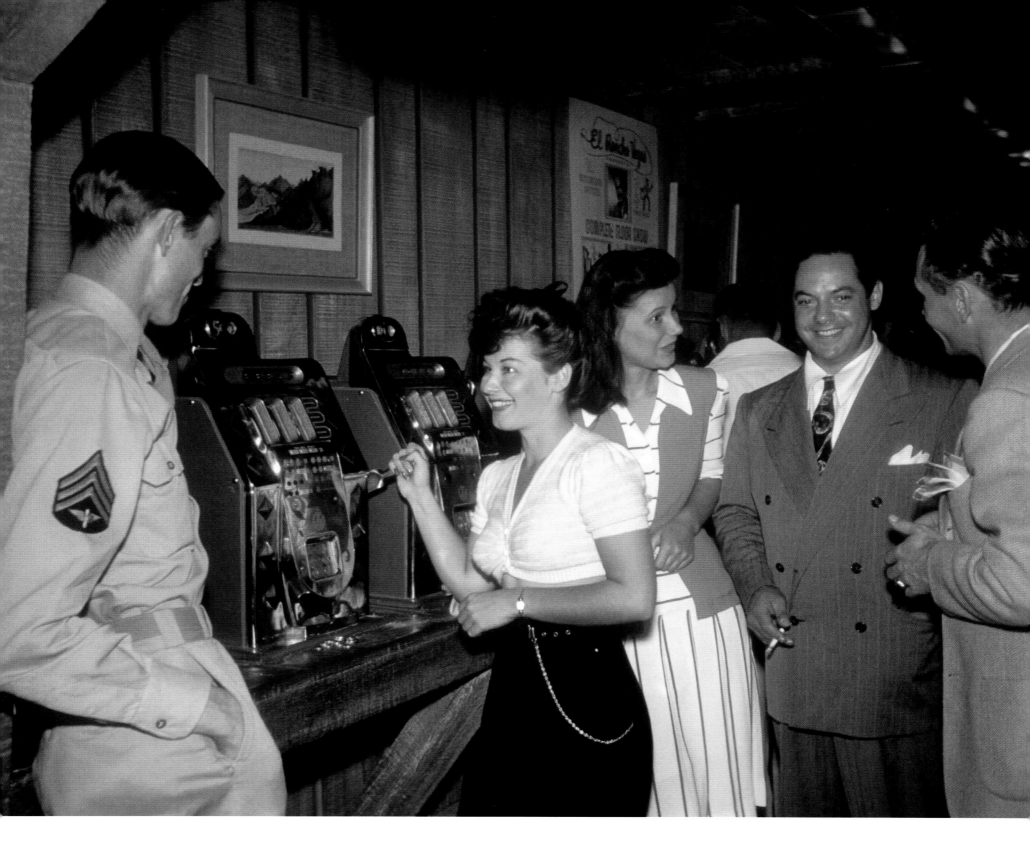

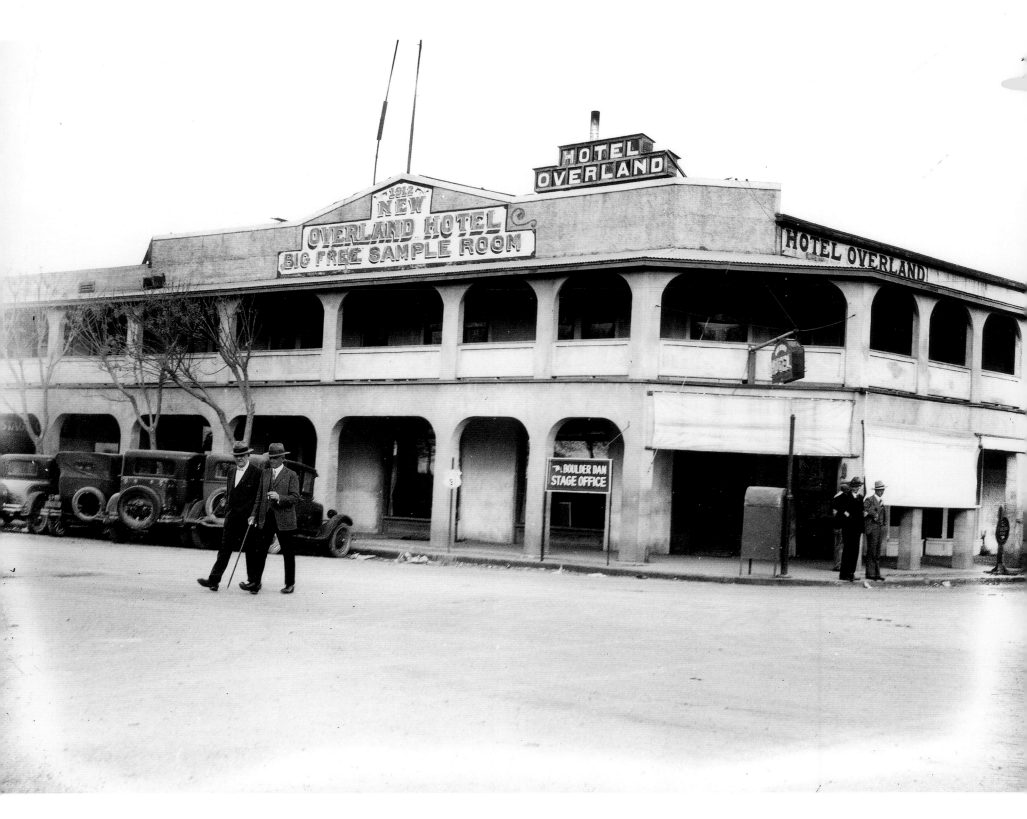

The Overland Hotel RENAMED 1961

John Stewart Wisner, a longtime railroad contractor from the Northwest, arrived in Las Vegas in 1904. He acquired what was perhaps the town's most prominent corner—the northeast edge of Fremont at Main—and the following year he built the Overland Hotel at 2 Fremont Street, the gateway to the new town's main business district.

Wisner soon found himself competing with the saloons and brothels of what was then known as Block 16 and Block 17, about a block to the east of the Overland. The new town made that area its red-light district and the only place in town where alcohol could be served. Wisner went ahead and set up a saloon offering alcohol at the Overland in violation of the town policy but officials looked the other way.

In 1911, the Overland started showing motion pictures on its second floor, but by May of the same year, a blaze swept through the hotel, killing one person and causing about $50,000 in damage. Firefighters who tried to douse the flames were hampered by a lack of pressure in the town's water system.

Wisner rebuilt the Overland using reinforced concrete and a design incorporating distinctive pillars and arches on its first and second floors. He renamed it the "New Overland Hotel." The building and its second-floor balcony wrapped around both sides of the corner of Main and Fremont and extended about a half block down both streets. Guests could survey much of the town from the Overland's open-air balcony. Following a brief illness, Wisner died in 1922, leaving an estate, valued at $100,000, to his daughter Ethel Wisner Genther.

In 1925, the hotel benefited when the city paved the first five blocks of Fremont Street from Main. In 1930, the Overland advertised a second-floor showroom, which traveling salesmen could use for free to display their wares, an antecedent to the commercial shows and conventions that would become a major business in modern Las Vegas. The hotel installed pull-down drapes extending down to the first floor on Fremont to shield its sidewalk and lobby from direct sunlight.

The Overland's cachet in Las Vegas declined with the legalization of casino gambling starting in 1931. Soon, small casinos opened with brightly lit neon signs several blocks south along Fremont Street while the Overland remained simply a hotel with a bar and coffee shop. By 1935, its rooftop signs were removed and the Union Bus service used it as the drop-off point for passengers at Fremont and Main. In the 1940s, the hotel installed new, arched signs on Fremont and Main. The explosion of the casino gambling industry after World War II, both downtown and outside the city limits, would further overshadow the Overland. J. Kell Houssels, owner of the Las Vegas Club casino on the other side of Fremont, moved it across the street in 1949 and took over about half of the Overland's frontage on Fremont. The Overland essentially became the Las Vegas Club's hotel, in keeping with the trend of combining hotels and casinos, starting with The Meadows resort in downtown Las Vegas in the early 1930s.

By the early 1950s, the Overland advertised a lounge called the Chatterbox Bar. The hotel's walls were painted white and its roof overlaid by Spanish-style stone shingles. The Overland's second-floor balcony, where visitors had surveyed Fremont Street for decades, was removed to make way for neon signs for the Las Vegas Club and its restaurant, Biff's.

Casino operators Mel Exber and Jackie Gaughan took over the Overland and the Las Vegas Club casino in 1961. Although they refurbished the 56-year-old Overland, they renamed their new venture the Las Vegas Club and Hotel.

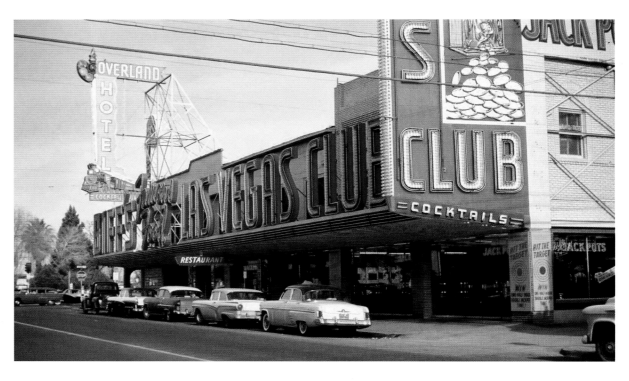

LEFT *Two men walk across Main Street away from the Overland Hotel, at the corner of Fremont and Main streets in about 1930.*

RIGHT *The Overland started to become overshadowed by casinos in the 1930s after gambling was legalized.*

TOP RIGHT *The Overland (left) as it looked in the 1940s.*

Hotel Apache CLOSED 1964

The Hotel Apache, with the Apache Casino on the first floor, would be one of the cornerstones of Las Vegas along Fremont Street at Second Street for three decades. The Apache was built in 1932 by Pietro O. Silvagni, an immigrant from Italy who arrived in America in 1904. His three daughters and son joined him in Las Vegas after he opened the Apache. Silvagni served as landlord of the three-story building and leased the hotel, casino, coffee shop and other interior parts to others. An advertisement placed in the *Las Vegas Age* newspaper invited the public to peruse the Apache, starting at 5 p.m., for its grand opening on March 19, 1932. Las Vegas Mayor E.W. Cragin had the honor of opening the doors to launch the hotel and a party atmosphere soon ensued. A woman named Rose Marie, identified as an "Indian princess," served as a hostess for the opening. The Apache hotel, managed by Sydney Smith, William Brown and Robert R. Russel, had its rooms on the second and third floors over the casino and featured the first elevator built in Las Vegas. It was perhaps the most modern and stylish hotel-casino in town. The interior had an Old West decor with thick carpeting, chandeliers, a pharmacy and several other stores, a

coffee shop and a basement banquet hall. Each of its 56 rooms had a bathroom, another first in Las Vegas at the time. Single rooms went for $3.50 a night, doubles ranged from $4 to $5, twin bedrooms $6.50 and there were special rates for guests staying a month or more. The restaurant operation, overseen by Brown, boasted one of the first automatic dishwashers in town. It had one of the first cooling systems in Las Vegas in the 1930s, and in 1941 Silvagni put in a modern air-conditioning system, giving the Apache a huge competitive advantage. In a town that would one day become a center of outlandish stunts to promote its hotels, Apache treasurer and publicist Robert "Colonel" Russel was one of the original Las Vegas publicity men. He set up a publicity shot of a man posing as an old miner checking in at the hotel with a burro. The photo was

ABOVE *The Hotel Apache's neon sign sits on the roof above the Horseshoe Club casino on the first floor in the mid-1950s. The hotel's rooms were on the second floor.*

ABOVE *The Hotel Apache's first floor was leased to the S.S. Rex Club by the time of this mid-1940s shot.*

RIGHT *The Eldorado Club, below the Hotel Apache, is shown during its better days in the early 1950s.*

OPPOSITE *A promotional photo for the Apache Casino, which operated under the Hotel Apache in the early 1940s.*

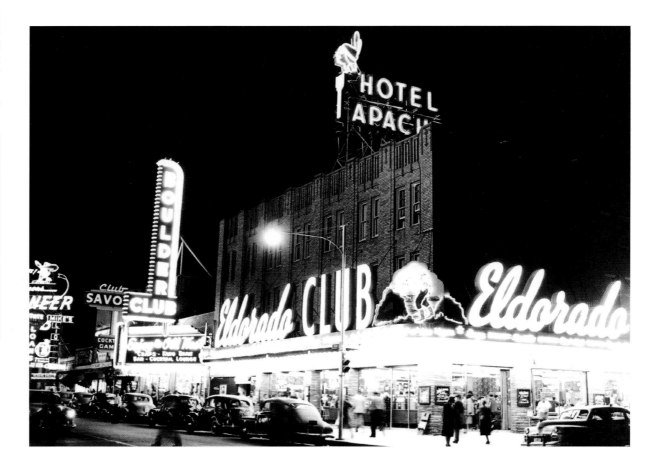

widely publicized across the county, viral for the time. After Hoover Dam opened, Russel distributed a photo of himself, "Colonel Russel," beside a fish he said was the "first" caught at the newly formed Lake Mead outside Las Vegas. The publicity turned sour when the fish turned out to be a Pacific Ocean variety.

Within months of the opening, the Apache turned its basement into a nightclub called the Kiva Club. The city granted the Apache's casino, managed by Charles Mason and Jack Doyle, a roulette table and then gradually issued licenses for slot machines, craps, blackjack and keno. The small casino section fronted Fremont Street. Over the years, while the hotel part of the Apache remained, its casino section and the café, shops and nightclub would go through a succession of new managers, and new names, with the ups and downs of the economy during the war years of the 1940s. In 1941, the casino was renamed the Western, then the New Western Casino in 1942. Three years later, former Meadows casino partner and one-time gambling ship operator Tony Cornero took ownership and called it the S.S. Rex, after the illegal floating casino he once operated off shore in Southern California in the late 1930s. The colorful Cornero installed a popular race wire for wagering to go with casino games. But Cornero, dogged by complaints from patrons about the fairness of his games, sold out only three months later to Silvagni who in turn sold the S.S. Rex to well-respected operator Guy McAfee in the summer of 1945. McAfee sold to yet another new owner in 1946. Moe Sedway, a one-time associate of murdered gangster Bugsy Siegel, took over in mid-1946 and renamed it the Rex Club, then the Eldorado the following year. Yet two other owners struggled with the Eldorado. The casino's owner, Dr. Monte Bernstein, got into a dispute with the landlord Silvagni, and the Eldorado closed in 1951. Former Texas gangster Benny Binion famously acquired it by buying out Bernstein's debts for about $300,000. Binion turned the casino—with the Apache in the upper two floors—into a standout success as Binion's Horseshoe Club. Binion laid carpet in the casino, unusual for the time, and offered gamblers high-limit wagering. But when Benny had to serve a few years in federal prison in 1953 for tax evasion, he sold the place to Joe Brown, who renamed the casino Joe W. Brown's Horseshoe. Binion and his family took over the business in 1960. In 1964, when the family owned the place outright, they dropped the Apache name altogether and called the entire hotel-casino Binion's Horseshoe.

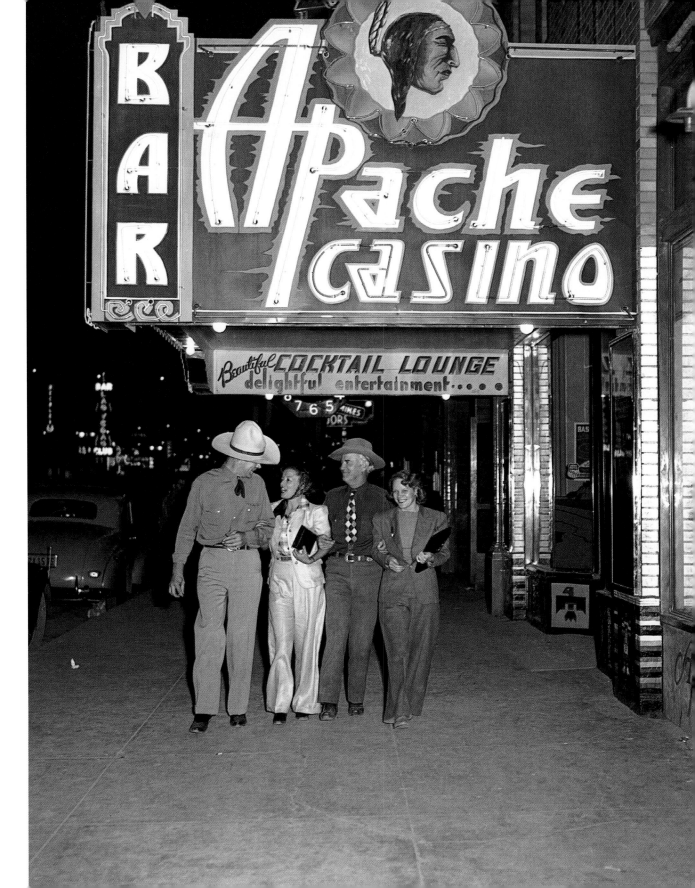

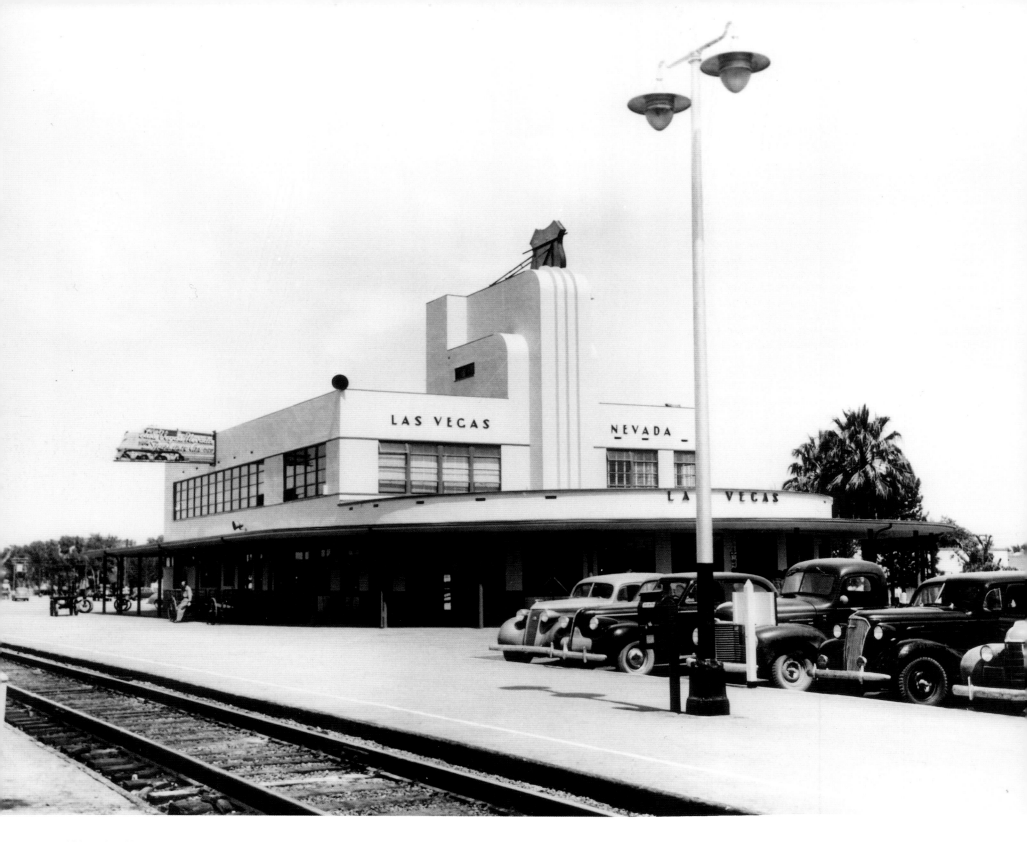

Passenger Rail DISCONTINUED 1968

In 1902 Montana Senator William Clark purchased the Las Vegas Rancho property on behalf of the San Pedro, Los Angeles and Salt Lake Railroad. At first there was a race to create a settlement, with John T. McWilliams buying 80 acres to found the "original" Las Vegas Townsite. But Clark had the railroad and in May 1905 he used a passenger car as a temporary station building to receive the first train and investor-speculators for his great land auction. Clark's Las Vegas Townsite guaranteed investors access to the railroad and the development battle was won. The fledgling settlement got its own Mission-style building in December 1905. A contemporary newspaper article from the *Las Vegas Age* described the outer walls of the depot as buff-colored with contrasting terra-cotta tile

roofing. The two-storied building had telegraph rooms, and dressing rooms for the train crews on the second floor, while most of the first-floor space was taken up by a large waiting room, ticket office, baggage room, and "a ladies waiting room of liberal proportions."

Contemporary photographs of the Mission-style railroad depot, the nearby ice plant and railroad cottages illustrate how the city's existence revolved around the railroad. From 1909 to 1911 the SPLA&SL railroad built 64 cottages to house workers and their families employed in the railyards and machine shops that were established in Las Vegas. They were built at Third and Garces, but were gradually swallowed up as commercial development in the 20th century overtook downtown Las Vegas. One of the cottages was eventually transferred across town to the Clark County Museum in Henderson while the other three cottages went to the Las Vegas Springs Preserve.

In 1940, the gleaming new Union Pacific Station took the place of the original Mission-style Salt Lake Depot at Main and Fremont. Contemporary publicity described the new station's style as being in the "typical modernistic western motif" and billed it "the first streamlined, completely air-conditioned railroad passenger station anywhere." Over the

LEFT *Built right at the end of the Art Deco period, the Union Pacific Station was in service for just 28 years.*

TOP RIGHT *A postcard of the Union Pacific Station.*

RIGHT *Beyond the intersection at Main and Bonneville lie rows of railway cottages built for SPLA&SL workers.*

BELOW *The original Mission-style station pictured soon after it was built in 1905. Were it around today, it would stare down Fremont Street through the Plaza Hotel.*

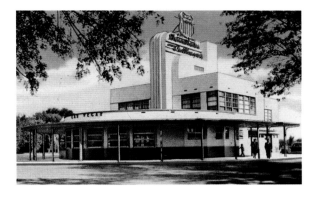

years, the station became something of a downtown landmark. In the 1950s and 1960s, a typical Saturday night for Las Vegas teenagers would include "dragging" Fremont Street in their cars, and then driving around the circle in front of the Union Pacific Station.

Passenger train service to Las Vegas was discontinued in 1968 and the Union Pacific Station was razed in 1970. The 26-story Union Plaza Hotel—a joint venture between the Union Pacific Railroad and a private corporation—was constructed just in front of the demolished station site. The Plaza opened on July 2, 1971, with what was then the world's largest casino. Although both stations are gone, a new passenger terminal may be built in the future to bring passengers to Vegas. The proposed X-Train (party train) from Fullerton, through Crucero Canyon hit financial problems, but Amtrak is still looking at the possibilities of reopening the route.

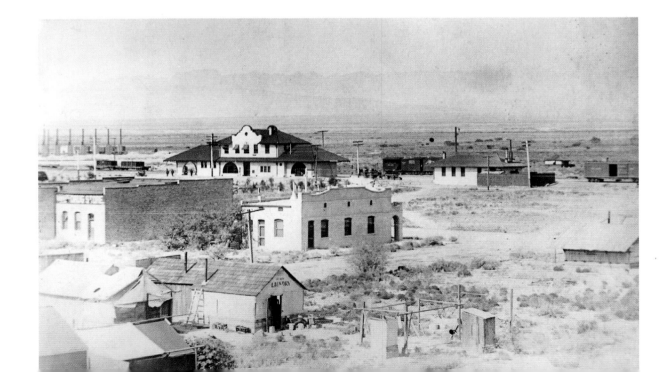

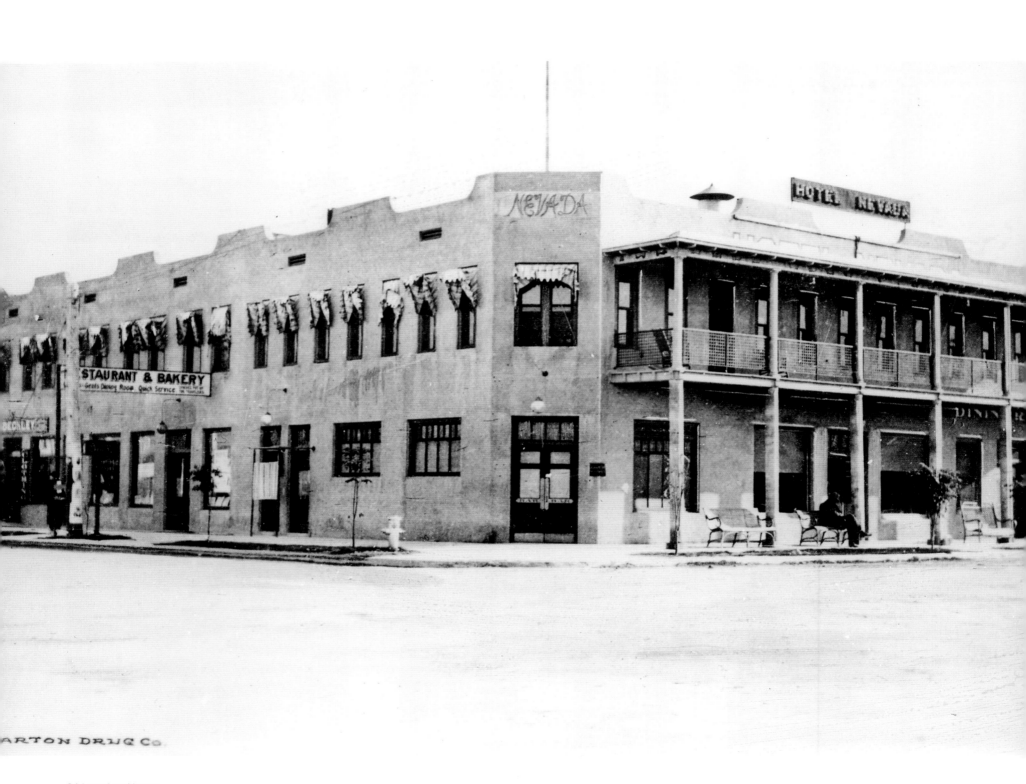

Hotel Nevada / Sal Sagev RENAMED 1974

On January 13, 1906, John F. Miller started the first hotel in Las Vegas, just months after the 1905 land auction, which sold parcels of subdivided land that made up the area's planned downtown. The location of Miller's $1,750 parcel, at Main Street and the beginning of Fremont Street, was a perfect locale for a hotel, right across Main from the Las Vegas depot for the San Pedro, Los Angeles and Salt Lake Railroad. The address was One Fremont Street. The Hotel Nevada was two stories high, built of stone masonry at the east corner of Main and Fremont. Its rooms measured only 10 feet square, rented for a dollar per night and offered shade with little protection from heat, but there were steam radiators to beat the cold days. After the opening, a Las Vegas newspaper gleefully described the rooms as "first class" and "as comfortable a hostelry as can be found anywhere," which was probably true then. A year later, in 1907, the first telephone in Las Vegas was installed at the Hotel Nevada, and fittingly its number was 1. Inside, the

hotel operated games of chance, as long as Nevada permitted them. In 1909, the state legislature banned gambling and so the Hotel Nevada stored away its roulette and poker tables. Outside the hotel, Las Vegas's main thoroughfare, Fremont, remained a dirt and gravel street until the city paved it in 1925. Now more accessible for motorists and buses, the hotel prospered and added an outdoor electric neon sign.

But the greatest boon to local businesses came when Nevada legalized nearly all casino games in 1931, giving the hotel the opportunity to reopen its casino. That year, the old Hotel Nevada was renamed the "Sal Sagev," Las Vegas spelled backwards. Throughout the 1930s, the Sal Sagev was one of the busiest hotels in Las Vegas, adjacent to a point of entry for people getting off and on the train bound for Salt Lake City or Los Angeles. By the 1950s, downtown Las Vegas had lost much of its trade to the luxury hotels cropping up on the Las Vegas Strip outside town. In 1955, a

group of Italian Americans from the San Francisco area, including Italo Ghelfi, Al Durante, Dan Fiorito, Roberto Picardo and Leo Massaro, acquired the Sal Sagev and added a casino, the Golden Gate, which was named after San Francisco's famous bridge to Marin County. In 1959, Ghelfi, who would manage the Sal Sagev for decades, added a touch of San Francisco's Fisherman's Wharf to the hotel—a 50-cent shrimp cocktail, consisting of cold baby shrimp inside a glass with cocktail sauce. The cocktail became a huge favorite among visitors and a classic Las Vegas treat.

In 1974 it was renamed the Golden Gate Hotel and Casino. By 1991 the hotel had sold 25 million of its famous shrimp cocktails. The Golden Gate remains open on Fremont Street, with some of its now-modernized rooms still available to guests at the hotel.

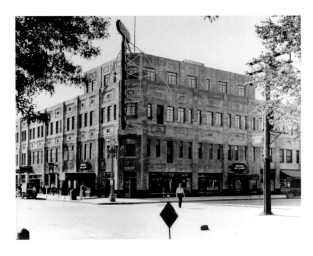

ABOVE *The Hotel Nevada changed hands in 1931 and became the Sal Sagev—Las Vegas spelled backwards.*

LEFT *The Hotel Nevada, on the south corner of Fremont and Main streets, was built by John F. Miller in early 1906. The hotel was situated across from the town's train depot.*

RIGHT *In the mid-1960s, its new owners, who were from San Francisco, renamed the casino the Golden Gate Casino. The Sal Sagev hotel name was dropped in favor of the Golden Gate Hotel and Casino in the 1970s.*

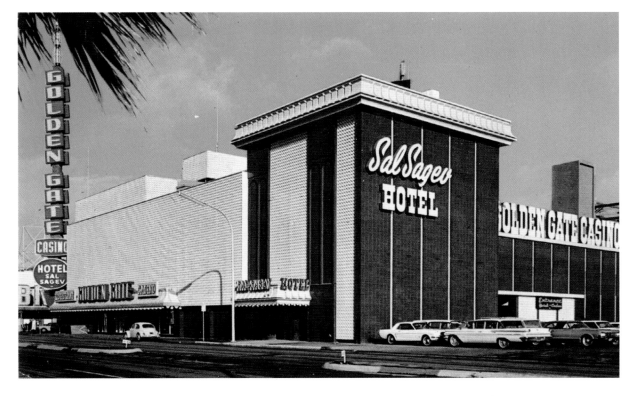

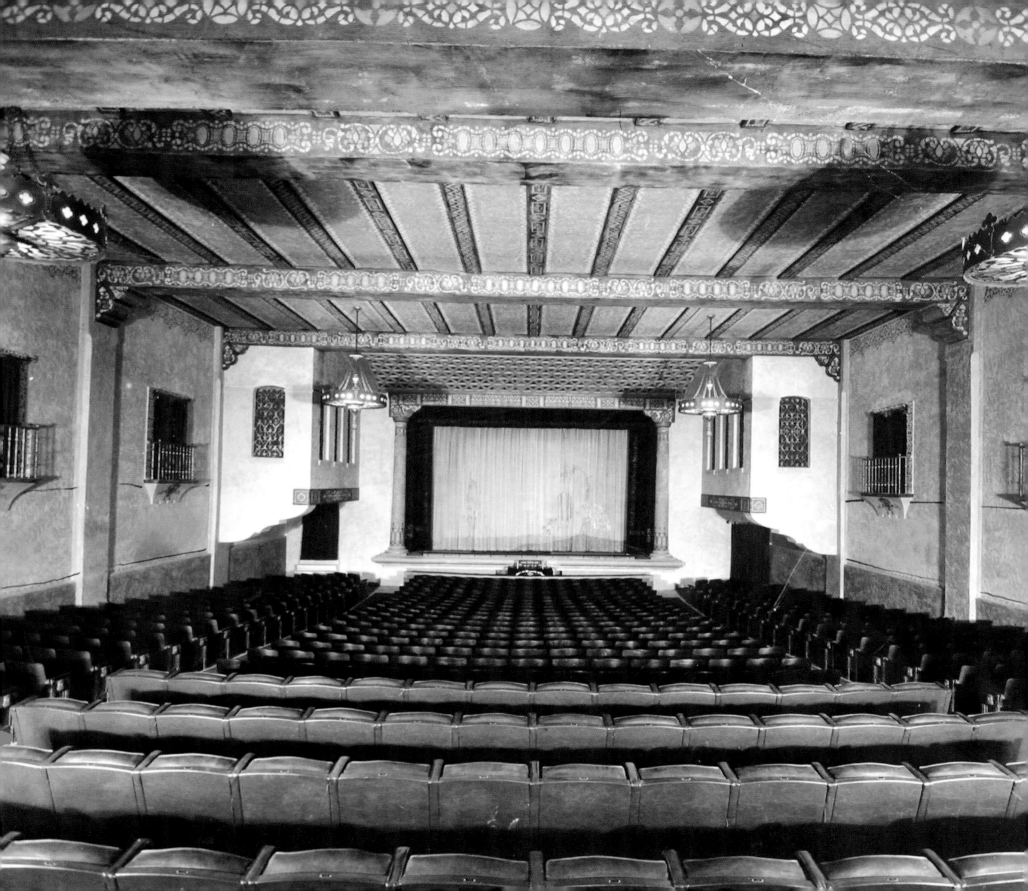

El Portal Theater CLOSED 1978

Built in 1928 on Fremont Street, the El Portal Theater became Las Vegas's first luxury movie show place. Movies had been screened in Las Vegas for years. The town's first real movie house was the Isis Theater on Fremont Street that started in 1908, but it was torn down by the time early Las Vegas developer Edward W. Griffith had built the Majestic Theater in 1912 on Fremont. Ernie Cragin, an insurance salesman from Wyoming, worked in his spare time at the Majestic, next door to his sales office. After learning how to run a theater, Cragin and his insurance business partner William Pike opened a fenced-in, outdoor movie theater on Fremont called the Airdome in 1915.

Cragin and Pike did well enough by the 1920s to begin planning the El Portal, Las Vegas's most stylish and modern theater, at the site of the Airdome. They hired architect Charles Alexander MacNelledge who went with a Spanish hacienda motif and a marquee sign outside displaying movie titles and star names. Inside, chandeliers hung from the ceiling among thick, wooden exposed beams, and a Wurlitzer organ played to accompany the silent movies. The partners put in a sound system to

exhibit soundtracked films the following year. The theater's luxury box seats in a loge section were lined in leather and available for a higher-priced ticket. The theater's 700 seats were on the floor and a second-story balcony.

Hollywood paid notice to the El Portal right way. On the theater's official opening date, June 21, 1928, the El Portal offered a sneak preview of *Ladies of the Mob*, a star vehicle for actress Clara Bow. It was the first building in town with interior air-conditioning, or what was advertised as "Manufactured Weather." The theater was a central meeting place for local residents, and not only for movie watching. Play productions, vaudeville acts and high school graduations were also held there. The theater's prominence no doubt aided Cragin in his election as Las Vegas mayor in 1931. But Cragin would for decades require African-American and Hispanic patrons to sit in sections segregated from white patrons. One of those steered to the "colored" section was young African-American entertainer Sammy Davis Jr., who would recall later in life the hurt he felt being directed to sit there after buying a ticket.

The El Portal hosted some brightly lit movie premieres, among them *Meet Me in Las Vegas*, with Dan Dailey and Cyd Charisse in 1956 and *The Joker is Wild*, in 1957, when its star, Frank Sinatra, and other cast members greeted the paparazzi. After Cragin died in 1959, his wife Marleau oversaw a major redecoration of the theater in 1961. She installed updated sound and projection equipment; 730 new seats; remote-controlled curtains in front of the screen; rose, black and gold-colored carpeting; a new cast and stone facade to replace the old stucco one; a new triangular, 75-foot marquee and a 60-foot-high vertical neon sign.

The El Portal lasted as a theater until 1978 when the space was converted into souvenir shops. In recent years it has housed an American Indian arts and crafts store, its tall "El Portal" theater neon sign still looming outside.

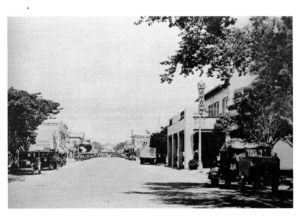

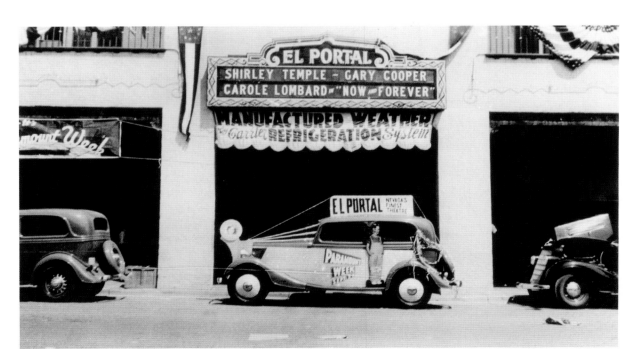

ABOVE *The El Portal Theater as it appeared soon after it opened on Fremont Street in 1928.*

LEFT *The theater advertised its air-conditioning, or "manufactured weather," along with a Shirley Temple movie on its marquee in the mid-1930s.*

OPPOSITE *The detailed interior of the 700-seat El Portal is shown here, with its ornate, Spanish hacienda-style wooden ceiling and walls. The Wurlitzer organ, which used to play during silent movies, is below the stage. The theater's three rows of luxury seats, with extra plush cushions, are in the foreground.*

MGM Grand Hotel and Casino CLOSED 1986

Kirk Kerkorian opened the MGM Grand Hotel in 1973, diagonally opposite the Caesars Palace hotel, on the corner of Flamingo Road and the Las Vegas Strip. It was the first major hotel on the Strip to rival the renowned Caesars, built in 1966. Kerkorian, who delivered planes across the Atlantic during World War II, made a fortune in the 1950s and 1960s with his commercial charter airline to Las Vegas. By the early 1970s, Kerkorian was the greatest-ever deal maker for land on the Strip. He owned large parcels on three of the four corners of Flamingo and the Strip, considered then the heart of the Strip. In 1969, he completed the International Hotel, a few blocks east of the Strip, at the time the largest hotel in the world with 1,512 rooms. After that achievement, his fascination with Hollywood drew him to start buying stock in the famed movie company MGM Studios and he won the majority stake in MGM in 1971. He now controlled the rights to MGM's distinguished classic movie library and

soon announced plans to build a new MGM-themed hotel in Las Vegas. The site would be on Kerkorian's land on the southeast corner of Flamingo and the Strip, the former location of the failed Bonanza hotel. It would be called the MGM Grand, named after the MGM movie *Grand Hotel* released in 1932. Kerkorian sold the International and Flamingo hotels to the Hilton Hotels chain and embarked on the MGM at a then-astronomical construction cost of more than $100 million. Yet again he wanted to create the largest hotel in the world, surpassing the International, and did.

By the time Kerkorian arrived on opening night, December 5, 1973, with his friend, actor Cary Grant, the MGM Grand had 2,200 hotel rooms and suites. The resort had two showrooms, where he booked Barbra Streisand in one and the Broadway musical *Hair* in the other for the opening. Along with five restaurants, the place had a theater reserved for showing MGM-produced films and Kerkorian lined part of the interior with portraits of Clark Gable and other MGM stars. Kerkorian also famously included a jai alai fronton, where guests could watch the fast-paced Basque ball game and place wagers on its playing teams. Kerkorian created a new high standard for Las Vegas hotels.

But in 1980, the worst hotel disaster in Las Vegas history occurred at the MGM. A devastating fire triggered by a blown electrical cord on the first floor spread through the hotel's casino. The resulting smoke rose to the upper floors, overcoming dozens of guests in their rooms. The fire killed 85 people and injured hundreds more. Government officials blamed MGM's builders and Kerkorian himself—who demanded the MGM be built quickly after its April 15, 1972 groundbreaking—for scrimping on safety features. Many lawsuits ensued. Kerkorian rebuilt and reopened the MGM just eight months later, in mid-1981. He soon refocused on deals for yet more Strip properties, purchasing the Sands and Desert Inn hotels in the 1980s and selling them at a profit. His attention shifted back to Hollywood, where he acquired the United Artists movie company in 1984. But perhaps readying himself for another challenge, Kerkorian sold the MGM and an MGM hotel he opened in northern Nevada to Bally Manufacturing Company in 1986 for almost $600 million. The new owner renamed it Bally's. Meanwhile, Kerkorian sought to

outdo himself again. Several years later he bought another large piece of land on the Strip, the site of the Marina hotel and an 18-hole golf course. He used the location to build the next generation MGM Grand hotel that opened in 1993, again with MGM movies serving as the theme, setting a new world record with 5,005 guest rooms.

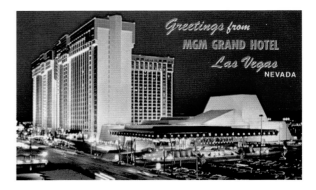

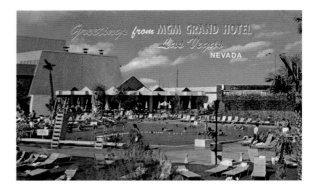

ABOVE *Postcards from the 1970s show the exterior of the MGM Grand by day and night, and the resort's secluded pool in the shadow of the hotel's L-shaped hotel towers.*

RIGHT *The MGM Grand's giant marquee on the Las Vegas Strip in the late 1970s.*

LEFT *Helicopters hover over the MGM Grand to try and rescue guests from the roof of the hotel amid the smoke from a major fire in 1980 that erupted inside the casino and would kill 85 people, most of whom died in their guest rooms of smoke inhalation.*

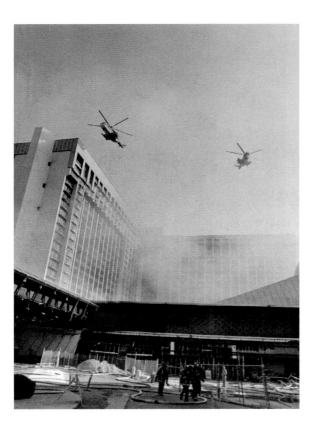

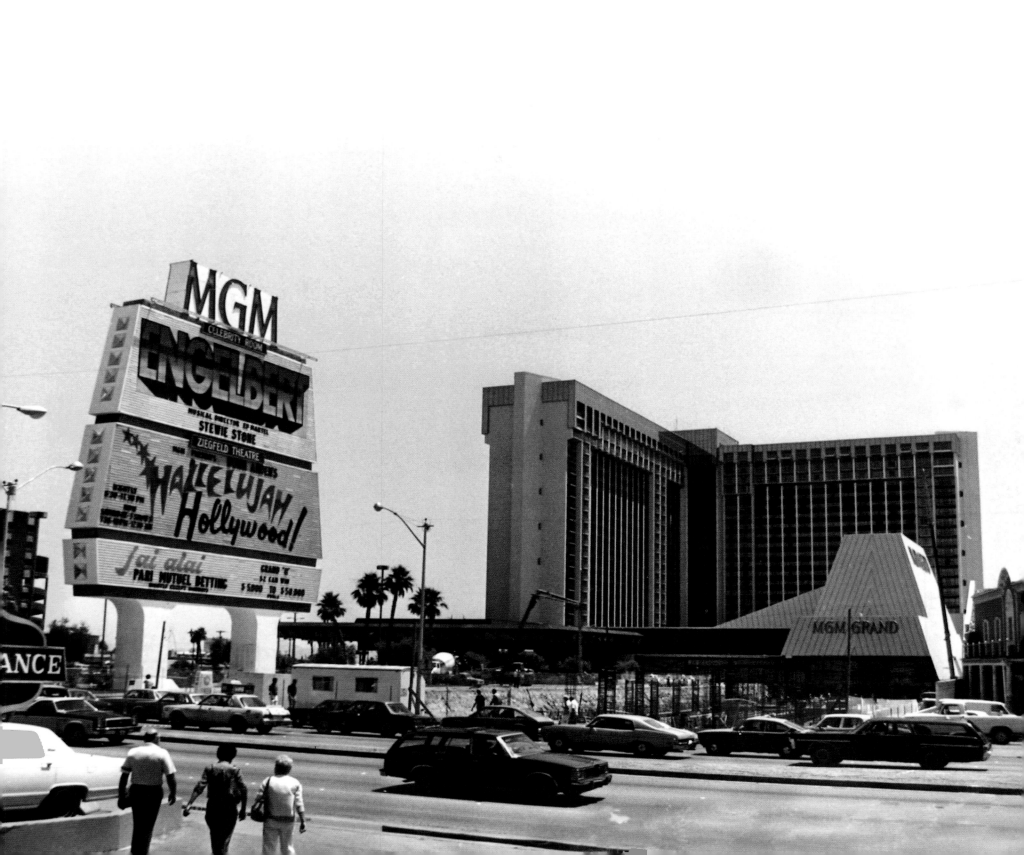

The Castaways Hotel & Casino CLOSED 1987

The Castaways Hotel & Casino was among a handful of resorts that arose on the Las Vegas Strip in the 1960s. Opening in 1963 its location was the site of the former Red Rooster Club that in 1931 became one of the original nightclubs on Highway 91, well before the roadway became known as the Strip. In the early 1950s, the Red Rooster sat next to an "auto court" motel called the Sans Souci, owned by George Mitzell. In 1957, Mitzell bought the old Red Rooster and opened a new hotel-casino called the Sans Souci, with a 400-seat showroom. But Mitzell's experiment did not pan out, and he filed for bankruptcy protection in 1958 and closed it down. Other operators ran the Sans Souci, without a casino, until 1963.

Enter new owner Ike LaRue, who led a group of investors who bought the Sans Souci that year when it was still a fairly new property. They made improvements, introduced a South Pacific island theme, and renamed it the Castaways. The hotel had 100 rooms in a pair of low-rise buildings on either side of the casino. LaRue soon added another 150 rooms, some two-story, split-level luxury suites—an advancement for the time that would be copied by other Strip hotels—and an Olympic-sized pool. Its sign included neon fashioned into a large, broad-winged bird. Inside, LaRue decorated the hotel's cocktail lounge with a then-fashionable tiki theme. He put a huge fish tank in the lounge and wowed customers by having showgirls in bathing suits swimming inside it. He renamed the showroom the Samoa Room. But the casino part of the business was relatively small, with little more than 150 slot machines and a handful of table games, and failed to attract much gambling action or profits. The casino closed in 1964 and while management kept trying to revive it over the years, the Castaways—like the Sans Souci—never succeeded on the gambling side. For many years, its casino opened, failed and abruptly closed. The business served mainly as a drive-in-type hotel with decent restaurants and nightclub entertainment for budget-minded customers.

Despite its lack of success as a gambling parlor, the Castaways nonetheless attracted tourists and Las Vegas residents alike. The hotel's Samoa Room and Kon Tiki cocktail lounge were constantly busy with live performers every day and all night long.

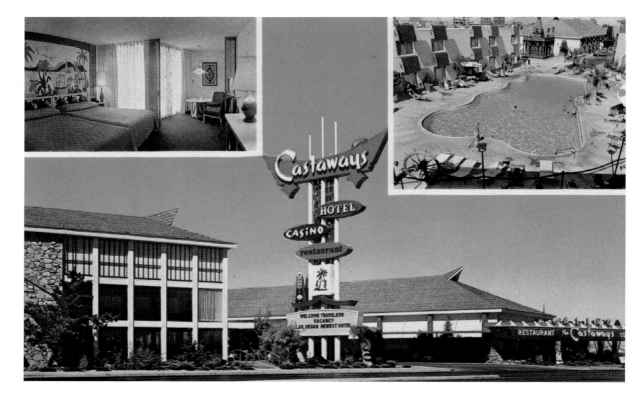

The Samoa famously served as the venue of a well-liked sex-comedy revue called "Bottom's Up," starring comedian Redd Foxx. The hotel bought and reassembled a replica of an East Indian shrine known as the Jain Temple that had been on display at an exhibition in St. Louis back in 1904. The temple, made of teak wood, was placed outside the hotel on the Strip as a free curiosity for passersby.

Perhaps the biggest moment in the life of the Castaways came in the late 1960s, when it caught the eye of billionaire recluse Howard Hughes. Hughes, who moved into the nearby Desert Inn hotel in 1966, bought the Castaways and five other major Strip resorts, or "toys" as he called them, from 1967 to 1969. His Summa Corporation ran the Castaways for years, including after Hughes died in 1976. Hughes' capable managers, including Bill Friedman, made the hotel's casino work as well as it could. In 1987, the Castaways ended its almost quarter-century run on the Strip. Steve Wynn, owner of the Golden Nugget casino in downtown Las Vegas, bought the property and tore down the hotel to make way for The Mirage hotel-casino in 1989, regarded as the first of a new wave of modern mega-resorts on the Strip. Wynn built the Treasure Island hotel-casino on another part of the former Castaways in 1993.

ABOVE *A postcard of the Castaways hotel, showing its low-rise hotel and casino, one of its finer guest rooms and its unique, island-shaped swimming pool.*

RIGHT *The hotel's grounds, including its winged marquee sign, the dark-colored East Indian shrine (upper center), its striped parking lot and rather ordinary-looking hotel buildings to the rear.*

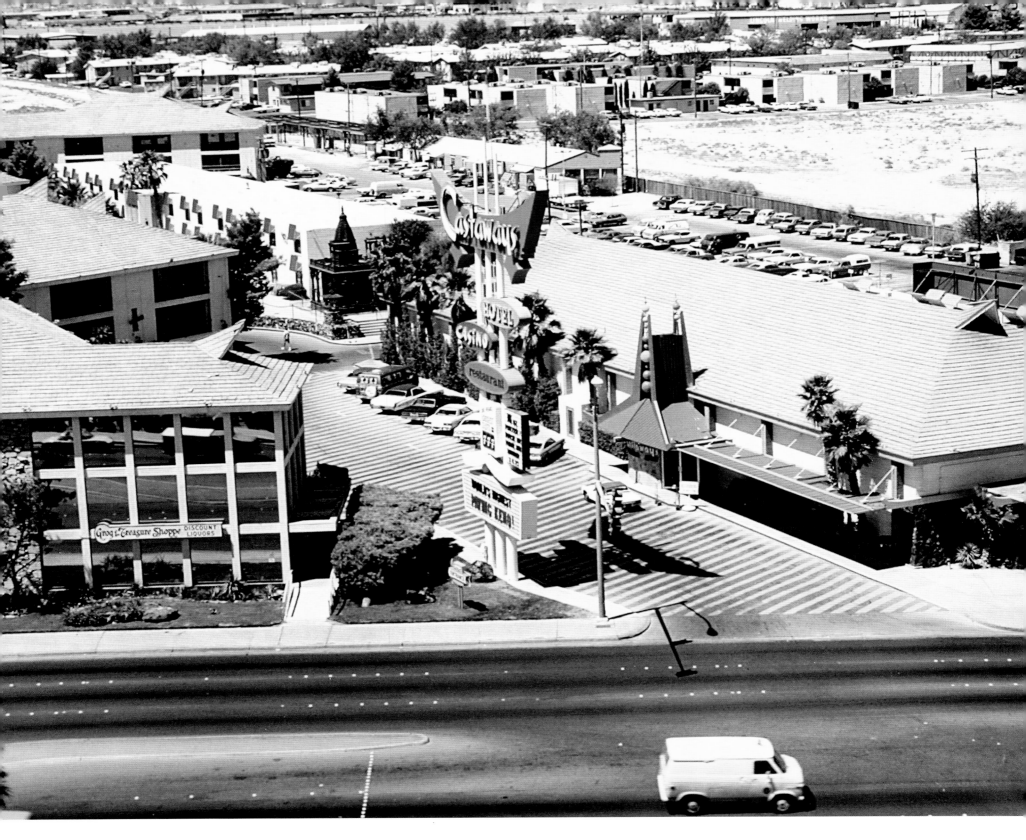

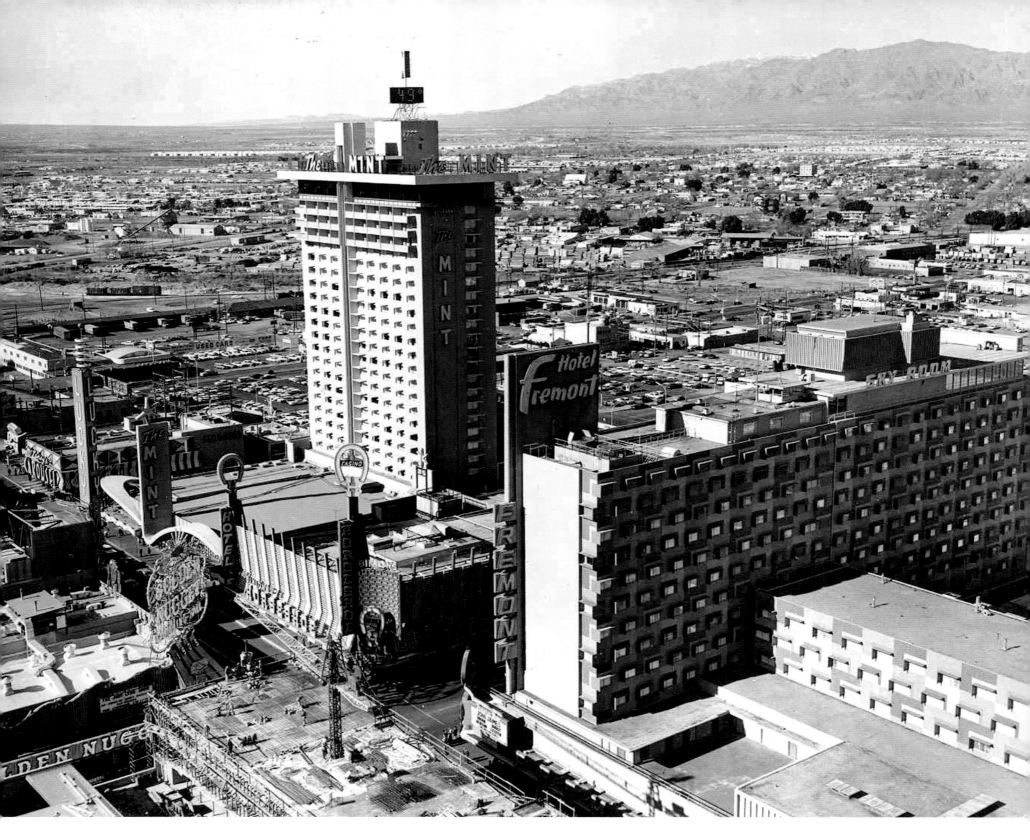

Mint Hotel CLOSED 1988

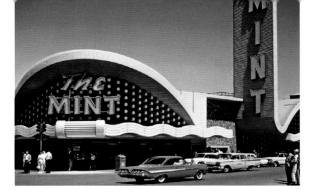

The Mint was one of the gems of Fremont Street when it opened during the late 1950s, a time when the new resorts on Las Vegas Strip outside town received much of the nation's attention. One of the most colorful stories to come out of the hotel was the night in 1966 when Hollywood actors Lee Marvin and Woody Strode were relaxing in their room during a break from the Western film, *The Professionals*. Across Fremont Street from the Mint, the Pioneer casino's famous standing cowboy sign, "Vegas Vic," was waving its left arm to a continuously playing recorded message, "Howdy Partner." The noise was keeping the actors awake, so they took an Indian bow, apparently used in the motion picture, and shot arrows across the street at the neon cowboy. Mint operators appreciated the publicity the hotel garnered from the actors' drunken stint.

Milton Prell oversaw the Mint's debut in 1957. Prell, originally from St. Louis, Missouri, was riding high in Las Vegas. He headed a company that owned the Mint and the Lucky Strike Club across from it on Fremont, and the Sahara Hotel that opened on the Strip in 1952. The Mint's pink and white vertical neon sign, topped by a six-prong twinkling star, was an instant hit on Fremont and the start of a history of distinctive neon signage that would make the Mint one of the most memorable casinos ever in Las Vegas.

Prell hired Sam Boyd—who would later become one of Las Vegas's top casino owners—as the hotel's chief executive. With Prell's backing and Boyd's management skills, the Mint quickly assumed a leading role downtown, emphasizing entertainment with jazz combos and up-and-coming singers in its lounge. In 1960, Prell, who now owned a half-dozen parking lots downtown, expanded the Mint down North First Street after taking over the old Bird Cage casino, Busy Bee Café and Lido Bar. At the time, the Mint and the next door Horseshoe Club, then operated by Fremont casino executive Ed Levinson, were the major rivals in the downtown casino business. With the Mint now a more valuable property, Prell sold it to casino developer and fellow Sahara partner Del Webb in 1961. Changes made by Webb to the Mint's neon exterior made it even more famous—an arcing "eyebrow" over the front entrance with its bright neon light cascading up and down. In the early

1960s, the Mint booked country artists Loretta Lynne, Johnny Cash and Patsy Cline into its lounge, where patrons watched them for the price of two cheap drinks. The Mint made its biggest splash in 1962, when Webb opened a new 26-story tower. The tower had an outdoor elevator and a top-floor restaurant, the Top o' the Mint, along with the Skyroom Lounge, which had expansive views of Las Vegas, especially at nighttime looking toward the Strip. Starting in the mid-1960s, the Mint made national news by sponsoring the Mint 400 Off-Road Rally, a series of races in the Nevada desert of motorcycles, cars and other vehicles. In 1971, journalist Hunter S. Thompson wrote about his stay at the Mint while covering the races.

In 1988, Del Webb sold the Mint, then a failing property with a declining customer base, to its more prosperous neighbor, Binion's Horseshoe. The Horseshoe's owners, the Binion family, tore down the walls separating the two, closed the Mint's lounge and live entertainment, and replaced its neon sign with a "bullnose" sign touting Binion's. The Mint's old hotel tower closed in 2009 after the Horseshoe itself was sold.

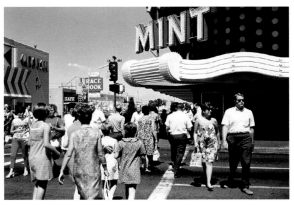

ABOVE *The Mint had one of the most famous exteriors, and flowing neon signs, ever built in Las Vegas.*

OPPOSITE *The Mint's 26-floor tower, with a view of the northeastern Las Vegas Valley beyond.*

BELOW *A colorful postcard from the early 1960s.*

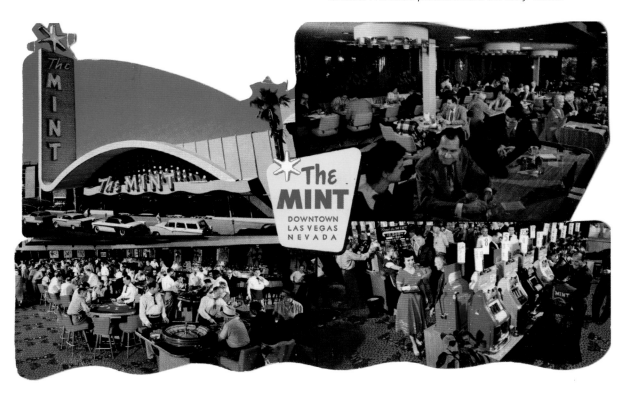

Silver Slipper TORN DOWN 1988

The Silver Slipper debuted on the Las Vegas Strip in September 1950 as the Golden Slipper Saloon and Gambling Hall, an amenity of sorts to the Last Frontier Village, an Old West town amusement attraction on the property of the Last Frontier hotel. The Frontier's operator, Beldon Katleman, intended to call the place the Silver Slipper, but had to wait to buy out an obscure club outside of Las Vegas by the same name in December 1950. The newly renamed two-story Silver Slipper Saloon and Gambling Hall had a casino, bar and lounge stage on the first floor and Las Vegas's first dedicated convention hall on the second level. The building looked like a brick saloon and rooming house out of a Hollywood Western. Inside, the hotel's "Silver Slipper Burlesque" theater served as a venue for scantily clad showgirls, decked out in feathery boas and headgear. It also hosted striptease dancer shows, such as ones put on by legendary nude dancer and producer Sally Rand in the 1950s. Headliners at the theater included strippers Blaze Starr, Tempest Storm and Evelyn West. The bawdy shows at the Silver Slipper contributed to Las Vegas's reputation as the capital of sin. The club's late-night entertainment attracted celebrities at rest after their performances on the Strip, notably singer Frank Sinatra.

In 1958, the Silver Slipper installed what would become an iconic sign, a glittering, giant revolving woman's slipper that famously stood out on the Strip. Designed by Jack Larsen of the Young Electric Sign Company (YESCO), the sign was 12 feet high and 17 feet wide with about 900 incandescent lights. The distinctive turning slipper would serve as a fixation for billionaire eccentric Howard Hughes. Hughes bought the Silver Slipper for $5.4 million to take over on April 30, 1968. According to local lore, Hughes had become paranoid seeing the Silver Slipper's rotating slipper, which seemed to stop turning while pointing right at his suite at the Desert Inn and he feared the slipper might contain a camera to spy on him. After buying the club, Hughes ordered the club's lights turned off and the moving slipper frozen in place.

In the 1980s, the Silver Slipper hosted a show called "Boylesque," a review of female impersonators.

The venerable club came to an end when Margaret Elardi bought the Frontier in 1988. The Slipper closed on November 29, 1988. Elardi had the club razed for more parking spaces for the Frontier and a planned hotel expansion that never materialized. The city of Las Vegas refurbished the club's original slipper sign for public display in 2009.

RIGHT *The Silver Slipper casino gave its burlesque show, with a "stageful of beautiful girls," top billing on its marquee, over the $1.57 buffet, in the late 1960s.*

BELOW LEFT *The two-story Silver Slipper was built in 1950 beside the Last Frontier Village, a simulated Old West town with Western antiques and gift shops.*

BELOW *The Silver Slipper's iconic revolving 12-foot-high slipper was originally installed over the casino in 1958 and later moved to its marquee sign on the Strip. In 2009 the sign was restored and installed at the Neon Boneyard.*

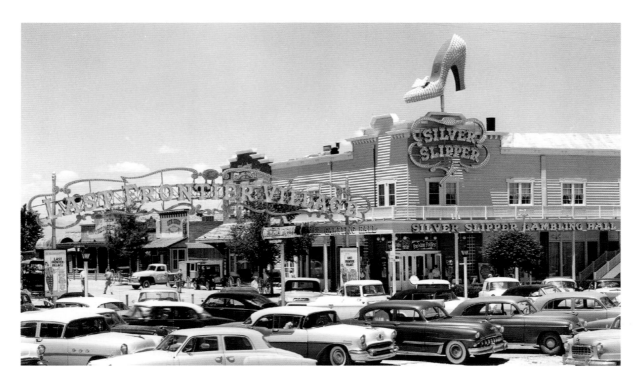

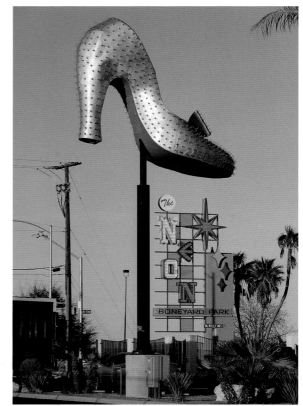

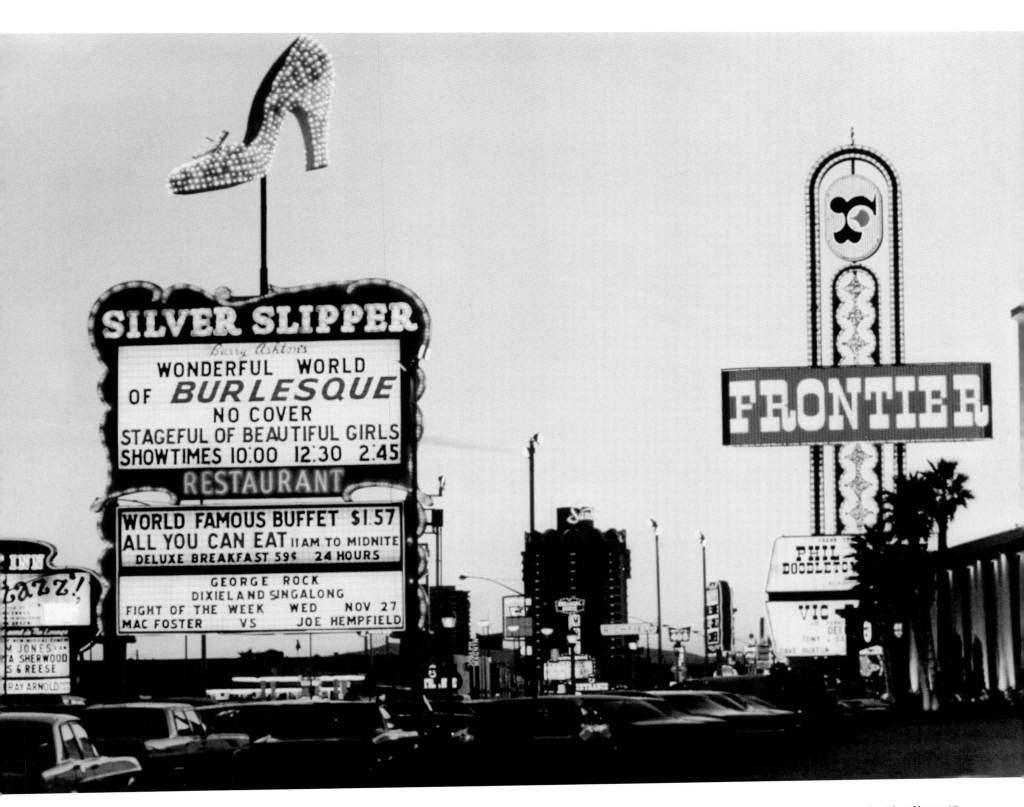

Las Vegas Convention Center REBUILT 1990

By the 1950s, Las Vegas with its temperate weather, healthy supply of hotel rooms and entertainment options, had evolved into an ideal setting for conventions and meetings, and not only for convention organizers. Hotel operators and local leaders realized that the numbers of tourists coming to town tended to rise and fall during the year. Their goal was to fill those gaps with conventioneers, especially on weekdays between the popular weekends. Another goal was to move Las Vegas beyond the regional gambling market and to make it a national and international destination. They prevailed on the Nevada State Legislature to create a special agency, the Fair and Recreation Board, for Las Vegas in Clark County and levy a hotel room tax to fund a center for conventions, trade shows and meetings. They selected a site east of the Las Vegas Strip on Paradise Road. The tax receipts helped build the Las Vegas Convention Center, overseen by a new agency, the Las Vegas Convention and Visitors Authority.

The convention center, designed by Adrian Wilson & Associates, opened on April 12, 1959, at a cost of $5.3 million. It was the beginning of the Space Age, a time reflected in American culture and architecture, including the convention center itself. The building's prominent feature was a silver-colored, ultra-modern "spaceship" rotunda jutting from the roof in front. The rotunda covered a 20,340-square-foot central theater with 6,300 seats beside a 90,000-square-foot exhibit hall and 18 meeting rooms.

The complex hosted eight conventions for 22,500 delegates in its first year. Those numbers would grow steadily and the theater soon became a major venue for concerts and community events. President John F. Kennedy visited in September 1963 and delivered a speech to an overflow audience inside the rotunda. On June 29, 1964, the pop group the Beach Boys performed at a "Rock-A-Rama" show in the theater. Then, more famously, on August 20, 1964, the Beatles performed two sold-out concerts, at 4 p.m. and 9 p.m., in the rotunda during the second date of the rock group's first American tour. More than 8,400 people crammed into the theater for the Beatles' afternoon show. The next year, Cassius Clay and Floyd Patterson battled in the rotunda for the world

heavyweight boxing championship. From 1966 to 1982, the University of Nevada, Las Vegas played its college basketball games in the rotunda. In the 1960s and 1970s, popular music groups on national tours such as the Kinks, the Doors, Steppenwolf, Three Dog Night, Spirit, Jethro Tull, Yes, Rush, ZZ Top, Black Sabbath, the Eagles and Aerosmith played in the rotunda theater. American evangelist Billy Graham used it to speak during national crusades from 1978 to 1980. High schools in Las Vegas booked the theater for graduation ceremonies.

In 1978, the Consumer Electronics Show started locating at the convention center (and has remained ever since, and evolved into the world's largest trade show). The next year, the COMDEX computer tradeshow started a long association with the center. But times were changing. The convention center was getting too small to hold the orders for conventions and meetings. Other concert venues, including the Ice Palace and the Aladdin Center for the Performing Arts, took dates away from the theater. The convention authority converted the rotunda into exhibit space in the late 1980s. Some observers made light of the out-of-fashion spaceship dome out front. The rotunda was finally demolished in 1990 in favor of a 1.6-million-square-foot expansion of the convention center that made it one of the largest such facilities in the world.

OPPOSITE The new Las Vegas Convention Center opened with the "World Congress of Flight" show in 1959, with its saucer-shaped domed roof and circular front parkway. Atlas and other new rocket models of the time are on display behind the building.

BELOW *Parked cars line outside the convention center in the 1960s, seen looking east from Paradise Road.*

BOTTOM *A well manicured, wide front lawn in the traffic circle in front of the convention center in the 1960s was later removed in favor of a parking lot.*

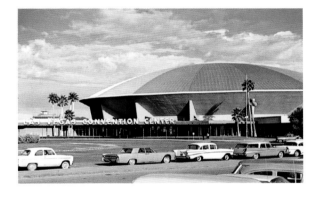

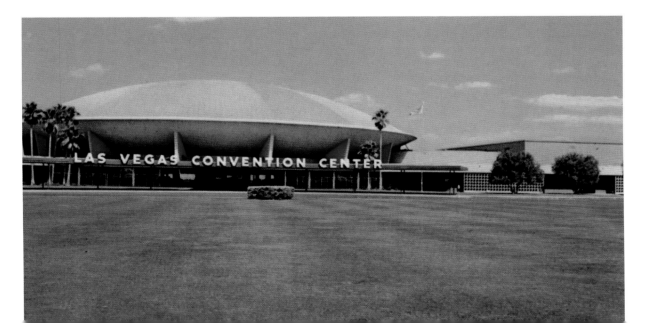

Nuclear Testing ENDED 1992

The United States successfully tested an atomic bomb in New Mexico before dropping the two nuclear devices that ended World War II. After the Soviet Union successfully tested a nuclear device in 1949, the United States embarked on a new testing effort on federal land in the Nevada desert, within Nye County, 65 miles northwest of Las Vegas. The U.S. Department of Energy established the 1,350-square-mile site—larger than the state of Rhode Island—on January 11, 1951. It was first named the Nevada Testing Grounds, then the Nevada Test Site and finally, decades later, the Nevada National Security Site. A 680-mile section of the site, formerly used by the Air Force for bombing and gunnery testing, would be converted to a range to test nuclear explosions. Over the years, until it closed in 1992, there would be 928 tests at the site, counting 24 joint tests by the United States and Great Britain. Testing started almost right away, with the dropping of a one kiloton bomb—code named Able—from an airplane on the site on January 27, 1951. The following year, American viewers watched an open-air test there. Code named Charlie, the detonation of the 31-kiloton bomb dropped from an aircraft was broadcast live on national television.

At first, many of the tests were above ground, including artillery shells fired from cannons and viewed by military troops. In Las Vegas, some hotels held parties for people to watch the mushroom clouds from the tests rise above the far horizon. Few worried about the nuclear radioactive fallout from the blasts, which were considered too far away to be harmful. But years later, some claimed winds from the open-air explosions blew radioactive dust eastward

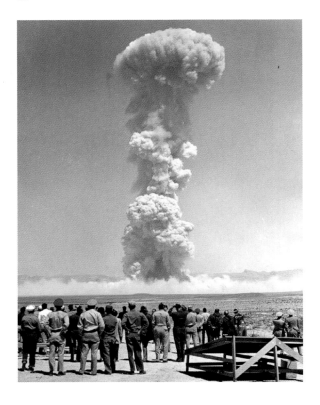

and led to cases of leukemia among people—in Utah and elsewhere—who were later known as the "Downwinders."

Tests at the site were temporarily halted in 1958, when the United States and Soviet Union pledged not to conduct new tests, but ended when the Soviets resumed testing in 1961. While underground testing began at the site in 1961, a total of 100 above-ground tests took place there. Many exploded from the top of tall metal towers, as high as 700 feet, and in the late 1950s, even helium balloons were used to carry some into the air for detonation. The last open-air test, "Little Feller," was on July 17, 1962. With the Cuban Missile Crisis a few months later, a new policy would emerge. President John F. Kennedy and Soviet leader Nikita Khrushchev signed a ban on atmospheric nuclear testing on August 5, 1963. But the ban did not include below-ground tests, and there would be 828 of them at the site. The underground tests included bombs exploded in tunnels and shafts, with ground-level craters left in the wake. Hundreds

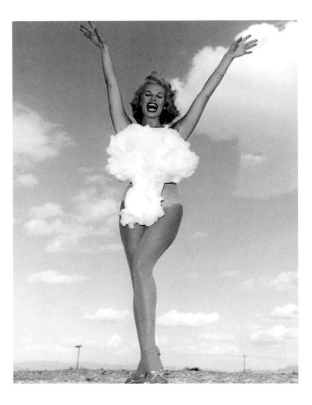

of people joined protests at the test site in the 1980s and 1990s. In 1992, the United States, Russia and France signed the Comprehensive Nuclear Test Ban treaty, ending underground tests.

ABOVE *The Sands Hotel Copa girl dancer Lee Merlin, crowned Miss Atomic Bomb, in a promotional photo to publicize Las Vegas in 1957.*

ABOVE LEFT *Members of the U.S. military and others watch a nuclear test at the Nevada Test Site in 1955.*

LEFT *A postcard from the 1950s, with a cloud from a nuclear bomb test seen on the horizon.*

RIGHT *One of many Nevada Test Site photo opportunities offered to the media in the 1950s.*

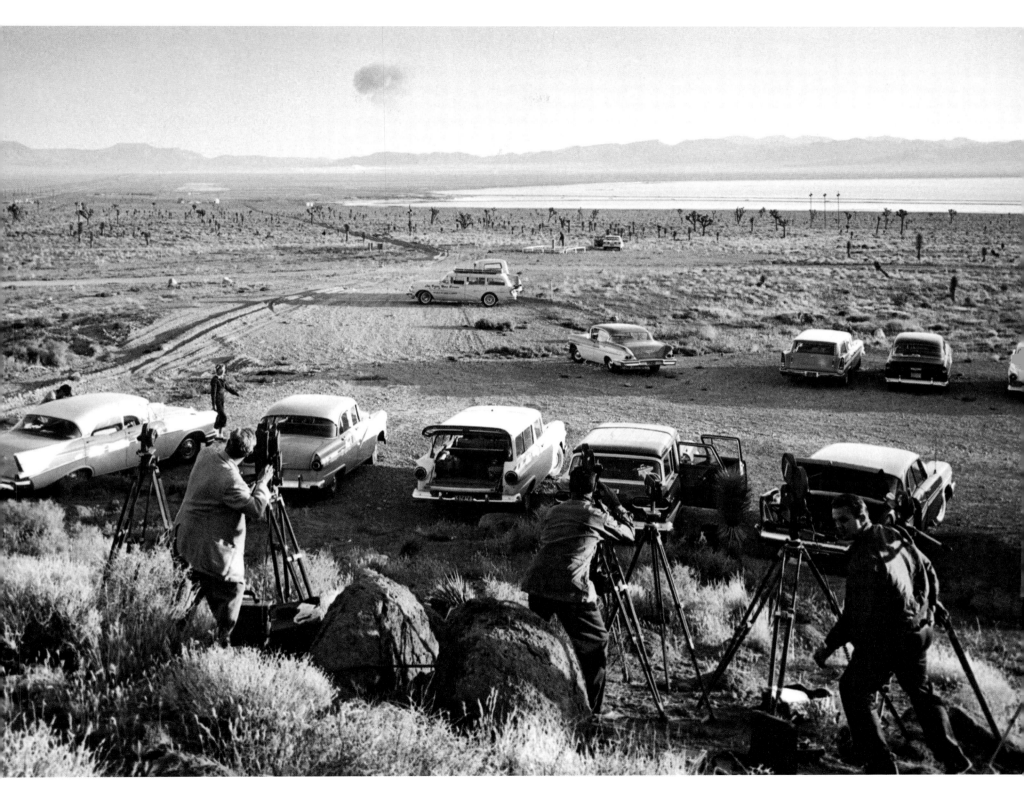

Thunderbird / Silverbird / El Rancho

CLOSED 1992

Los Angeles developer Marian Hicks and Nevada Lieutenant Governor Clifford Jones opened the Thunderbird hotel on the Las Vegas Strip in the fall of 1948. The time was right, as more Americans were traveling by car, rail and air in the years after an inspiring victory in World War II. The Thunderbird

.**TOP** *The rear pool area at the Thunderbird included lush landscaping, seen in this hotel postcard from the 1950s.*

ABOVE *The Thunderbird's famous neon bird perched atop a three-story tower, soon after it opened in 1948.*

RIGHT *An advertisement promoted the popular suggestive adult comedy revue, "Bottoms Up," that ran in the afternoons at the Thunderbird starting in 1967.*

OPPOSITE *The front of the Thunderbird, with its marquees and porte-cochère, in the mid-1950s.*

lost money to lucky gamblers on opening night, but was almost immediately successful. In a new take on the usual Western theme in local casinos, Hicks and Jones blended the Old West motif with Native American symbols. The Thunderbird name was based on a Navajo tribal myth. The partners also borrowed a bit from Hollywood movies, choosing names such as the Pow Wow Showroom and the Wig Wam Room. Best known to Las Vegas history were the Thunderbird's two emblematic, neon figures of eagles taking flight, the larger one topping a three-story square tower on the hotel's roof and the smaller one on a tower sign fronting the Strip. The Thunderbird was a trendsetter by being the first in Las Vegas with a covered front porte-cochère. Deluged with reservations for the small supply of 76 guest rooms, Hicks and Jones expanded the place to more than 200 rooms. As other Strip hotel-casinos popped up, the attractive and well-managed Thunderbird stayed popular with tourists and celebrities. It soon evolved into a favored venue for conventions. Las Vegas residents flocked to its restaurants. Another expansion

followed, with 110 motel-type rooms and the opening of the Algiers Bar, in 1953. The hotel became famous for having the foresight to book performers just before they blossomed into stars, such as singers Rosemary Clooney and Frankie Laine.

But all was not well behind the scenes. The Thunderbird would become famous for something else in the mid-1950s. While Hicks and Jones were the public side of the Thunderbird, word came out that Jake Lansky, brother of infamous mob chieftan Meyer Lansky, held a hidden interest in the profits from the Thunderbird, as did a Meyer Lansky associate. Hicks and Jones lost their state gaming licenses but later regained them on court appeal. The national publicity wrought by the Thunderbird case, revealing the frequently denied truth about organized crime infiltration in Las Vegas casinos, prompted Nevada to create the Nevada Gaming Control Board to review license applications for people investing or working in the state's casinos.

The debate, however, did not harm business at the Thunderbird, which remained fashionable and

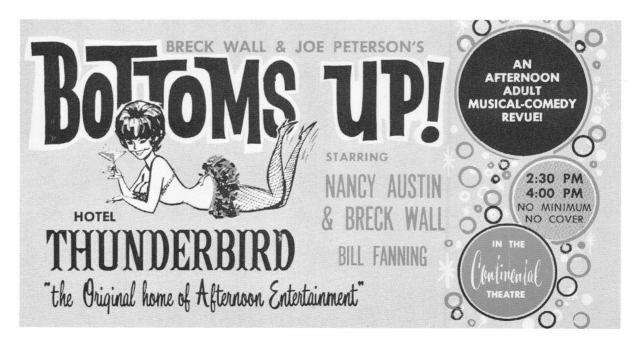

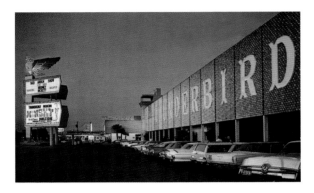

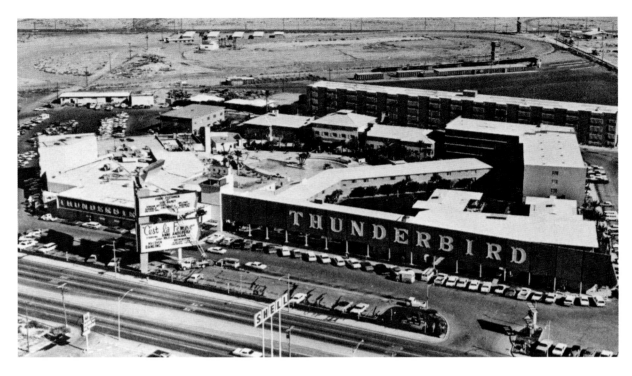

ABOVE *The Thunderbird's elongated front wall sign at night, following a renovation in 1965.*

RIGHT *An aerial shot of the Thunderbird showing the expansion, including 500 new guest rooms, built by owner Del Webb in the mid-1960s.*

BELOW RIGHT *The Thunderbird gave way to the Silverbird, operated by veteran casino executive Major Riddle, who opened the new resort in 1977.*

profitable into the start of the 1960s. Never a "high class" place compared to the Sands and Tropicana, the Thunderbird sustained itself as an inexpensive hotel for middle-class visitors, with good food, live entertainment and comfortable guest rooms. In the late 1950s to early 1960s, the Thunderbird had showgirls performing in late-night nude revues. In the mid-1960s, the Del Webb Corporation, then-owner of the Sahara hotel, took over while the Thunderbird was still riding high. The place had around 500 guest rooms and an Olympic-sized swimming pool. Its Thunderbird Showroom seated 650 people and played host to major acts including comedian Jack Benny and Judy Garland. To compete with other Strip hotels, the owners added a new sign that stretched 700 feet on the property.

Del Webb sold out to partners who ran the Caesars Palace hotel in 1972. The Caesars group in turn sold it in 1977 to veteran casino man Major Riddle, whose big idea was to rename it the "Silverbird." Riddle removed the old neon thunderbirds, renamed the main rooms and added new glittering neon signs. He revamped the decor of the now-80,000-square-foot casino. But though a temporary hit, the Silverbird ran out of appeal and in 1981, Riddle left to turn the place over to Las Vegas casino manager Ed Torres. Like his predecessor, Torres renamed it, this time the El Rancho in tribute to Las Vegas's first Strip resort,

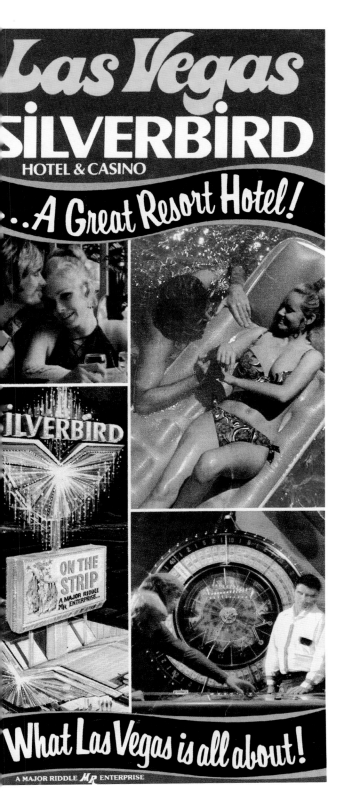

the El Rancho Vegas. He added a new sign and some flourishes but put little else into it, leaving the property mostly the way he found it. Business at the El Rancho fell off sharply in the 1980s as better-financed resorts upgraded and expanded. Few people stayed or gambled at the El Rancho and no one seemed interested in buying the property. Torres finally closed the hotel-casino in 1992. The abandoned building and its dark neon sign languished as an eyesore for years until it came down in 2000 to make way for a condominium tower.

LEFT *An advertisement for the Silverbird from the late 1970s sells the hotel as a fun getaway for couples.*

RIGHT *Riddle sold the Silverbird in 1981 to Ed Torres, another long-time Las Vegas casino operator, who changed the name to the El Rancho, after the Strip hotel that burned down nearby in 1960.*

BELOW *Torres's El Rancho closed in 1992 but remained vacant until new owners imploded the buildings in 2000.*

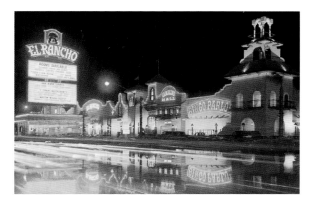

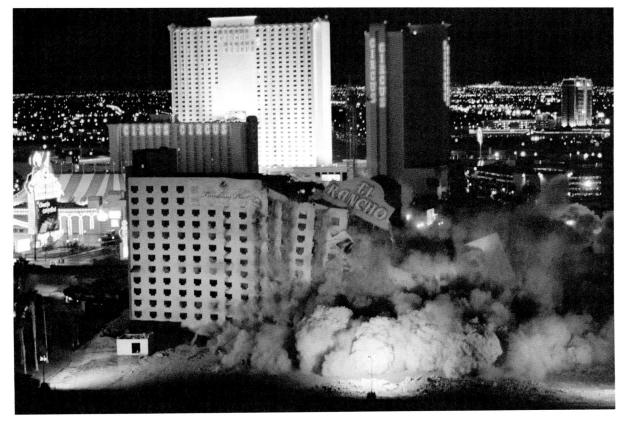

The Dunes CLOSED 1993

What would eventually become the Dunes Hotel started as a land deal in the early 1950s. Al Gottesman, a retired movie chain owner living in Miami, received a phone call out of the blue. A pair of developers needed a loan of $58,000 to secure some desert land in Las Vegas for a hotel project. In exchange, Gottesman would get a small share of the hotel's profits. Gottesman agreed and sunk another $16,000 for a hotel architect. He later found out other partners, from Rhode Island led by Joe Sullivan, had invested in the project. When the hotel developers dropped out, Gottesman and Sullivan's group took over title to the land. Inspired to develop a big gambling resort, they raised another $1.5 million. Another partner was Beverly Hills costume

jewelry seller Bob Rice. An additional investment from a Teamsters Union's pension fund, which had ties to organized crime figures, helped complete the $3.5 million hotel. It would not be the only source of money from organized crime at the Dunes. Years later, it was revealed that Rhode Island mobster Ray Patriarca had secretly contributed to Sullivan's investment.

The Dunes based its decor on the *Arabian Nights* folktales. By the time the hotel opened on May 23, 1955, it fulfilled the ambitions of lead partners Gottesman and Sullivan. An eye-catching 45-foot-tall statue of a smiling, costumed sultan figure greeted visitors over the drive-up porte-cochère. There were 200 guest rooms in

some two-story buildings beside a 90-foot, V-shaped swimming pool, a 150-foot lagoon and a center fountain with sculptured seahorses. Its Arabian Room had both the size and technical capabilities of a Broadway theater, and started out with a revue featuring 30 showgirls on a revolving stage. The singer Vera Ellen headlined on opening night. The partners nicknamed their creation, "The Miracle in the Desert," and started thinking about expanding on the 85-acre site with 500 more guest rooms and a shopping center.

But Gottesman and company soon were shocked by the money they lost investing in the money-losing guest rooms, food and drinks and expensive headliner entertainment, while suffering a poor return from table games in the casino. The Arabian Room could not duplicate the success of showrooms in other Strip hotels. The hotel embarrassed itself nationally when it spent $11,000 on Wally Cox, a well-known television comedian who had to be fired after only a few bad performances. Even managers of the established Sands hotel, who leased the showroom and the casino for a while, could not make money there. The

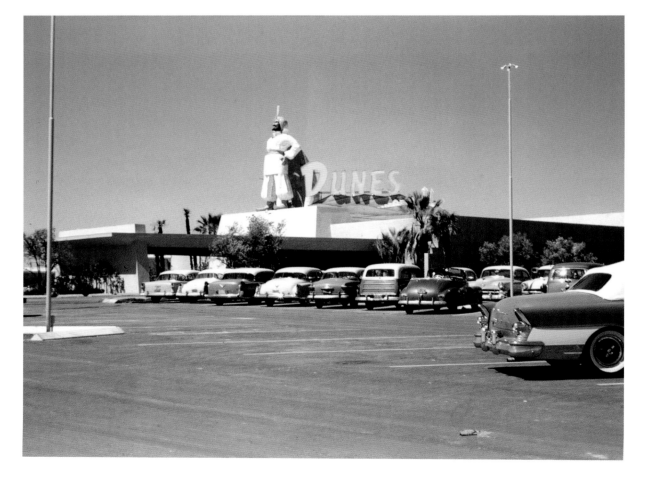

ABOVE *This postcard from the early 1970s shows the hotel's famous vertical cascading neon sign, the curving roof of its Dome of the Sea restaurant and its 24-story Diamond of the Dunes tower.*

LEFT AND RIGHT *These two 1950s photos show the Dunes' smiling Sultan statue towering over the hotel's front porte-cochère.*

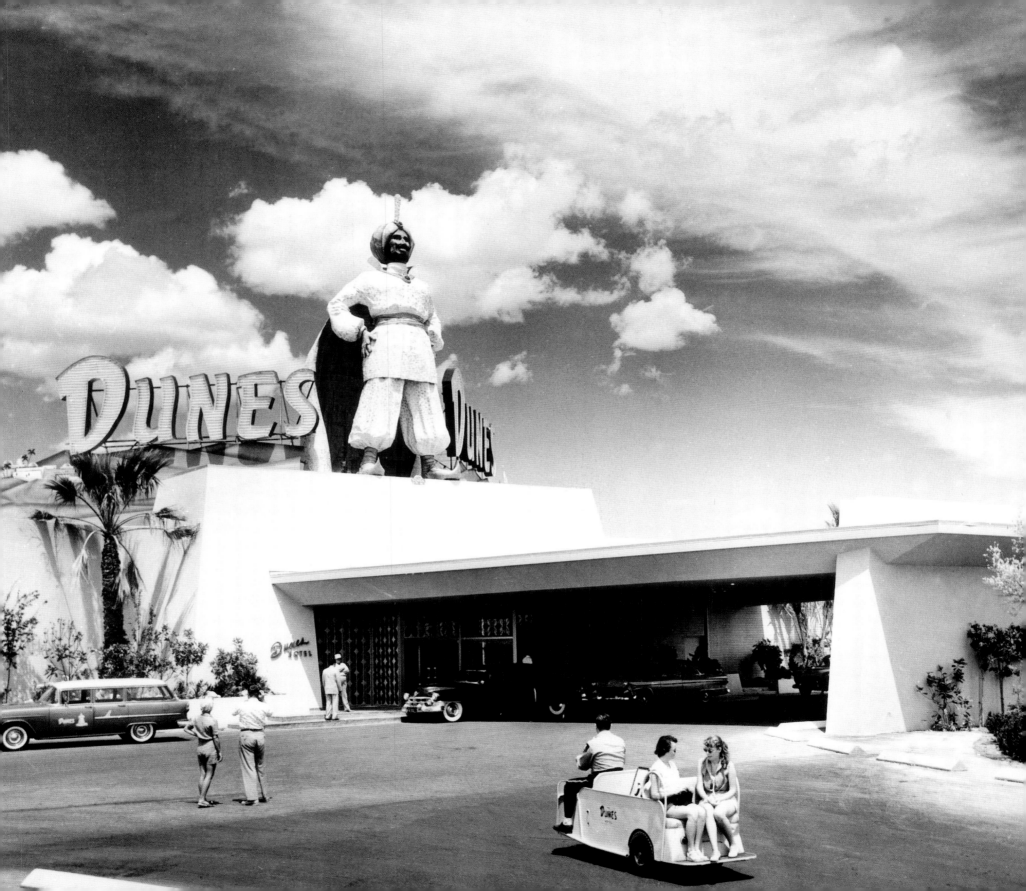

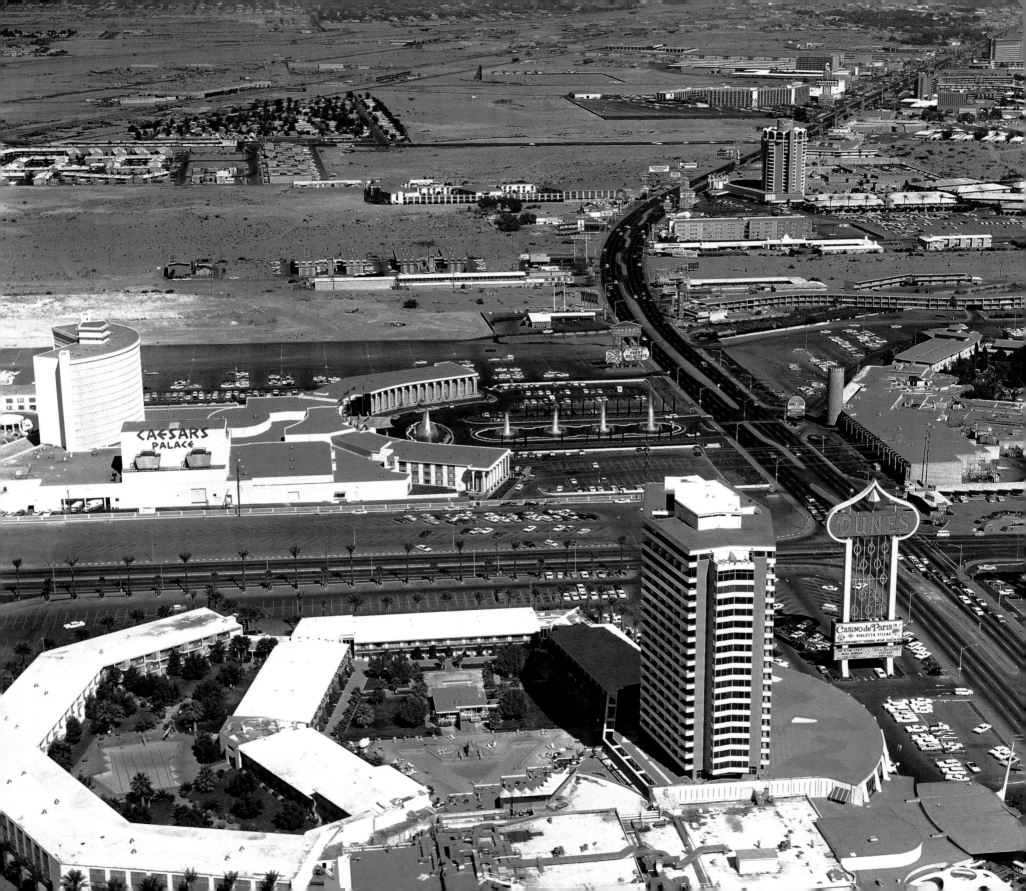

year the Dunes debuted, other Strip hotels such as the Riviera enjoyed grand openings, making for a competitive environment for tourist dollars.

By August 1955, Gottesman, fed up with having to use his own money to keep the hotel going, was ready to sell out. At one point, the partners closed the casino for lack of business. In 1956, Gottesman and Sullivan finally sold the Dunes to Chicago freight company owner Jake Gottlieb, who in turn sold a minor interest to an associate from Chicago, Major Riddle. Bob Rice stayed on to work on the entertainment side with Riddle. In 1958, the Teamsters pension fund, influenced by corrupt union boss Jimmy Hoffa, loaned $4 million to Gottlieb and Riddle. With Riddle at the helm, the Dunes' Sinbad Lounge showcased performers like the Ink Spots and hypnotist Traian Boyer. Actress Jayne Mansfield once worked the showroom for $35,000 a week. The hotel expanded in the 1960s, building a 24-story tower with 250 guest rooms and a roof-level club called Top O' The Strip. Behind the hotel, the partners installed an 18-hole golf course, the Dunes Country Club. Celebrities such as actor Cary Grant and actress Jane Fonda married their fiancés at the Dunes. The hotel's 180-foot neon sign, turned on in 1964, had lights constantly flowing in red from top to bottom and became a fixture on the Strip into the 1990s. The hotel's Dome of the Sea became one of the best-known restaurants in Las Vegas.

By the 1980s, the Dunes stood among the aging icons of the Strip, with a steady income but relying on its old, 1950s-era casino, swimming pools, low-level guest rooms and low-rolling gamblers. Morris Shenker, who was Jimmy Hoffa's former lawyer, owned the hotel amid concerns from Nevada gambling officials. Shenker attempted to revitalize the place with an advanced race and sports betting book, but it was too late, and he filed for bankruptcy. Next in the line of owners was Masao Nangaku, a Japanese investor who could

not turn things around either. No longer viable as a casino, the Dunes' main attraction for a buyer was its huge 85-acre site, which had its own water well. New York investor Donald Trump expressed an interest in buying it.

Finally, Mirage hotel owner Steven Wynn acquired the Dunes property in 1992. Wynn had much of the place imploded on live television, including the toppling of its classic marquee sign in 1993 and another hotel tower in 1994. Wynn built the billion-dollar Bellagio Hotel at the site—making good use of the Dunes' water sources—and sold other pieces of the Strip property to builders who later constructed the Monte Carlo and New York-New York hotels.

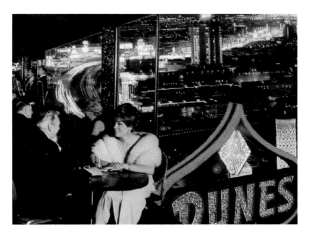

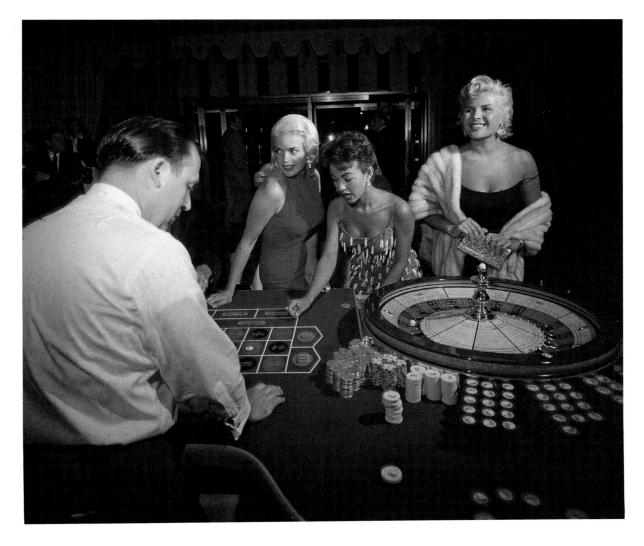

LEFT *The grounds of the Dunes, with its low-rise hotel buildings in the rear, in the 1970s. The Caesars Palace hotel is seen above and the Flamingo Hotel and Flamingo Capri hotels on the other side of the Strip at right.*

RIGHT *A publicity photo promoting the Dunes with Jayne Mansfield (dressed in red) at a roulette table in 1955.*

TOP RIGHT *Patrons are seated in the Top of the Dunes, a popular place to watch lounge entertainment, inside the top floor of the Diamond of the Dunes tower, built in 1961.*

Fremont Street COVERED AND PEDESTRIANIZED 1995

Fremont Street was Las Vegas's first main street, named after Western explorer John C. Fremont who visited the Las Vegas Valley in the mid-19th century. Fremont Street immediately became the central part of Las Vegas, starting from the original land auction that sold off parcels for development on and around the street on May 15, 1905. Montana Senator William Clark, who made a fortune in mining, was building the San Pedro, Los Angeles and Salt Lake Railroad through the valley from Utah on the way to California. Clark bought most of Helen Stewart's Las Vegas Ranch for $55,000 and his auction of that land started Las Vegas. The best lots on Fremont went for around $1,500. The train's Spanish Revival–style depot for Clark's railroad was built at the eastern end of Fremont Street. The first hotels and other structures on and near the street were canvas and wood tents that gave way to scattered buildings made of clapboards, then brick and concrete. Soon, the town would have shops, a bank and other respectable businesses. Those offering liquor, gambling and other vices were not allowed on Fremont, and had to open about a block north in the red-light area known as Block 16. Expansion in 1905 on Fremont took right off. Block & Bodkins, the town's first men's clothing store, opened that year. The town's first brick building housed the Las Vegas Drug Store and Crowell & Alcott retail shop. John F. Miller opened a concrete hotel building, the Hotel Nevada, at Fremont and Main in early 1906. John Wisner's Overland Hotel soon opened across from Miller's hotel, and another hotel, the Lincoln, debuted on the street in 1910. Businesses stretched down Fremont to Fifth Street and beyond while housing for railroad workers and other locals bloomed south of Fremont.

Fremont Street would remain the hub of Las Vegas into the 1940s and the location for the town's first modern advances and conveniences. The telephone appeared in the town's first hotel, the Hotel Nevada, in 1907. The first movies were shown in the town's first theater, the Isis, in 1909. In 1912, the Majestic theater, owned by Edward W. Griffith, also hosted traveling vaudeville acts. Fremont was the first paved street in Las Vegas in 1925 and the first with a traffic light. The Hotel Apache in 1932 had the town's first elevator and later an early form of air conditioning. Legalized gambling in the early 1930s, with Mayme V. Stocker's Northern Club, the town's first licensed casino at 15 E. Fremont, led to a wave of neon signs along Fremont and locals would dub the street "Glitter Gulch." J. Kell Houssels, who launched his small Las Vegas Club

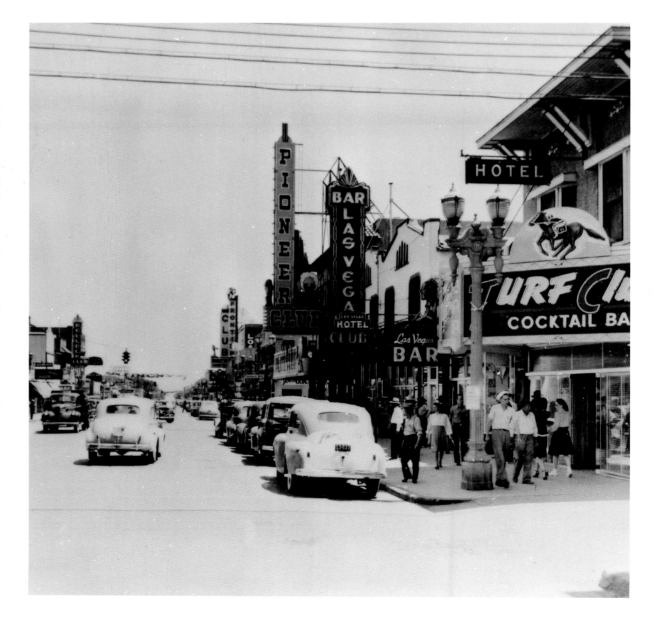

RIGHT *Pedestrians walk among the bars and clubs on the south side of Fremont Street in the 1940s.*

OPPOSITE *People returning from a Fourth of July celebration walk under the shade of trees on East Fremont Street in the 1920s.*

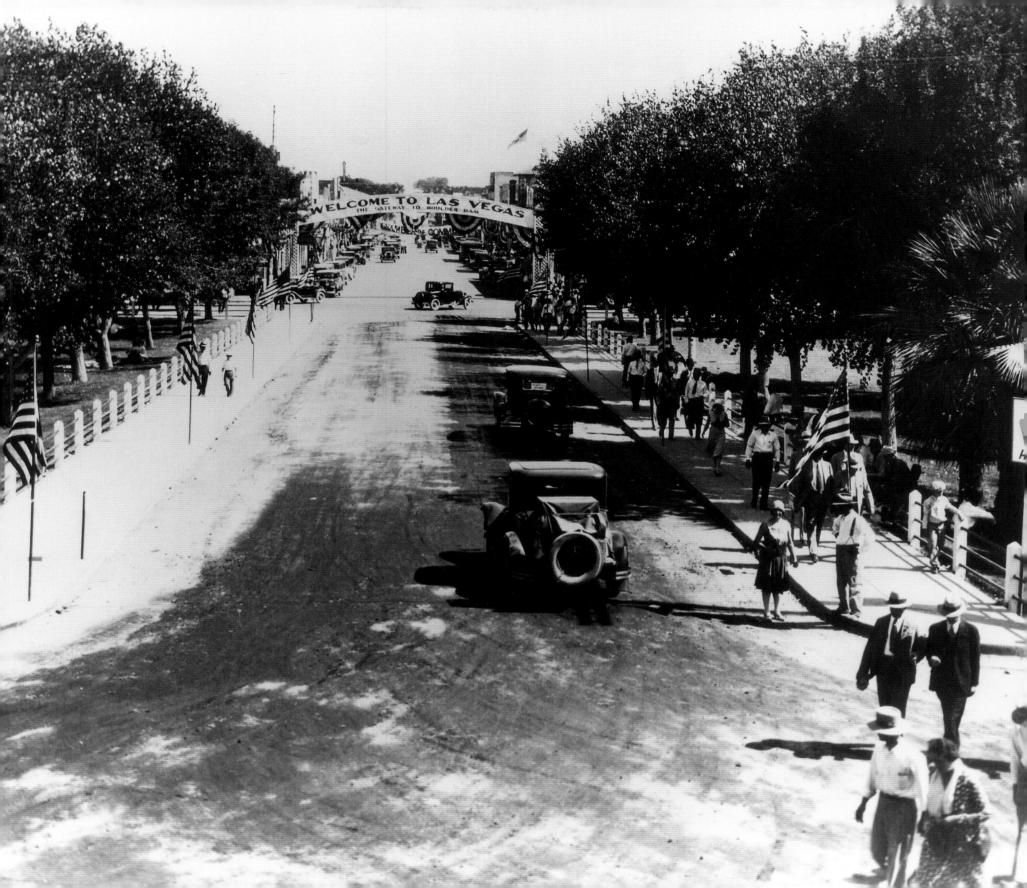

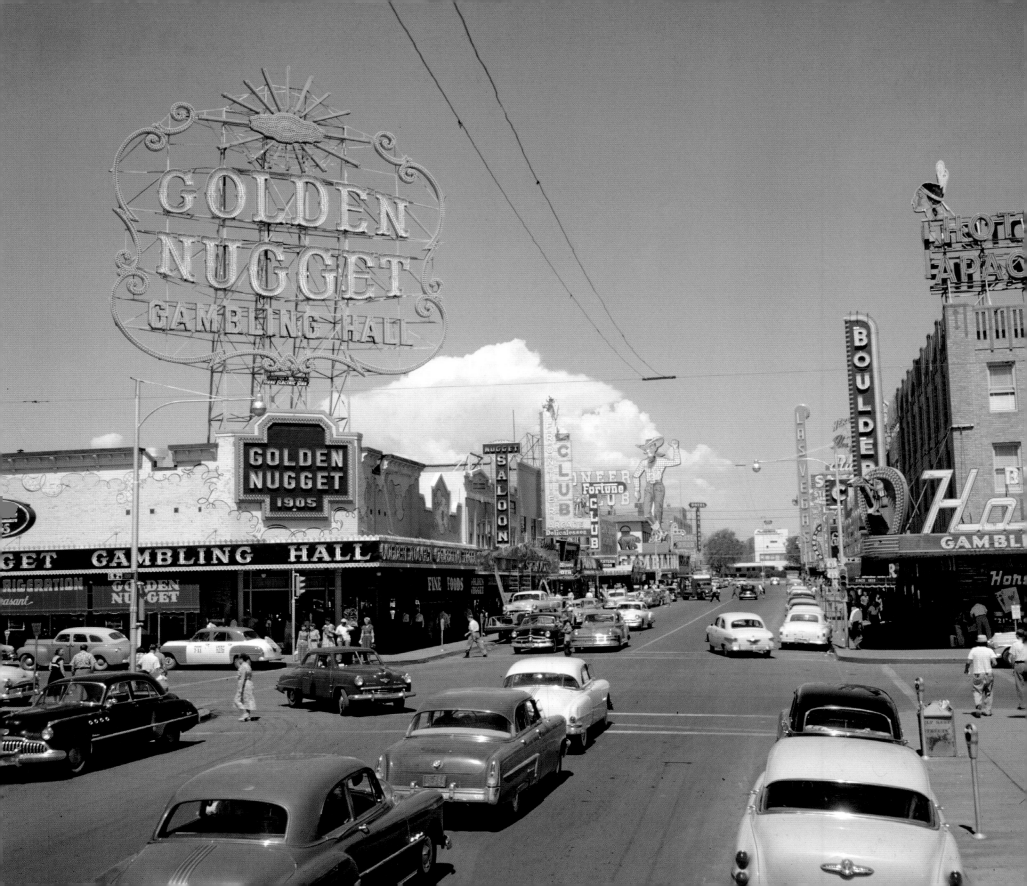

in 1929 and later at the site of the old Overland in the 1940s, became one of the most successful of all operators on Fremont. Business boomed with the building of Boulder Dam in 1931 and its debut in 1935. The town started the Old West–style Helldorado Rodeo and Parade down Fremont in 1935 and it became an annual event for many years. A few gambling clubs opened in the 1930s on Highway 91, the precursor to Las Vegas Boulevard, or Las Vegas Strip, and the first two

Strip resorts started there, the El Rancho Vegas in 1941, and Last Frontier in 1942. Still, Fremont remained the center of casino gambling in Las Vegas well into the 1940s. Marion Hicks built the El Cortez hotel and casino on East Fremont in 1941 to great success, and soon accepted Los Angeles mobster Benjamin "Bugsy" Siegel as a partner. Guy McAfee, the former Los Angeles police captain (who coined Highway 91 the "Strip" after Los Angeles' club row known as the Sunset Strip, a

OPPOSITE *A color view of Fremont Street, looking west, in 1953 with the Golden Nugget casino at left, the Horseshoe Club at right and the Union Pacific rail depot at the end of the street.*

BELOW *A night scene of the same view of Fremont Street showing neon signs of the Golden Nugget, Lucky Strike, Pioneer Club, Las Vegas Club, Boulder Club, Hotel Apache and Horseshoe Club in 1955.*

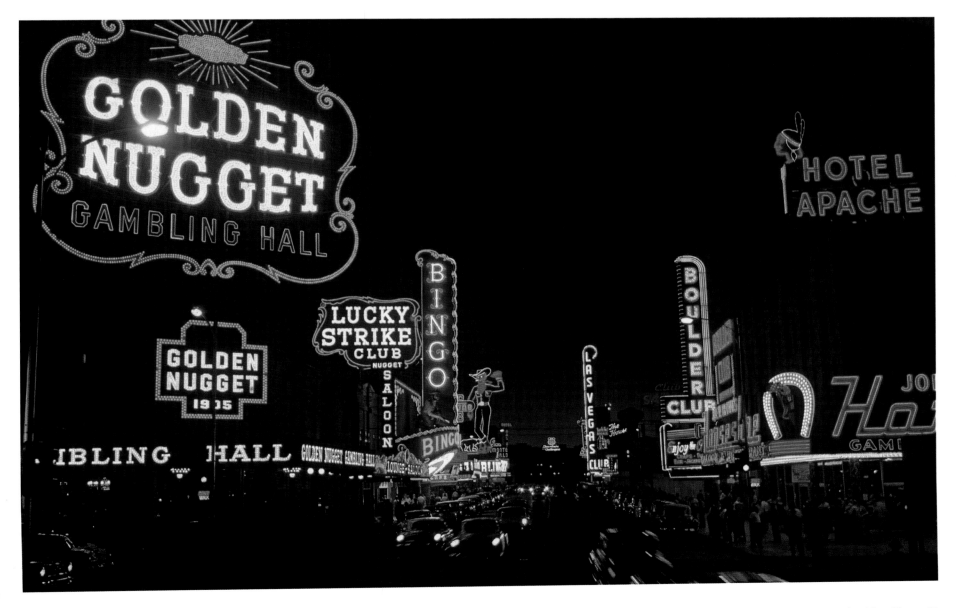

nickname that stuck) sold his club on the highway and moved downtown. McAfee bought interests in several casinos on Fremont, and within only a few years became the town's top casino man, opening the Golden Nugget—without hotel rooms—with partners in 1946. As casinos dominated Fremont, some non-gambling businesses started moving farther east or down Main Street. The Strip flourished after World War II, starting with the Flamingo hotel in 1946, Club Bingo in 1947, the Thunderbird in 1948 and the Desert Inn in 1950. In 1952, the Sahara and Sands opened on the Strip. Seven more major casinos would crop up on the Strip by 1960. But Fremont Street remained fairly healthy and popular, if for a relatively few casinos. Benny Binion, a street hood from Dallas with a criminal record including a murder conviction, took over the Hotel Apache for his Horseshoe Club in 1951. Edward Levinson opened the first high-rise building in downtown Las Vegas, the 15-story Fremont Hotel—where singer Wayne Newton played the lounge as a teenager—on the street in 1956. But more and more tourists were flocking to the new, cutting-edge resorts on the Strip that also attracted more attention from the national and international news media. While the Strip drew the big gamblers and profits, Fremont's "low roller" casino customers came with less to spend. In the 1960s and 1970s, the Las Vegas metropolitan area spread out into suburbs, with shopping centers, clothing, hardware and other businesses that people used to flock to on Fremont. Steve Wynn brought a modern touch to Fremont in the 1970s as new owner of the Golden Nugget, adding a hotel tower, showroom and casino that approached the opulence of the Strip. Hotels renovated and expanded but attempts to revive the area resulted in only brief blips. By the 1990s, the Strip garnered

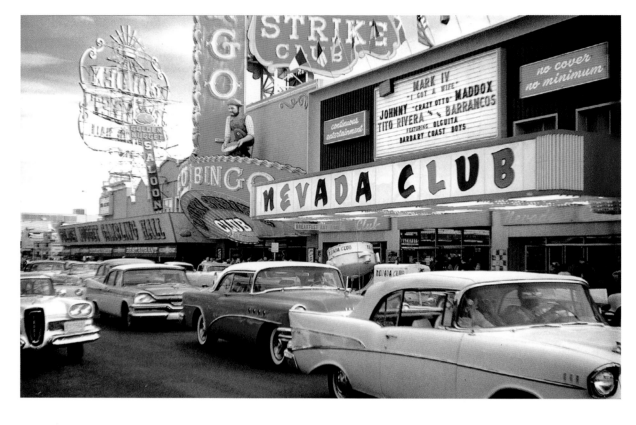

the vast majority of the Las Vegas casino business. Casino owners floated the idea of having Venice-like canals, "Los Venice," or a river walk along Fremont, or a huge model of Star Trek's starship *Enterprise*. A group of 10 casino owners finally agreed on a proposal, the Fremont Street Experience, an enormous, five-block-long metal canopy over the street, designed by architect Jon Jerde. The first five blocks of Fremont Street would

be closed to through traffic for good. Built in 1995 at a cost of $70 million, borne by the casinos, the canopy's ceiling held what was said to be the largest screen in the world, eventually with 12.5 million LED lights showing a variety of computerized animations accompanied by music. Fremont Street now had the feel of an indoor shopping center. While it boasted of having a must-see attraction, the addition met with limited success for Fremont Street's casinos.

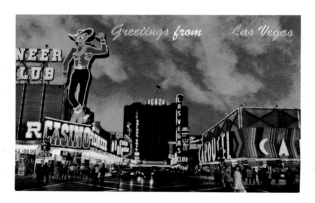

ABOVE *Cars crowd Fremont Street outside the Nevada Club and Lucky Strike in the late 1950s.*

LEFT *Two 1970s postcard views of Fremont, dominated by the Golden Nugget and the Pioneer Club. The Horseshoe's vertical sign featured a revolving "H."*

RIGHT *The waving Vegas Vic sign stands beside the Pioneer Club, with the Plaza Hotel at the end of Fremont and the Carousel casino at right in 1961.*

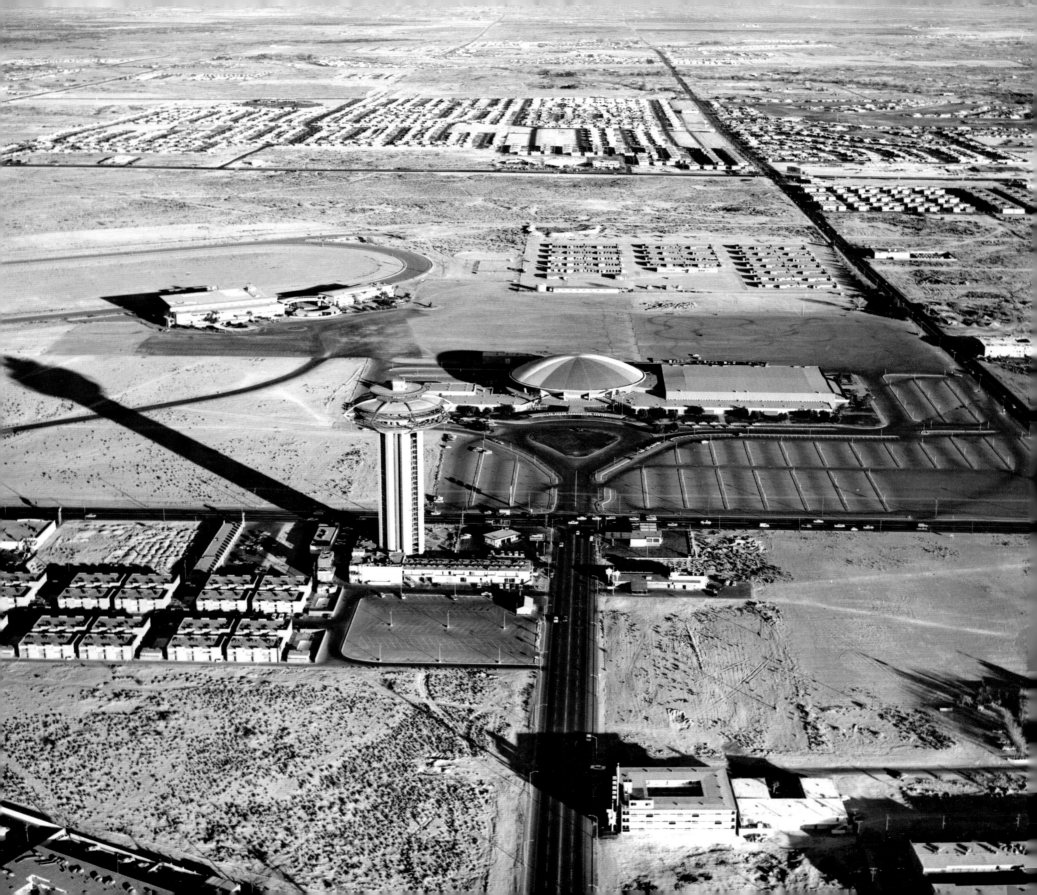

Landmark Hotel IMPLODED 1995

The Landmark Hotel began as the vision of Kansas City builder Frank Carroll, who in 1960 acquired 22 acres off the Las Vegas Strip and right across the street from the new Las Vegas Convention Center. Carroll dreamed of emulating the swank Hollywood Landmark hotel in Los Angeles. But it was the early 1960s, when space travel was a national obsession. Instead of a facsimile of a hotel for Hollywood celebrities, Carroll would base the Landmark on the anticipated Seattle space needle tower, which opened in 1962. Carroll hired California architect John W. Jamieson to fashion a similar, shorter tower, with hotel rooms in the tower's shaft and topped by a multiple-floor cupola with a nightclub, restaurants, casino gaming and a panoramic view of Las Vegas.

Carroll, however, wanted to go even further. He aspired to build the tallest structure in Nevada at 15 stories. But builders of the Mint Hotel in downtown Las Vegas had similar aspirations and announced a plan to build a tower reaching over 20 stories. To beat them, Carroll ordered the Landmark redesigned to 31 stories. His fateful decision would require more money. He had a $3-million loan from the Appliance Buyers Credit Corporation and in 1961 built a shopping center, the Landmark Plaza, with a department store and a large apartment complex, beside the unfinished tower. The ground-level buildings brought in some revenue but Carroll needed $10 million to fulfill his ambition of a 31-story tower. He would not get it from Appliance Buyers Credit, which refused to extend his credit

line. In 1962, building on the tower came to a stop with the outside structure about 80 percent completed. Like the halted Desert Inn project in the late 1940s, the nearly finished but unoccupied Landmark became the butt of local jokes. In 1963, the vacant tower helped serve as a backdrop for a scene in the Elvis Presley movie *Viva Las Vegas*. The Mint opened its tower in 1965. But finally, a year later, the Teamster Union pension fund loaned Carroll $6 million. The Teamster fund was famously a source of loans for several Las Vegas casinos secretly controlled by mobsters, but Carroll was not one of them.

Carroll intended the Landmark to open in 1967. The project, including a single-story building with hotel rooms, was virtually complete by then, but Carroll had yet to even obtain a state gambling license to have a casino. In 1968, still unable to start his dream property, Carroll accepted a proposition —a buy-out bid of $17 million from billionaire Howard Hughes, who pledged to cover Carroll's other outstanding debts with building contractors.

Hughes sank additional millions to fulfill Carroll's vision. He finished the rest of the Landmark's distinctive tower. A glass elevator, seen from outside the hotel, took patrons to the top-floor, three-story windowed cupola. Taking advantage of the view of Las Vegas, the cupola had a Chinese restaurant, a steakhouse and a coffee shop, a lounge, small casino and on the top floor a dance club for over 200 people.

Beside the tower, Hughes put the finishing touches on Carroll's expansive, one-of-a-kind lagoon-like swimming pool with bridges leading to an island with palm trees, grass and chaise lounges, and a broad, two-story waterfall beside it. The hotel's entrance, made of solid marble, led guests to the first-floor casino and a 500-seat showroom. The hotel had 535 guest rooms, some in

ground-level side buildings, others packed awkwardly into the shaft of the tower. On top of the tower stood a soon-to-be-famous revolving "L" in red neon. On the ground, its marquee sign had "Landmark" outlined in blue neon and filled with flashing red lights.

Hughes opened the place on July 1, 1969, the day before Kirk Kerkorian's International Hotel right across the street. At more than 1,500 rooms, the International became the largest hotel in the world at the time. It was adjacent to the Convention Center and took advantage of it. Hughes had popular comedian Danny Thomas perform in the Landmark's showroom on opening night. Unlike the other five hotel-casinos Hughes bought off the shelf in the late 1960s, the Landmark was the only one he opened. But despite starting off with all the bells

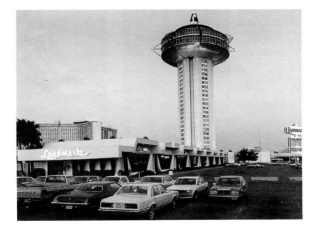

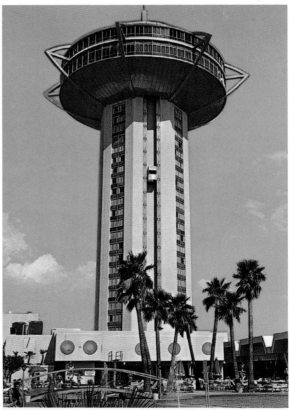

OPPOSITE *The Landmark Hotel's tower, topped by its three-story windowed cupola, stands next to its low-rise hotel rooms to the left and the Las Vegas Convention Center above it in 1970.*

LEFT *The view from the parking lot of the Landmark's tower after its opening in 1969.*

RIGHT *A postcard view of the tower from the 1970s.*

Landmark Hotel, Las Vegas

and whistles Hughes could muster, the Landmark—several blocks away from the action on the Strip and with little help from the Convention Center—lost a lot of money. About a year later, Hughes, who kept his other five hotels, transferred the Landmark to his former wife Jean Peters when they were divorced.

The Landmark stayed afloat for years, a frequent subject of Hollywood films, its iconic cupola a main attraction. Its showroom played host to a remarkable list of singers and comedians who were mainstays of the Vegas and national entertainment circuit. But the big-spending gamblers preferred other hotels. An accident involving the leakage of carbon monoxide gas into the structure killed one person and injured more than 100 people in 1977.

In decline, the Landmark changed hands several times in its final years. Its last gasp came in the late 1980s. Former college football star William "Wildcat" Morris, the new owner, closed it down for months and pumped in millions of dollars borrowed from Wall Street investors with the hope of luring high-rolling gamblers. He reopened in 1988 but it did not work and Morris went bankrupt. The Landmark, understaffed and neglected, closed down in 1990 and never reopened. More Hollywood movie roles for the Landmark's shuttered tower, as an enormous prop, followed in the 1990s. The Las Vegas Convention and Visitors Authority bought the property and decided to convert it into a large parking lot for its conventioneers. An aging star, more successful as a symbol of the outlandishness of Las Vegas than a business, the Landmark was imploded in 1995. In the hotel's last performance, producers of the movie *Mars Attacks!* used a film of the implosion, showing the spectacular tumble of the Landmark's cupola and tower, to dramatize an alien invasion.

BELOW *The Landmark in the center of this night photo, used as a postcard, with the Las Vegas Hilton at left and green-lit Las Vegas Convention Center at right in the 1970s.*

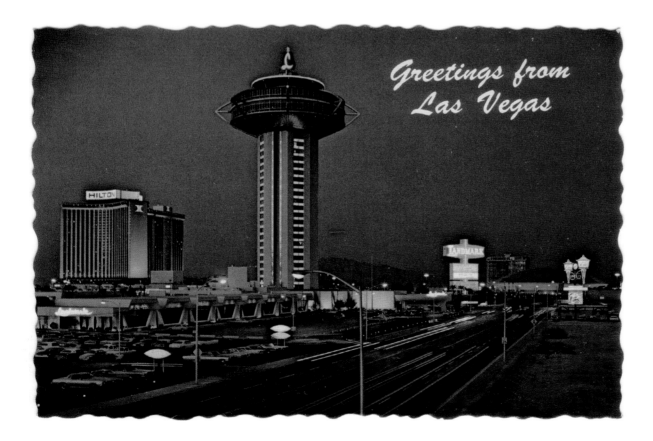

ABOVE *An advertisement attempted to sell the Landmark as a romantic, sexy getaway in the 1970s.*

RIGHT *The Landmark Hotel project, though its tower was completed in 1963, remained unoccupied for six years as its builder Frank Carroll looked to raise more money to open it.*

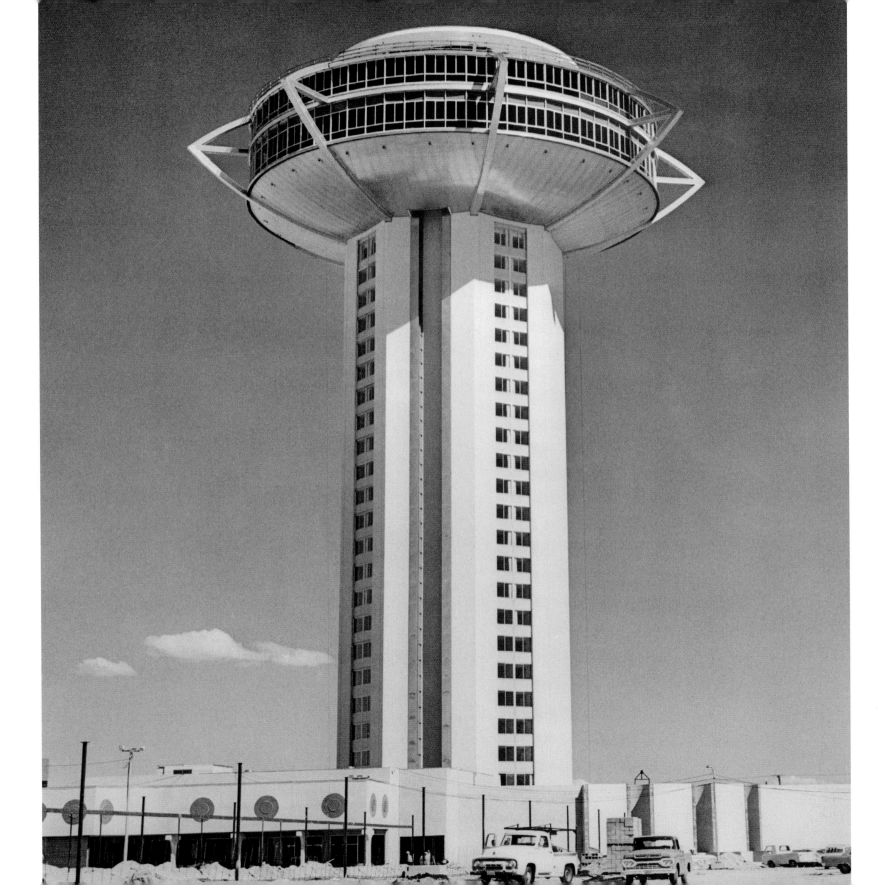

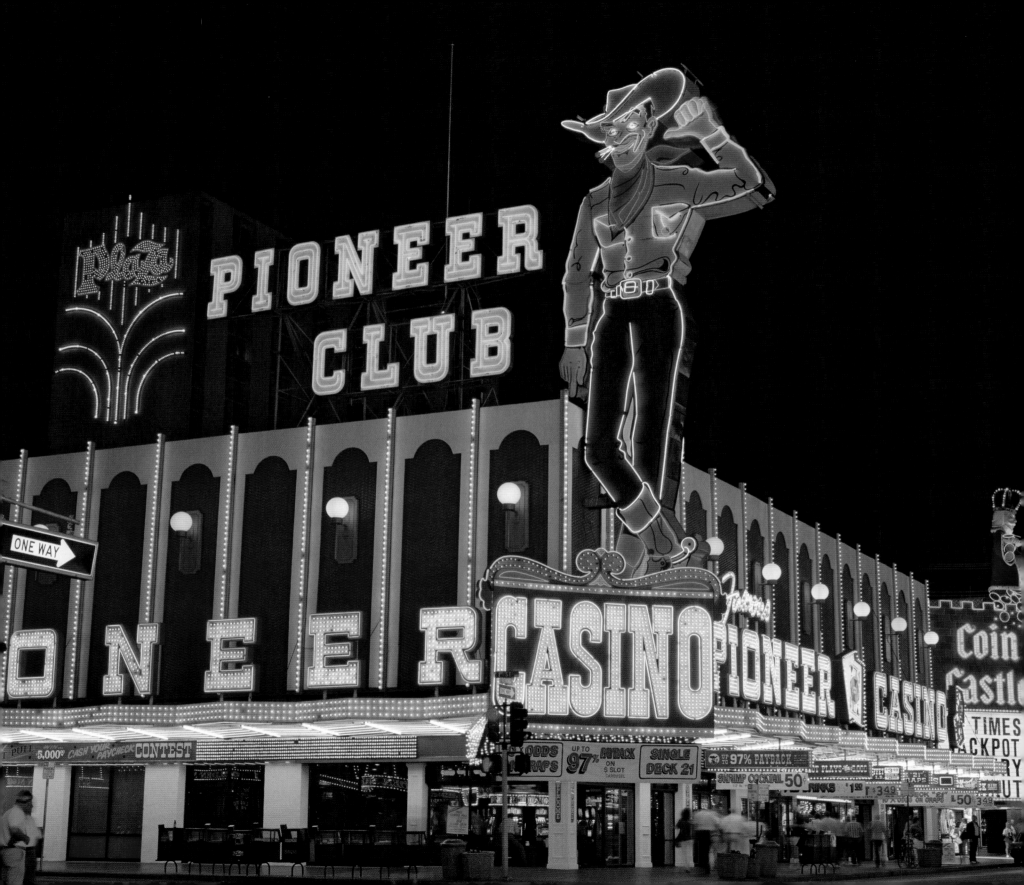

Pioneer Club CLOSED 1995

The Pioneer Club was a success soon after it opened in 1942. But nearly a decade later it was the addition of a 40-foot-high waving, talking, standing neon cowboy sign dubbed "Vegas Vic" by locals that would bring it national fame. The sign became a landmark, a link to the city's favored Western theme and a symbol of Las Vegas. The Pioneer's location on 25 East Fremont Street was originally Beckley's, an early Las Vegas men's clothing store started by Will Beckley. Former California gambling operators Tutor Scherer, Farmer Page, Bill Curland and Chuck Addison were the Pioneer's original partners. The casino, with slot machines, blackjack, craps, poker and keno, wrapped around the corner of East Fremont and First streets with a vertical neon sign carrying the casino's name and neon outline of a horse-drawn covered wagon. The partners put their experience in illegal casinos in California to work, legally this time, and soon developed a reputation for quality management. In the mid-1940s, the Las Vegas Chamber of Commerce created the Live Wire Fund and extracted small contributions from local businesses and casinos to pay for advertising to promote Las Vegas nationally as a tourist attraction. In 1947, the chamber hired the West-Marquis company to sell Las Vegas. The firm's big idea was the neon cowboy in full Western garb—blue jeans, checked shirt, red bandana, 10-gallon hat—and a cigarette hanging from its lips. The Pioneer would be the beneficiary of the concept. The casino hired the Young Electronic Sign Company, the premiere Las Vegas neon sign maker, to fashion the 40-foot standing cowboy and installed it outside the casino in 1951. Young also put up a roof sign across the street with Vic's head on it and a neon arrow pointing to the Pioneer. A recording of "Howdy Partner," West-Marquis' idea as a greeting for Vegas Vic, played continuously on a loud speaker from the sign until the mid-1960s (and was resumed from the 1980s to 2006). Vegas Vic itself would even overshadow the Pioneer, which was a profitable if ordinary casino. In 1956, the partners sold out to a group led by Milton Prell, whose company just opened the Mint hotel on Fremont Street. The Prell group renamed it the New Pioneer Club. Another owner bought the adjacent Hotel Elwell in 1965 and called it the Pioneer Club Hotel. Still other owners shed the hotel, selling it in 1984 to Steve Wynn, owner of the neighboring Golden Nugget. The Pioneer continued to change hands as a casino into the 1990s, serving as mainly a gaming machine-dominated "slot joint," but was in decline. It closed as a casino in 1995 and remained locked up and unused for three years. Yet another owner, Schiff Enterprises, reopened it as a souvenir shop. Vegas Vic remained, but part of his hat had to be trimmed off to make room for the Fremont Street Experience, a canopy and light show built over Fremont Street in 1995.

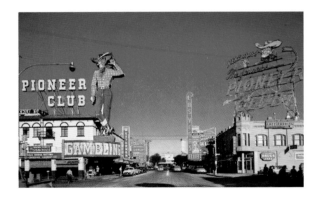

ABOVE The Pioneer Club casino dominated this view of Fremont Street with its Vegas Vic waving cowboy sign at left and rooftop sign across the street at right in the 1950s.

RIGHT The original Pioneer Club casino, at First and Fremont streets, at dusk in the late 1940s before the casino installed its Vegas Vic sign in 1951.

LEFT Vegas Vic stands tall in this view of the Pioneer Club in the early 1990s, before the Fremont Street Experience was built over it in 1995.

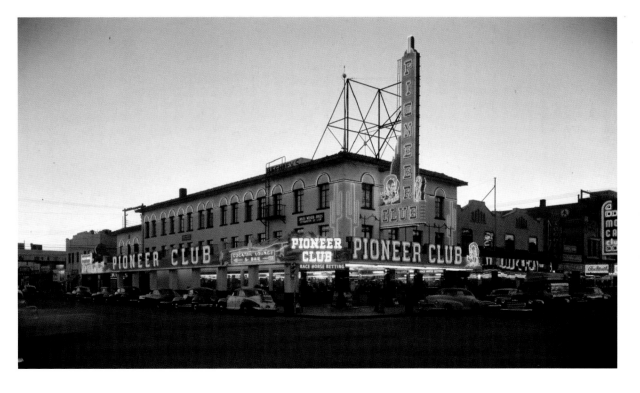

Vegas World CLOSED 1995

Vegas World was one of the strangest and most outlandish hotel-casinos ever in Las Vegas, a reflection of the person who built it, Bob Stupak. Part circus huckster, Stupak would parley his talent for salesmanship to make himself a fortune, despite the relatively poor location of Vegas World on the northern end of the Las Vegas Strip.

Born in Pittsburgh in 1942, Stupak took inspiration from his father, who operated an illicit gambling ring. As a young man, Stupak also seemed to lack focus and was attracted to risk taking, suffering injuries several times while racing motorcycles. After an unsuccessful stint as a nightclub singer, he made money selling two-dinners-for-one coupon books. He moved to Australia in the 1960s and succeeded again with the books and as a telemarketer. He moved back to the States and in 1971, he and his father raised $300,000, which the younger Stupak took to Las Vegas, seeking his fortune. He bought a restaurant

by the Las Vegas Convention Center that failed. In 1974, he bought land on Las Vegas Boulevard, several blocks north of the Sahara hotel, got himself a state gaming license and opened a casino called the Million Dollar Historic Gambling Museum. There, he started putting his talent for promotion—with some chicanery mixed in—to work that would be one of his trademarks later with Vegas World. He tacked up a phony $100,000 bill on the wall, and then placed advertisements on billboards inviting people to come "see what a $100,000 bill looks like." The ploy produced results from curious visitors. He also drew attention with a slot machine supposedly with a $250,000 payout, but never hit. The casino burned down one day, and he had to wait for the insurance money to come in. During the mid-1970s, he ran bars in downtown Las Vegas, one with blackjack games with both dealer cards exposed for 30 minutes a day to entice gamblers.

Soon Stupak, who dubbed himself "the Polish

Maverick," was ready to embark on what would be Vegas World. He opened the hotel-casino, with a hefty bank loan and just 100 hotel rooms, in 1979. Despite his marketing pitch, his place was not near the action on the Strip. He published misleading photographs showing Vegas World's sign juxtaposed among other Strip hotels. He had a slot machine with an announced $1 million jackpot, unheard of at the time—and no one seemed to win it—but no casino in Las Vegas had tried it and its intended effect was felt by the public. Other Vegas World gaming machines awarded cars as jackpots, a gimmick other casinos adopted. He revived blackjack with both dealers' cards revealed. Craps tables were "crapless," meaning the 2, 3 and 12 were point numbers. The highly rated CBS-TV news show *60 Minutes*—interested in his prowess as a gambler and poker player—interviewed him in his casino, gaining Stupak instant national fame. He later expanded Vegas World and added a hotel tower. The interior of the casino was the weirdest in town, with an outer space theme. Throughout the ceiling he placed containers of clear acrylic glass with bubbling colored water. Mirrors and stars covered walls. A glass case with a lot of currency

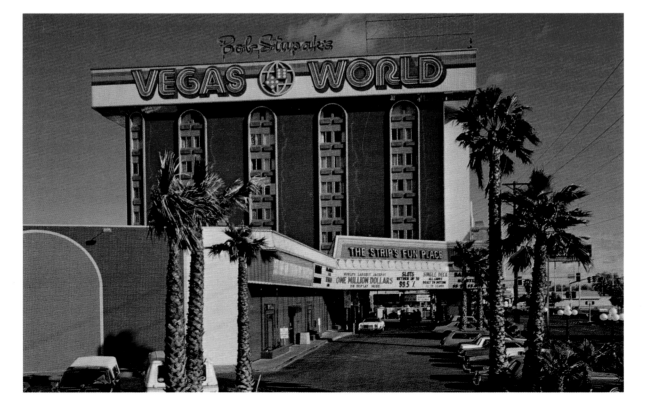

ABOVE *A postcard view of the hotel-casino after owner Bob Stupak added a 20-story tower to the eight-story hotel he built at the north end of the Strip in 1979.*

LEFT *The first incarnation of Stupak's Vegas World, which cost $7 million to build in 1979, carried the message "The Strip's Fun Place" over the entrance.*

was said to contain $1 million, but it had a number of large-denomination Vegas World casino chips tossed in. After American astronauts came back with rocks from the moon, he bought one from the Nicaraguan government and put it on display, next to a space exhibit with a hanging model astronaut and rocket ship. He had circus-like games, such as patrons dropping coins to play tic-tac-toe against a real duck, which always won by pecking the right squares. Vegas World also did a big international tourist bus business. He offered $396 "VIP Packages" with a two-day hotel stay, $400 in free casino playing chips, $400 in free slot tokens, a free gift and two drink coupons. Stupak made huge profits and acquired some neighboring motels and booked people into them when he ran out at Vegas World. However, Vegas World's guest rooms were not deluxe by any means. At one point, people complained that Stupak went too far in his promises while selling his VIP packages and eventually state gaming authorities stepped in, levied a large fine on him and warned about deceiving customers. In the mid-1980s, when Stupak ran unsuccessfully for mayor of Las Vegas, he reported his net worth was more than $50 million.

In the 1990s, Stupak planned to move on from Vegas World and build the highest freestanding tower in North America, some 1,800 feet high, with a casino, revolving bar and carnival rides in the observation area at its apex. He closed Vegas World in 1995 in anticipation of his tower. He had to reduce the tower's height to 1,149 feet high and it would open—with a wedding chapel, revolving bar, roller coaster and space needle thrill ride—in partnership with Grand Casinos, in 1996. But he and his corporate partners did not see eye to eye and they soon parted ways. Stupak would die of leukemia in 2009 at age 67.

RIGHT *Later in the 1980s, Stupak embellished his planetary theme with a neon Saturn outside the hotel. His Strip casino sign blew down during a windstorm and lead him to propose and build the Stratosphere Tower in the 1990s.*

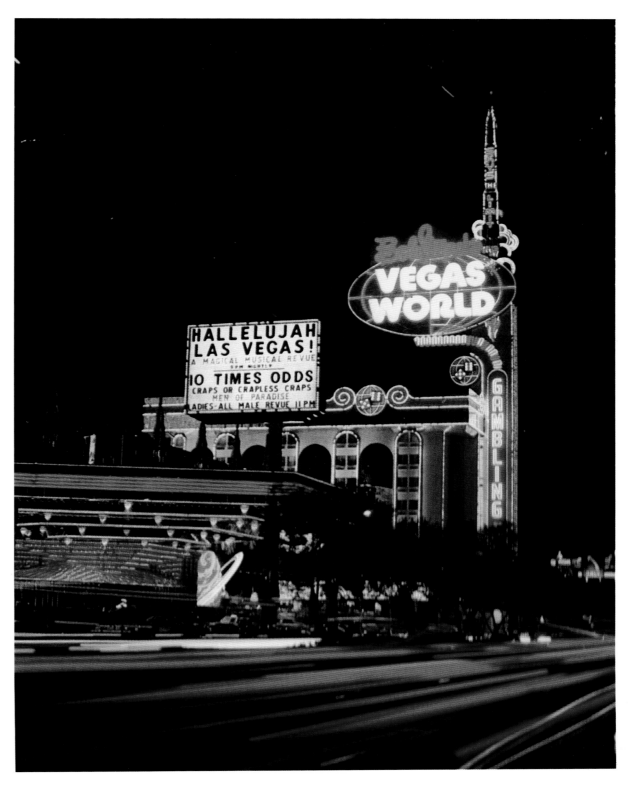

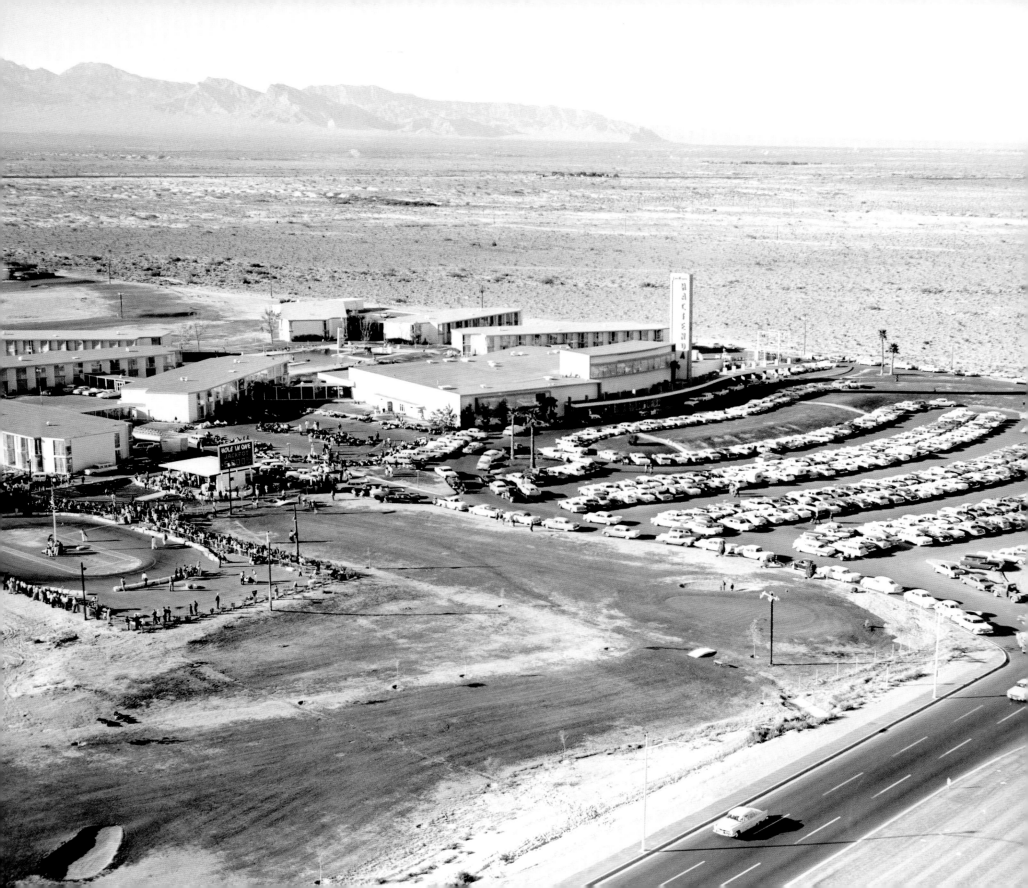

The Hacienda Hotel CLOSED 1996

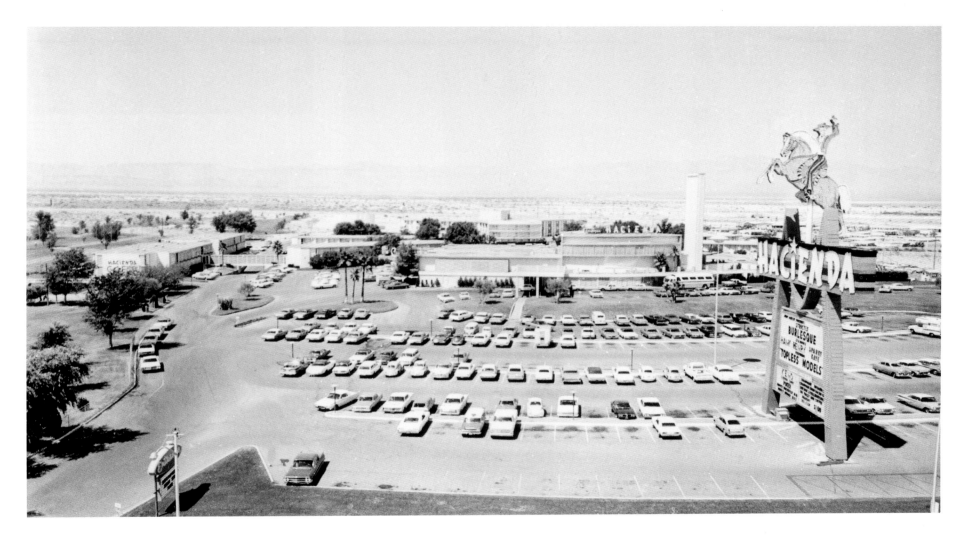

In the early 1950s, Warren "Doc" Bayley, a former farmer and travel writer from Wisconsin, and his wife Judy owned motels in Fresno and Bakersfield each known as the Hacienda. The Bayleys' motels had low-priced guest rooms for auto travelers, but unlike other cheap lodgers, they offered their guests hotel amenities such as a bellman and room service. As tourism continued to blossom in Las Vegas in the years after World War II, the couple decided to enter the hotel-casino business there with a sales approach unique at that time—discounted accommodations with the kind of services provided for well-heeled guests at the more expensive Strip hotels. They also would be the first hoteliers in Las Vegas to specifically target casino-playing adults who brought their children along.

Doc and Judy bought land at the far southern end of the Strip and the couple, along with some partners, built and debuted the Hacienda in 1956. But the resort had to open without a casino. One of the partners, Jake Kozloff, whom the Bayleys

ABOVE *The Hacienda's expansive parking lot that fronted the Las Vegas Strip in the late 1960s.*

OPPOSITE *Hacienda operator Warren "Doc" Bayley and his partners bought a large tract of land for the Hacienda's casino, guest room buildings and attractions, such as a go-cart racetrack, in the late 1950s.*

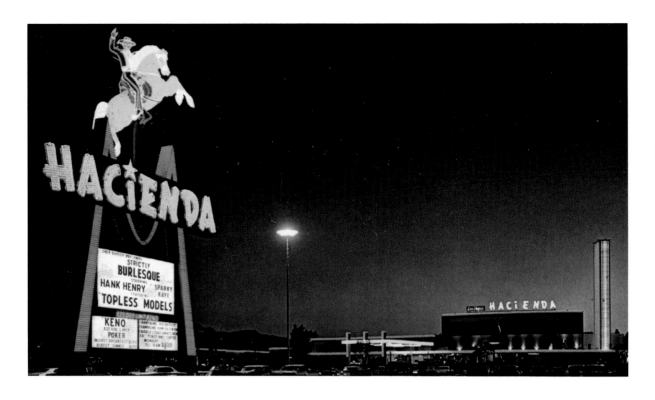

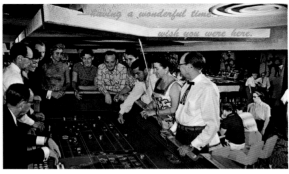

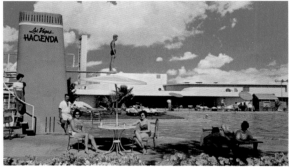

wanted as casino manager, failed to qualify for a state casino license, Nevada officials feared Kozloff had ties to organized crime. The Bayleys reluctantly replaced Kozloff in order to have a casino, which opened a year later in 1957.

Other new hotels were cropping up on the Strip at the time, making for stiff competition for tourists. But the Bayleys' Hacienda was not only the first casino drivers from California would see from the highway, it was the closest to Las Vegas's airport. The Bayleys' business strategy, centering on volumes of low-rolling travelers and families, attracted a steady stream of patrons. To help keep the children busy, they installed a go-cart racetrack and several swimming pools. Their best draw was a gimmick advertised on freeway billboards as the "Hacienda Holiday" that would get the adults started in the casino. For $16, a guest received a hotel room, free food and a bottle of sparkling wine plus $10 in casino betting chips. The Hacienda mailed paid commissions to gas station attendants in California who handed customers the $16 coupons redeemed at the Hacienda. The hotel also operated a small airline that flew patrons in from Los Angeles.

The Bayleys' Hacienda succeeded amid the

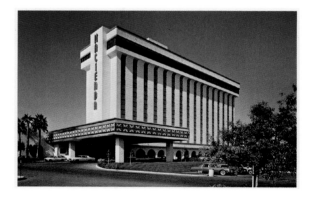

ABOVE *Postcards show various stages in the early life of the Hacienda, from a craps table in its casino (top) and swimming pool deck behind the casino (middle) in the 1950s to a new hotel tower (bottom) in the 1980s.*

ABOVE LEFT *The Hacienda at night, advertises a topless dance revue in its showroom in the 1970s.*

LEFT *The Hacienda's well-known neon sign of a rider and rearing horse went up in 1967 and remained until the hotel was leveled in 1996. The sign was later restored and moved by the city of Las Vegas to the downtown area.*

competition, in part by not getting into the war for highly paid entertainers at other Strip casinos in the 1950s. The hotel did not have a showroom. Live entertainment and dancing was left to the hotel's lounge that held daily complimentary champagne parties. By the early 1960s, the Bayleys ran eight small airplanes, flying in adult patrons from New York, Chicago, St. Louis, Dallas, San Francisco and Los Angeles. The planes included a piano bar, champagne and even live strippers. By that time the drive for families had been quietly put aside. The Hacienda also had a miniature golf course on its grounds. The hotel's manager, the well-regarded Dick Taylor, once attributed the Hacienda's success to the sexy, "nightie" outfits worn by its waitresses.

Upon Doc's death in 1964 at age 64, Judy Bayley took over the reins of the Hacienda. Judy, one of the rare women to manage a Las Vegas casino resort, earned the nickname "the First Lady of Gambling" from locals. After she died in 1971, her estate sold out to a new owner, Argent Corporation headed by Allen Glick, a real estate man from California. Glick soon purchased 80 acres next to the Hacienda for an expansion. But by 1977, the Nevada government learned that organized crime figures were stealing money from one of Argent's other Las Vegas casinos, the Stardust, and ordered Glick to sell his holdings. The Hacienda's next proprietor was Paul Lowden, a one-time Las Vegas bandleader who bought the hotel in 1979 with a group of investors. Lowden installed 300 new hotel rooms and by the 1980s the Hacienda became one of the biggest in Las Vegas with 1,100 rooms. Also under Lowden, the hotel acquired the Little Chapel of the West, a hit among celebrities, tourists and local residents as a quick and cheap place to get married. The Hacienda's steakhouse, the Charcoal Room, was a mainstay for Las Vegans as well as hotel guests.

In 1995, Circus Circus Enterprises, owner of the family oriented Circus Circus hotel-casino farther north on the Strip, bought the hotel from Lowden, but not to keep the nearly 40-year-old hotel running for long. The company used explosives to collapse the Hacienda in 1996, and later it served as the site of the Mandalay Bay resort.

RIGHT *A busy day outside the entrance to the Hacienda, with its vertical neon sign overhead, in 1956.*

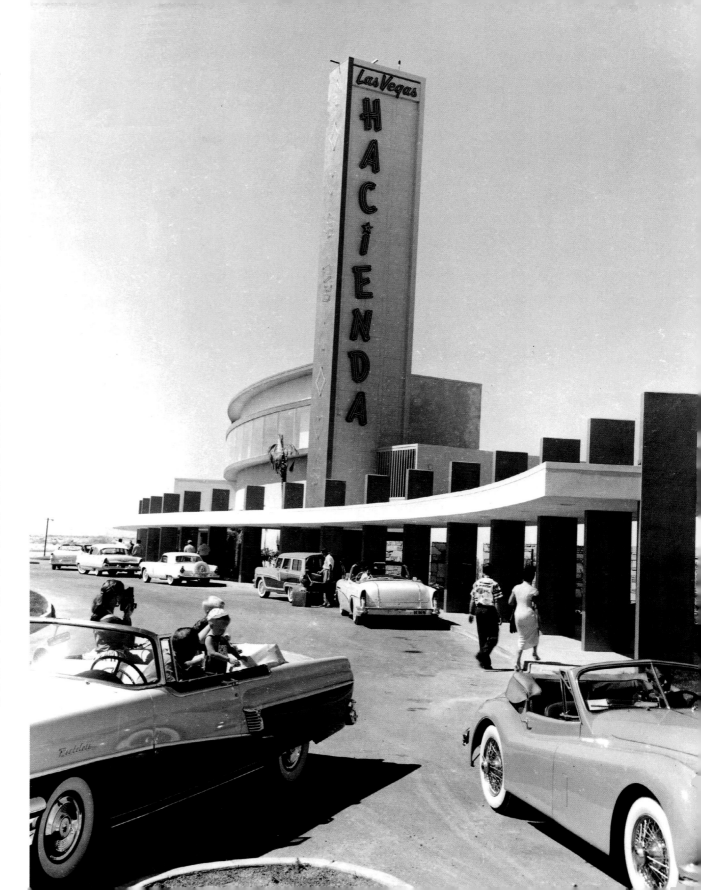

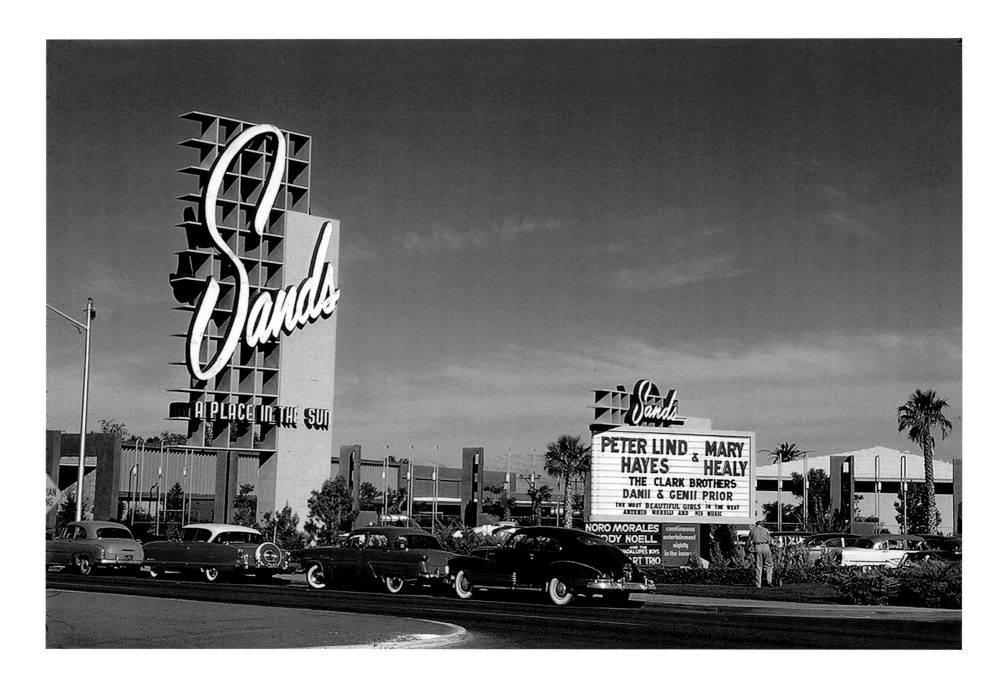

Sands Hotel CLOSED 1996

Jake Friedman, an oil businessman and gambler from Houston, began building the Sands hotel and casino on the evolving Las Vegas Strip in 1952, after buying the former La Rue restaurant. A year earlier, U.S. Senator Estes Kefauver had published a book detailing how organized criminals had infiltrated the Las Vegas casino business. The heightened sensitivity to gangsters drove Nevada gaming officials to put off licensing key members of Friedman's investment group who were former illegal bookmakers in other states. But after the brief delay, the Sands finally opened on December 15, 1952, with singer-comedian Danny Thomas in

LEFT *The original Sands Hotel in 1954.*

RIGHT *Sands postcards from the 1950s boast of its swimming pool, in the middle of the complex behind the casino, and its staff at the front porte-cochère.*

BELOW *Copa Girls dance before a packed crowd at the Sands' showroom in the 1950s.*

the showroom, the Copa Room. Jack Entratter, Friedman's brilliant entertainment chief, brought in more than 100 news reporters on junkets to cover the opening. Entratter, who used to book shows at the Copacabana nightclub in New York City, was as well-connected as anyone in American show business, and his stewardship at the Sands would make it one of the most famed casinos in Las Vegas history well into the 1960s.

In the front of the Sands, a driveway on the Strip led to a porte-cochère for guest drop-offs. In the rear were five two-floor guest room buildings, each one named after an American horse-racing track. On the south side were several drive-in private suites, each with a fenced lawn, small pool, indoor spa and a kitchen for parties. The hotel's marquee sign on the Strip advertised the Sands as "A Place in the Sun." Entratter used his contacts in show business and the national media to accelerate the competition for big-name entertainers against main rivals Desert Inn and the just-opened Sahara hotels.

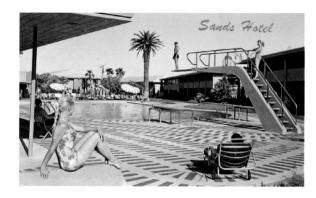

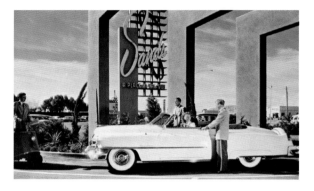

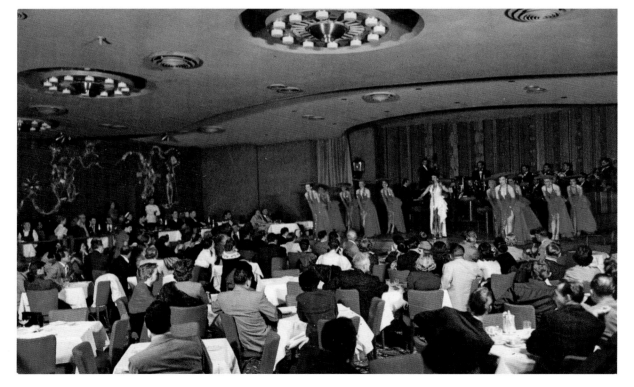

He introduced a popular line of beautiful female dancers, the Copa Girls, to amuse audiences for his star headliners. The Sands, with Entratter at the helm, would practically define Las Vegas in the 1950s and set a standard that no other casino could match. Singer and actor Frank Sinatra partied in Las Vegas as much as he performed while headlining at the Sands. His friendship with singers Dean Martin and Sammy Davis Jr. developed there. Their antics on and off the stage garnered international publicity and attention. Their friend U.S. Senator John F. Kennedy was elected president in 1960, the same year he watched the three of them perform at the Sands. When the "Rat Pack," as Sinatra, Martin, Davis, comedian Joey Bishop and actor Peter Lawford, became known, held what they called the "Summit" at the Sands in 1960 (and appeared in the movie *Ocean's 11* filmed in Las Vegas from 1959 to 1960), reporters from throughout the world mentioned the Sands as the

pack's headquarters. In 1961, the Sands put in a steam room where Sinatra and the others met in the late afternoon, performed in the Copa Room and then played all night on the town. Entratter courted controversy when he was the first to permit black singer Nat King Cole to stay in a guest room at the Sands in 1955, when other Las Vegas hotels honored a segregation arrangement—which lasted until 1960—that kept blacks, even headliners, from staying on the Strip. Black entertainers ended having to find accommodations in the city's black neighborhood, the Westside.

Large profits flowed in throughout the 1950s. The Sands' management team became known as the top casino overseer in town and its entertainment—in the Copa Room and its lounge, the Sands Celebrity Theater, with lounge king Louis Prima a contracted regular—the most in style and in demand. Former President Harry Truman showed up in 1962 to watch singing comedian Jimmy Durante. In 1963, managers embarked on constructing a unique hotel tower built in the shape of a cylinder. The hotel's new convention center was booked solid for years. Finally, in 1967, the Sands partners took up Howard Hughes' proposal to purchase the hotel for $14.6 million. Hughes pumped additional money to complete the 777-room hotel high-rise in 1968. Lingering disagreements with Sands managers prompted Sinatra to switch to performing at Caesars Palace, and Martin to the Desert Inn. The Sands retained some of its managers under Hughes but its heydays were mostly behind it. After Hughes died in 1976, his company Summa Corporation continued to manage things until Kirk Kerkorian bought the Sands in 1988. By then, the Sands, its grounds and large parking lot was far more valuable as development property on the Strip than a casino.

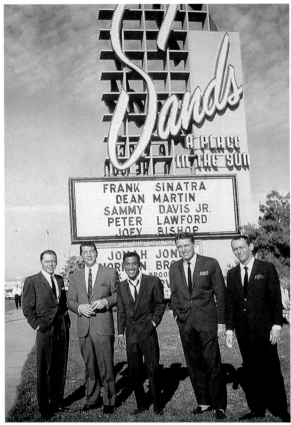

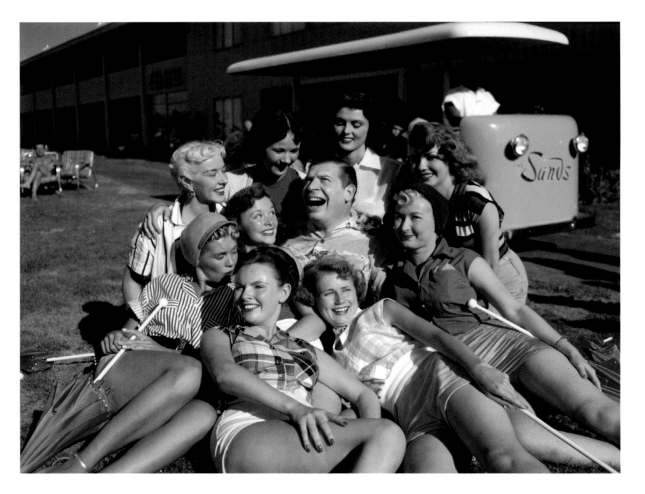

Kerkorian soon sold it at a profit in 1989 to vacation packager Sheldon Adelson, who later planned to build an enormous convention center on the property along with a new hotel project. He closed the Sands in 1996 and imploded the buildings to become the site of the Venetian hotel that opened in 1999 at a cost of $1.5 billion.

ABOVE *The Sands' top performers, during their "Rat Pack" years of the late 1950s and early 1960s, were, in order of billing, Frank Sinatra, Dean Martin, Sammy Davis Jr., Peter Lawford and Joey Bishop.*

LEFT *Television show host Milton Berle clowns with some of the Sands' Copa Girls by the hotel's pool in the 1950s.*

RIGHT *Sinatra headlined in the Copa Room in 1966 while the Sands' cylindrical hotel tower was being built.*

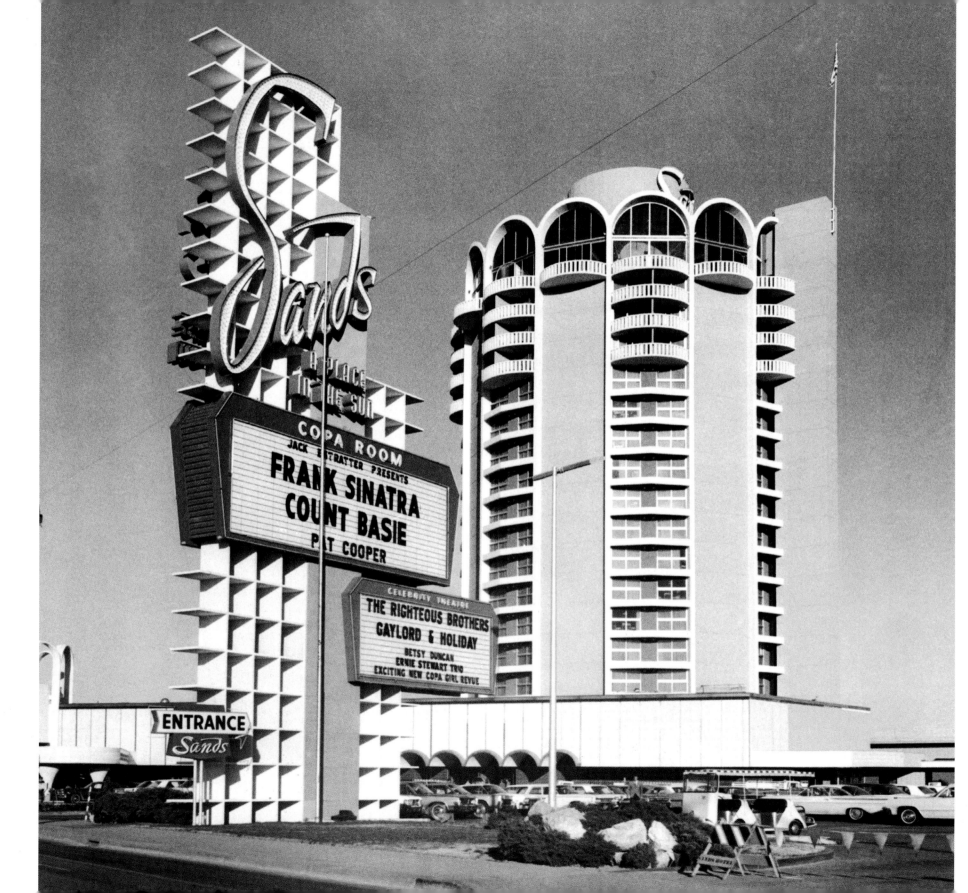

Alpine Village Inn CLOSED 1997

The Alpine Village Inn originally opened in downtown Las Vegas in 1950, when owner Hershel Leverton began serving his take on Bavarian-style food in a German mountain chalet setting. To run a German restaurant only five years after the end of World War II was somewhat of a bold move, but Leverton made the eatery friendly, inviting and a slow but steady success. In his newspaper advertising, Leverton liked to use the Bavarian greeting "Grüss Gott" (in lieu of "Guten Tag") for good day or goodbye. He would serve German favorites, wiener schnitzel, sauerbraten, German roast beef with sides—which became among his signature dishes—of warm potato salad and a special seasoned cottage cheese. The small restaurant grew enough for Leverton to relocate out near the Las Vegas Strip. In the late 1950s, he moved the place out to Bond Road (later renamed

Tropicana Avenue), two miles south of Highway 91, now Las Vegas Boulevard. His profitable business, and his employment of non-union workers, did not escape the notice of Al Bramlett, a powerful culinary labor union leader whose group was focusing its attention on Las Vegas's hotels, bars and restaurants. In 1958, Bramlett marched into the Alpine Village's bar and told Leverton he would be out of business if he did not hire union workers. Leverton defiantly called Bramlett's bluff and refused. Minutes later, Bramlett sent union members out to picket in front of the Alpine Village. Leverton stayed in business, ignoring picketing union members who would stand outside his restaurant, wherever it moved, off and on for several decades.

In 1970, Leverton moved the Alpine Village to its final and most popular location, on Paradise Road across from the International Hotel (now Las Vegas Hilton), a year after the huge resort had opened. He built a two-story, chalet-style, A-frame structure with a traditional Bavarian village home facade. His outdoor sign touted "Swiss German–American Cuisine" and Swiss and French flags flew from the front wall. Inside, Leverton made the most of the Bavarian theme with a miniature running train. The elegant main dining room, its walls decorated with simulated Bavarian home facades, had antique-style wooden ceiling lamps and round, white-clothed tables with seating for 250 customers. The cocktail lounge had white cushioned seats at the bar and a model mountain with simulated snow and toy skiers behind a wide glass window facing patrons. Downstairs, Leverton had a garish but informal "rathskeller," open from 5 p.m. to 11 p.m., with a party atmosphere for

consuming imported beers, strong cocktails and German food. Diners in the rathskeller, seated at tables with red-checked table cloths, were invited to grab salted, unshelled peanuts from bowls on their tables and drop the shells on the floor. Its small gift shop was filled with German ceramic and porcelain figurines for sale. Visitors to Las Vegas walked over or took taxis to the front entrance. But the Alpine Village enjoyed a large following among local residents for more than a quarter of a century on Paradise Road.

Labor troubles would continue beyond just the constant picketing outside the Alpine Village, as Bramlett resorted to greater lengths in his feud with Leverton at the still non-union restaurant. In 1975, a pair of bombs planted on top of the restaurant blew up while the place was loaded with about 400 customers. No one was seriously hurt. Authorities suspected Bramlett but there were no arrests over the crime. In a bizarre twist, Bramlett was found murdered in a remote part of Nevada in 1977. Years later, two local hoodlums, Tom Hanley and his son Gramby Hanley, admitted that Bramlett had hired them to plant the bombs. They also confessed to kidnapping and killing Bramlett and were sent to prison.

The Alpine Village finally closed in 1997 after almost a half century in business, and was eventually razed in favor of a parking lot at a time when local history was not much appreciated in Las Vegas. But the eatery remains a source of fond nostalgia for older Las Vegans to this day.

ABOVE *A matchbook cover for the Alpine Village with a drawing of the restaurant across from the Las Vegas Hilton on Paradise Road in the 1980s.*

LEFT *The remnants of an Alpine Village street sign, with its traveling Bavarian villager, after the business closed in 1997.*

FAR LEFT *A postcard from the 1980s shows the Alpine's warm and inviting interior.*

OPPOSITE *The Alpine Village's exterior on Paradise Road, showing its Bavarian village-style facade, with foreign flags over the drive-up porte-cochère that led to its rear parking lot, to the right.*

Showboat CLOSED 2000

Two of Las Vegas's most admired casino men in the 1950s, William Moore and J. Kell Houssels, teamed up for what would be the first casino-resort in the Las Vegas city limits. In its first incarnation, the casino was named the Desert Showboat Motor-Hotel, with 100 guest rooms on Boulder Highway. The front facade mirrored a mid-19th century Mississippi paddlewheel steamboat. Despite the pair's knowledge of gambling, they hired a group led by Moe Dalitz, a former Cleveland hoodlum who moved to Las Vegas to run the Desert Inn on the Strip in 1950, to oversee the Desert Showboat's casino. A partner of Houssels', Joseph Kelly, was in charge of the hotel side. The place opened on September 3, 1954 and while a unique property, its location away from the action on the Strip worked against it. Offering big-name entertainment and incentives to high-rolling gamblers, while good for the Strip casinos, failed to work for the Desert Showboat.

While the boat began to sink financially, Houssels and Kelly took a chance. They bought out Dalitz's investment in 1959 and steered the property toward a new market unique at the time—locals who gambled, in addition to low-rolling, budget-minded tourists. They renamed the resort the Showboat, started serving 49-cent breakfasts in the coffee shop, concentrated on slot machine players and built a 24-lane bowling alley, the Showboat Lanes, to lure Las Vegas residents. Their gamble paid off. The

Showboat became among the first and the most successful locals-oriented casinos in Las Vegas.

By 1963, the Showboat expanded by 100 more hotel rooms and doubled the size of its casino. In 1968, the partners took the casino company public and sold shares on the stock market to finance another remodeling project—a refurbished facade featuring a giant paddlewheel, a larger bowling alley and a new swimming pool. Houssels and Kelly added a bingo parlor that became another local hit. Still raking it in, in 1973 they put up a nine-story hotel tower with 250 rooms. In 1975, they expanded their popular bingo parlor to 850 seats—one of the largest in the country at the time—broadened the casino to a then-large 40,000 square feet and reached the 1,000 mark for slot machines. The nine-story hotel tower grew by 10 stories and 250 new rooms in the late 1970s. By the 1980s, the locals market continued to spell success for the owners and the Showboat evolved into its own phenomenon. Other casinos on Boulder Highway and elsewhere in Las Vegas started catering more to locals. The Showboat added a race and sporting betting parlor and a 5,500-seat Showboat Sports Pavilion that showed live boxing and other contests. The Showboat had about $50 million in annual revenues by the mid-1980s. Its company expanded by building a large casino in Atlantic City, New Jersey in the 1980s and entered the riverboat casino market in the Midwestern United States in 1990s, making investors far more money.

In the 1990s, the company saw the need to expand the Las Vegas casino again as large new competitors attempted to steal away its coveted local gambling market. But still, times had changed. The Showboat's audience was getting older and the casino was losing attention to the new billion-dollar mega-resorts on the Strip. The company finally sold the Showboat and the rest of its holdings to Harrah's Entertainment in 1998. Harrah's, uninterested in keeping the Las Vegas Showboat, sold it in 2000 to three investors who renamed it the Castaways but could not make a go of it, and the casino closed in 2004. The locals gambling company Station Casinos took over but decided to implode the aging building in 2006.

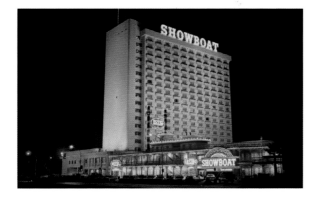

ABOVE *The Showboat in the 1980s with its new hotel tower, following a major renovation and expansion.*

RIGHT *A 1970s advertisement promotes the hotel's 19th-century Mississippi riverboat theme.*

RIGHT *The opening ceremony for the Showboat Hotel in 1955, with its facade of a faux 19th-century Mississippi steamboat next to a pool meant to simulate a river.*

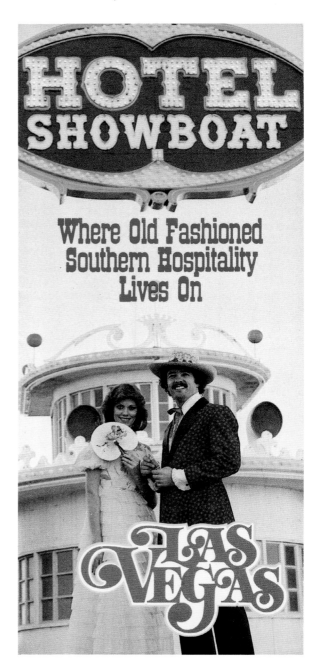

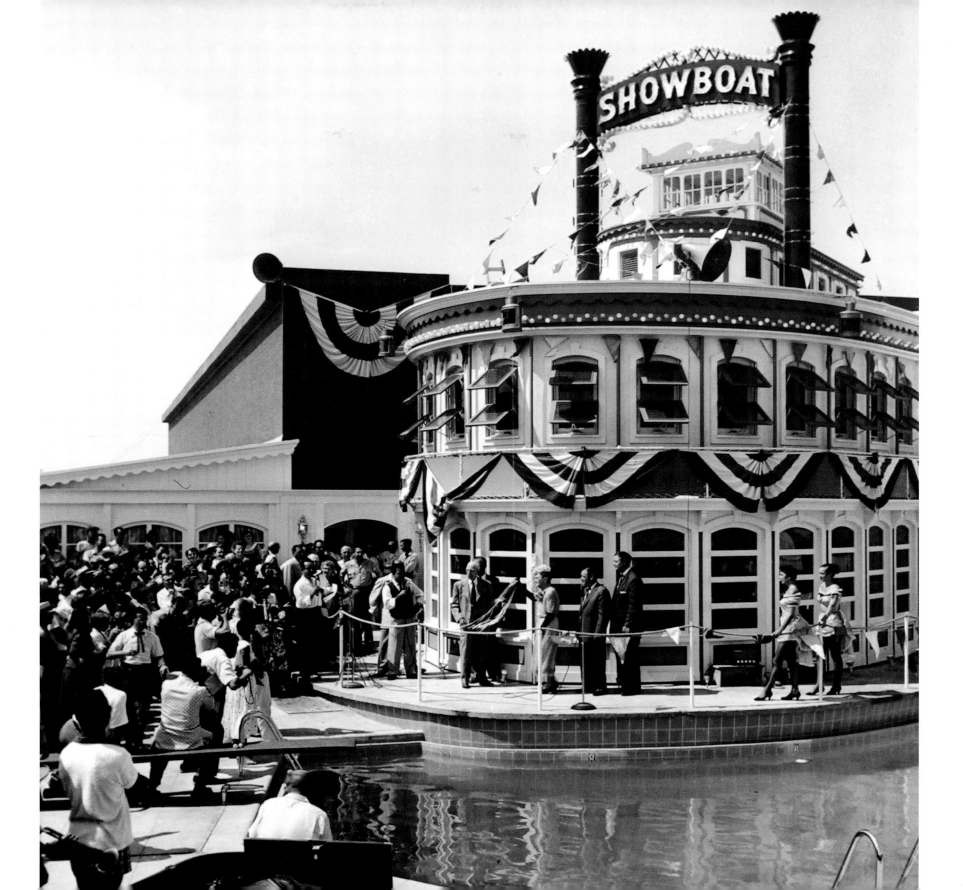

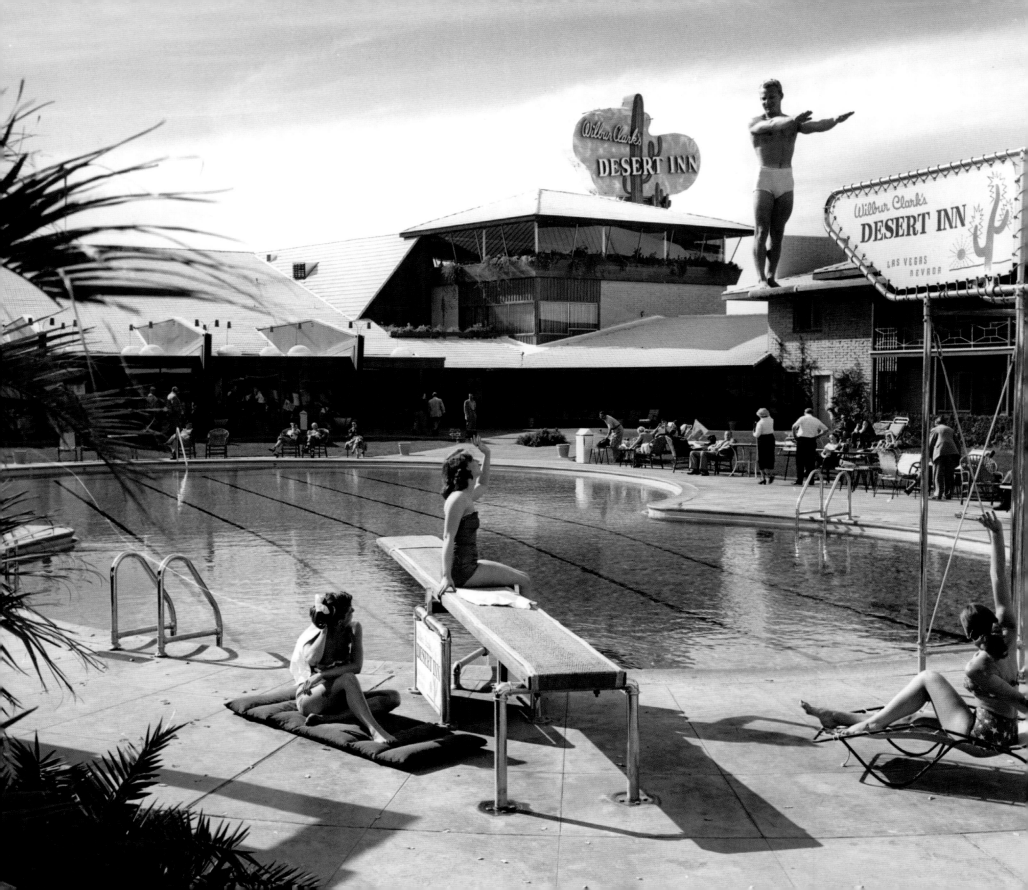

Desert Inn TORN DOWN 2001

In 1944, when he was 35 years old, Wilbur Clark sold a hotel he owned in San Diego to move to Las Vegas and buy a controlling interest in the El Rancho Vegas on Highway 91. The El Rancho was only a few years old, its casino and rooms fashioned after the Old West. But Clark wanted to design his own new, high-class hotel from the ground up. He soon sold the El Rancho at a profit and let some partners in on his Desert Inn resort project, to be built on the highway south of the El Rancho. Clark started building in 1947 but ran out of funds. The project languished, partially built, for about a year. Clark, desperate for investors, accepted a cash infusion from a group led by Moe Dalitz, an infamous mobster whose experience managing illegal casinos nonetheless made him a valuable partner.

With Dalitz now owning most of the project, the resort known as "Wilbur Clark's Desert Inn" finally opened on April 24, 1950, at a cost of $6.5 million. Decked out in pinkish light outside, the Desert Inn was a novel advance in modern, luxury resort building on the Strip. Clark had installed air-conditioning in each of the hotel's 300 guest rooms. The ventriloquist and national radio star Edgar Bergen opened the resort's Painted Desert showroom. Clark spent $75,000 to bring in news reporters to publicize the opening in papers throughout the country. The Sky Room restaurant overlooked a figure-8-shaped pool with water fountains that moved accompanied by lights and music. Dalitz's team managed the casino. The site covered 272 acres. Clark added a 165-acre, 18-hole golf course the following year at a cost of $1 million, and 200 more hotel rooms. He started the annual Tournament of Champions at the course, which for years attracted the top professional golfers and national media coverage.

Clark was perhaps the most famous hotelier in Las Vegas throughout the 1950s, playing host to the rich and famous such as former president Harry Truman, Senator John F. Kennedy, Winston Churchill, the Duke and Duchess of Windsor and TV host Ed Sullivan. The showroom had top-line entertainers for dinner shows including the likes of Noël Coward, Jimmy Durante and Frankie Laine. Clark reportedly telephoned Coward to ask him to perform and agreed to pay him $40,000 a week after Coward told him "Forty Grand and found."

Clark owned 25 percent of the revenue at the

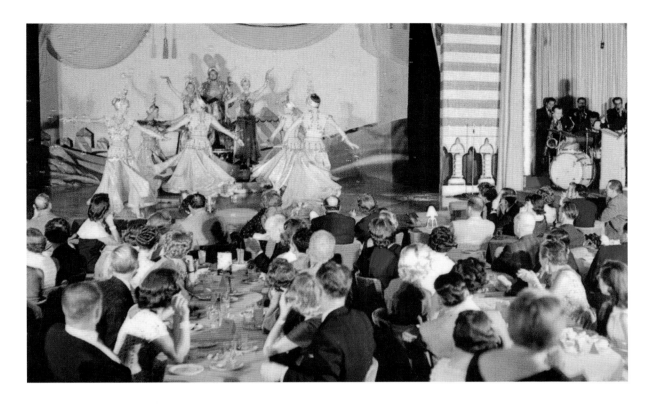

Desert Inn and was the resort's public face while Dalitz and his people discretely ran the casino and enjoyed most of the profits. Clark's role had diminished by the early 1960s. He sold his stake in the hotel in 1964 and died a year later.

In 1966, Dalitz allowed billionaire Howard Hughes to stay a while in one of the Desert Inn's penthouses, usually reserved for big gamblers. Hughes refused to leave and asked what Dalitz wanted for the hotel. Dalitz requested an overpriced amount of $14.6 million, and Hughes bought the Desert Inn the following year. Hughes would eventually buy five other Las Vegas Strip hotels, giving the local casino business—reputedly dominated by organized crime—new respectability and corporate governance. Hughes remained inside the penthouse literally every day until he left Las Vegas in 1970. His Summa Corporation continued to operate the Desert Inn after he died in 1976 and invested $54 million into an expansion and 14-story hotel room tower with reflecting glass windows. In

ABOVE *A dinner show in the Painted Desert showroom at Wilbur Clark's Desert Inn shortly after the resort opened.*

OPPOSITE *A man prepares to dive into the Desert Inn's swimming pool, with the hotel's Sky Room tower in the rear, in a hotel publicity shot from about 1950.*

BELOW *The Desert Inn's buildings surround the pool in this pilot's-eye view postcard from the early 1950s.*

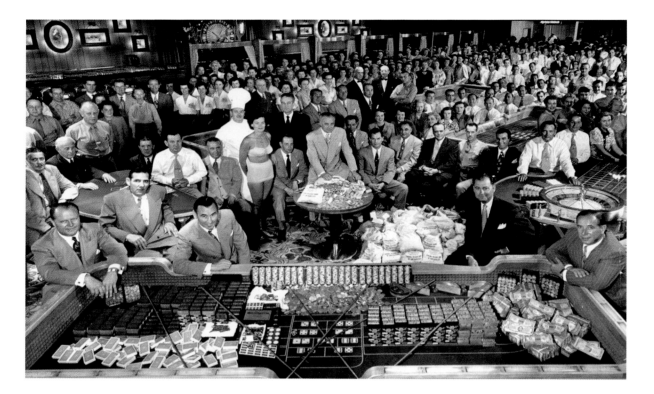

the late 1970s, *Vegas*, a popular television detective series, frequently used the Desert Inn for locations shots. Burton Cohen served as the hotel's chief executive.

Summa sold the hotel to Las Vegas hotelier Kirk Kerkorian in 1987. In the early 1990s, Frank Sinatra teamed up with Dean Martin, Shirley MacLaine, Liza Minnelli and other stars to perform continually in the showroom, and managers for a time renamed the hotel "The Stars' Desert Inn." Kerkorian spent $200 million on an expansion in 1997.

In 2000, Kerkorian sold the Desert Inn to Mirage hotel owner Steve Wynn for $275 million. Wynn, who lived in the vacant Desert Inn for a while, had the place torn down by implosion in 2001. He opened the Wynn Las Vegas resort there, at a cost of $2.7 billion, in 2005.

LEFT *A publicity shot taken just before the casino's grand opening on April 24, 1950. The photo aimed to show all the employees, money and gambling equipment needed to run a big casino for a single night.*

RIGHT *American flag bunting fronts the Desert Inn's facade shortly after the hotel opened in 1950.*

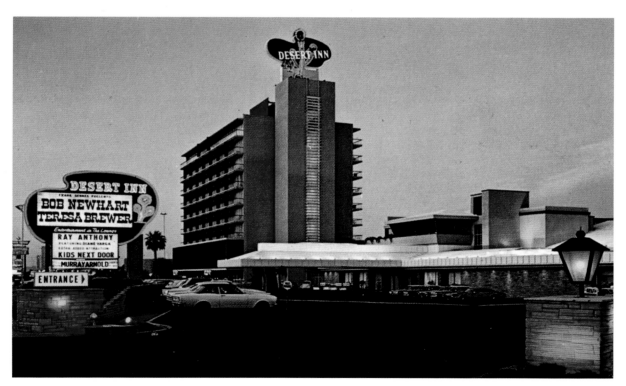

ABOVE *The Desert Inn's original casino, shown just before the hotel opened its doors in 1950.*

LEFT *The Desert Inn marquee, on a postcard from 1970.*

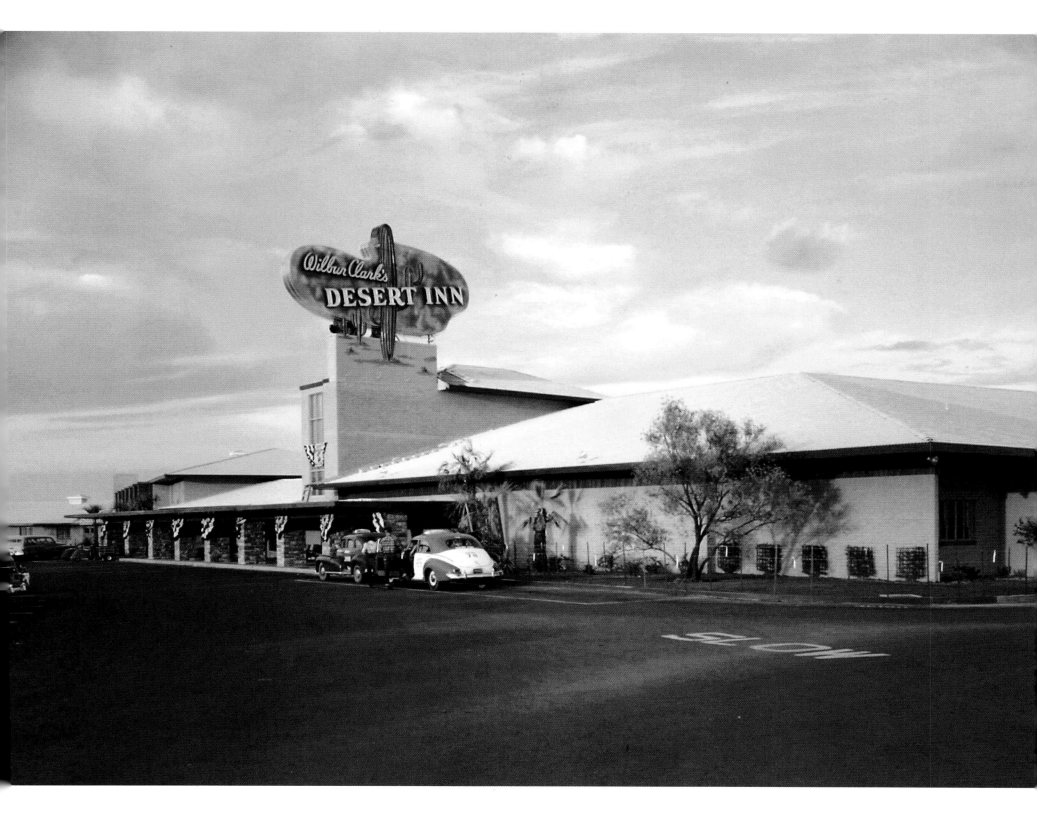

Holy Cow! CLOSED 2002

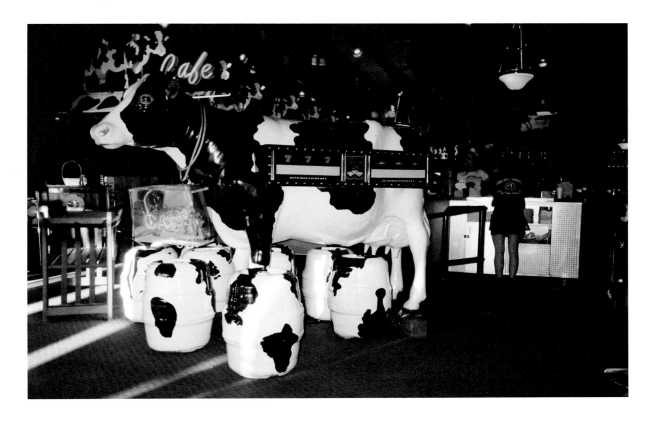

poker slot machines and a small casino with lines of slot machines on the floor beneath the exposed rafters of the two-story building. The walls featured humorous paintings of black and white spotted Wisconsin milk cows. The dark-wood, fully stocked bar had a faux milk can tower with beer taps from which poured its five hand-crafted beers. The beers were brewed in wide fermenters on the second floor that had a walkway for patrons to view them through glass windows. Holy Cow! had four 10-beer-barrel fermenters, making a light Cream Ale and its Amber Gambler Pale Ale that would win the Great American Beer Festival for the Classic English Pale Ale in 1993. It also brewed a red ale, Wisconsin-style Hefe Weiss, an India Pale Ale and, as a brew master special, a dark amber, spicy-smelling Pumpkin ale made with 500 pounds of fresh pumpkins. All beers were offered in various sizes and a half-gallon "growler" container for takeout orders. Wiesner served burgers, salads and other standard bar food from the kitchen but also included fried walleye, a freshwater fish imported from Wisconsin. Soon, he started selling his brewed beers at other bars in town. He would branch out, building another slot machine bar called Big Dog's west of the Strip and the Draft House, a beer-oriented eatery serving Wisconsin bratwursts, north of the Strip in the city of North Las Vegas. As other brewpubs cropped up in the 1990s, Holy Cow! began to fade as Wiesner's other businesses grew. The pub closed in 2002, the year Wiesner died from leukemia at age 63.

Tom "Big Dog" Wiesner would bring his Wisconsin roots, and millions from the sale of a bankrupted hotel on the Las Vegas Strip, to conceive and open Las Vegas's first brewpub, the Holy Cow! in 1992. Wiesner—a professional footballer for the Baltimore Colts and later Los Angeles Rams—arrived in Las Vegas in 1963 at age 24. He went on to start a successful tire company and soon gained entry to local political and business circles. Only six years after arriving, Wiesner won a seat on the Clark County Commission in Las Vegas—at age 31, the youngest-ever elected commissioner. A year later, in 1971, he sold his tire business. Wiesner remained on the commission until 1978. But his big success came in the late 1980s, when the Marina hotel on the Strip fell into bankruptcy and shut down. Wiesner and some partners edged their way into acquiring interests in the large casino property that included an 18-hole golf course. In 1989, casino operator Kirk Kerkorian

bought the old Marina for his planned MGM Grand Hotel project, dubbed "The City of Entertainment." Wiesner and partners made millions in the deal. Now he could do what he wanted—bring the cuisine, German-English styled beers from his native Wisconsin to Las Vegas. He launched a restaurant company, and in 1992, built the Holy Cow! on the Strip at the site of the old Foxy's Firehouse casino, across from the Sahara hotel. It would be the first microbrewery, or brewpub in Las Vegas—but first Wiesner had to persuade the state to change its laws prohibiting local breweries.

Holy Cow! had 20 bar stools, bar-top video

ABOVE *The figure of a Holstein cow stands inside the Holy Cow!, built by Wisconsin native Tom Wiesner.*

OPPOSITE *The facade and roof sign of the Holy Cow!, facing Sahara Avenue from the Strip in the 1990s.*

RIGHT *A side view of the Holy Cow!, with the Stratosphere hotel's tower behind, in the 1990s.*

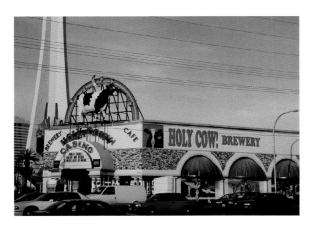

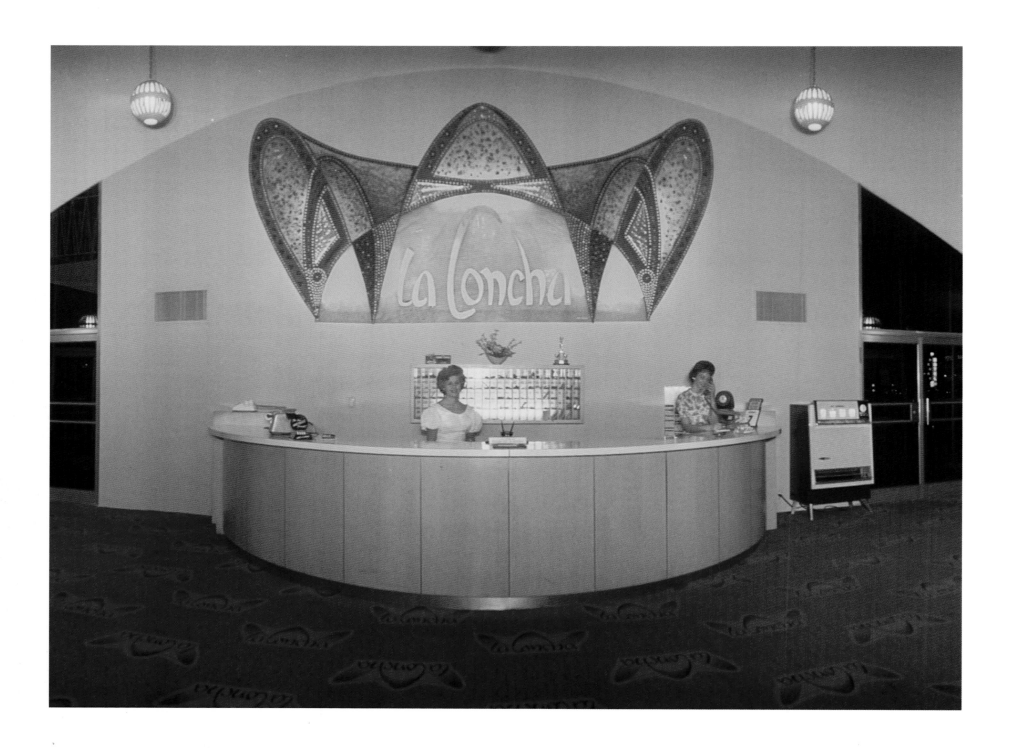

La Concha CLOSED 2003

Designed for owner Ed Doumani by renowned African-American architect Paul Revere Williams, the La Concha Motel opened in 1961 on the Las Vegas Strip between the Riviera hotel-casino and the El Morocco Motel, built by Doumani and his brother Fred in 1964.

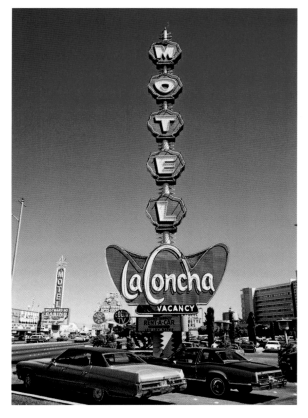

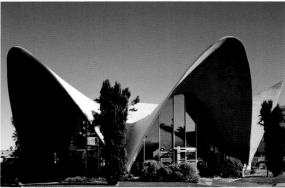

The concrete shell-like design of the La Concha lobby was one of the most striking examples of Googie or Mid-Century Modern architecture ever constructed in Las Vegas. Williams was also part of the architectural team that designed Los Angeles airport's iconic flying saucer-like Theme Building in 1961, though he was a master of many different styles. A similar thin-concrete-shell building, designed by structural engineer Mario Salvadori and built in 1958, was used to house the Perla restaurant for La Concha Resort in San Juan, Puerto Rico and still provides that role today. In Las Vegas, the shell structure housed the motel's lobby and front desk. Doumani put up foiled wallpaper and drawings of Spanish royalty from centuries past on the interior walls. La Concha had a small lounge often used by eccentric performers, such as a John Lennon impersonator in the 1990s. The motel made an appearance in the 1995 film *Casino* as the site of a tryst between the movie's mob heavy, Nicky Santoro (Joe Pesci) and his best friend Ace's wife, the doomed Ginger Rothstein (Sharon Stone).

In December 2003, the motel was closed and Ed Doumani's son Lorenzo demolished the accommodation wing to make way for a planned hotel development, which has yet to proceed after the economic downturn. The La Concha Lobby was placed on Preserve Nevada's list of 10 most endangered historic sites for 2004. Mindful of the architectural and historical significance of the La Concha lobby, a number of Las Vegas residents worked hard to ensure that Paul Williams' iconic structure would be preserved, and the Doumani family promised the building to the Neon Museum in 2005. Engineers struggled mightily with the logistics of moving the fragile concrete shell to its location near the museum's boneyard, just north of downtown. In 2006, it was cut out in sections, and transported by truck to its new location at night. The following year it was reassembled and restoration began on the structure in order to prepare it for its new role as the visitor center and gift shop for the Neon Museum.

TOP LEFT *The La Concha's vertical sign, shown here in the 1970s, attempted to catch the eyes of motorists on the crowded Las Vegas Strip.*

LEFT *Architect Paul Williams' arched design for the La Concha's front lobby building is captured here prior to its closing in 2003.*

OPPOSITE *The motel's curved front desk in a publicity shot for its 1961 opening.*

PAUL REVERE WILLIAMS (1894–1980)

Born in Los Angeles, Paul Revere Williams was the first African-American member of the American Institute of Architects (AIA). His training included Los Angeles Polytechnic High School, the Beaux-Arts Institute and the USC School of Engineering. Williams proved to be one of the most versatile architects of his generation, designing everything from churches and civic buildings to housing projects and luxury homes for Hollywood stars. He worked across a wide range of architectural styles and had a client list that included Frank Sinatra, Bill "Bojangles" Robinson, Lon Chaney Sr., Lucille Ball, Julie London, Tyrone Power, Barbara Stanwyck, Bert Lahr and Will Hays. Following the war he published his first book, *The Small Home of Tomorrow* (1945). Williams' Las Vegas projects date from the 1940s to the 1960s and include the La Concha Motel and the Guardian Angel Cathedral on the Las Vegas Strip. He also designed the Basic Magnesium Inc. housing tract in nearby Henderson, which provided affordable homes for hundreds of working families who had been recruited to work for the lightweight airplane parts manufacturer. A number of his works are listed on the National Register of Historic Places and their variety are testament to his versatility; they include grand houses, two churches, a YMCA and the Berkley Square neighborhood, a subdivision in West Las Vegas.

Moulin Rouge BURNED DOWN 2003

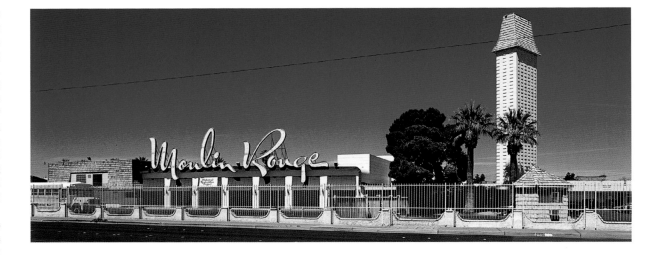

In the mid-1950s, most Las Vegas resorts were segregated. Hotel owners would not permit African-Americans to patronize casinos or even be seen on hotel property to avoid offending and risking the loss of customers to the other whites-only hotels. Even black celebrities, such as Sammy Davis Jr., Nat King Cole and Pearl Bailey, could not walk through the lobbies and casinos where they performed. They had to stay overnight in Las Vegas's Westside, a rundown neighborhood for the city's blacks. But in 1955, a group of Caucasian investors, including Will Schwartz of Las Vegas, Louis Reuben of New York and Alexander Bismo from Los Angeles envisioned a market for Las Vegas's first integrated hotel and casino.

They opened the Moulin Rouge, named after the famous Parisian cabaret, on May 24, 1955 just outside the Westside near downtown Las Vegas and several miles northwest of the Strip. Building costs totaled $3.5 million. The complex included a small casino and lounge with a center stage and French-themed murals

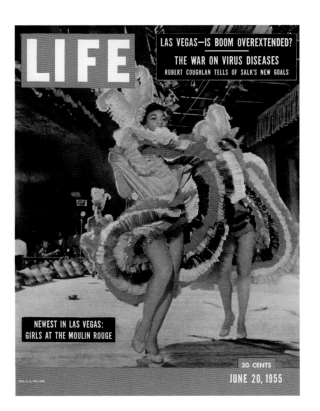

on the walls. Outside, a two-story, L-shaped building with 110 guest rooms stood by a swimming pool. A distinctive tower sign in front served as a beacon. The Moulin Rouge's opening show featured black women in full-dress costumes dancing in an old-fashioned French cancan-style review. The early days were memorable and drew racially mixed crowds that packed the casino to mingle late at night and to try to spot celebrities. The atmosphere was jubilant at a time when blacks were not allowed to show their faces in Las Vegas casinos. Davis and other big-name black performers walked through the casino to take to the stage, gamble and drink. Top white entertainers, including Milton Berle, Judy Garland, Marlene Dietrich and Davis's friend Frank Sinatra, showed their support for the integrated venture by stopping in after their evening shows on the Strip, mixing with patrons and at times performing on stage. In June 1955, *Life* magazine ran a story on the resort with cancan dancers in full 19th-century-style dress pictured on the cover.

But the Moulin Rouge's glory days were numbered. The partners clashed over managing the hotel-casino and paying its past-due building costs and other liabilities. Unwilling to sustain the money-losing business, they gave up and closed it down within only six months. A new owner, Leo Fry, took over and reopened in 1957 but closed it down again in 1960. That same year, African-American civil rights leaders and some Las Vegas casino managers met at the Moulin Rouge to negotiate a deal permitting blacks to enter, gamble and stay at the area's hotel-casinos. The pact followed a threat by rights leaders to lead a protest march down the Las Vegas Strip.

In the years to come, the Moulin Rouge changed hands but was never much more than a local cocktail lounge with some gambling and low-rent hotel rooms. Sarann Knight-Preddy, regarded as the first African-American woman in Nevada history granted a state casino license, managed the place for many years as Fry continued to own the property.

In 1992, the Moulin Rouge obtained historic landmark status and made the National Register of Historic Places as the first integrated casino in Las Vegas. A fire destroyed the casino building in 2003. Preservationists saved the Moulin Rouge's distinctive cursive front neon sign and some of its pink-tiled pillars before the city of Las Vegas ordered the rest of the structure demolished in 2010.

ABOVE *The Moulin Rouge shortly after a 2003 fire devastated its rear section.*

LEFT *The Moulin Rouge made the June 20, 1955 cover of* Life *magazine for an article on the opening of the first integrated hotel in Las Vegas.*

RIGHT *The Moulin Rouge is shown prior to its 1955 opening. Its cursive front sign was designed by Betty Willis, who would design the "Welcome to Las Vegas" sign in 1959.*

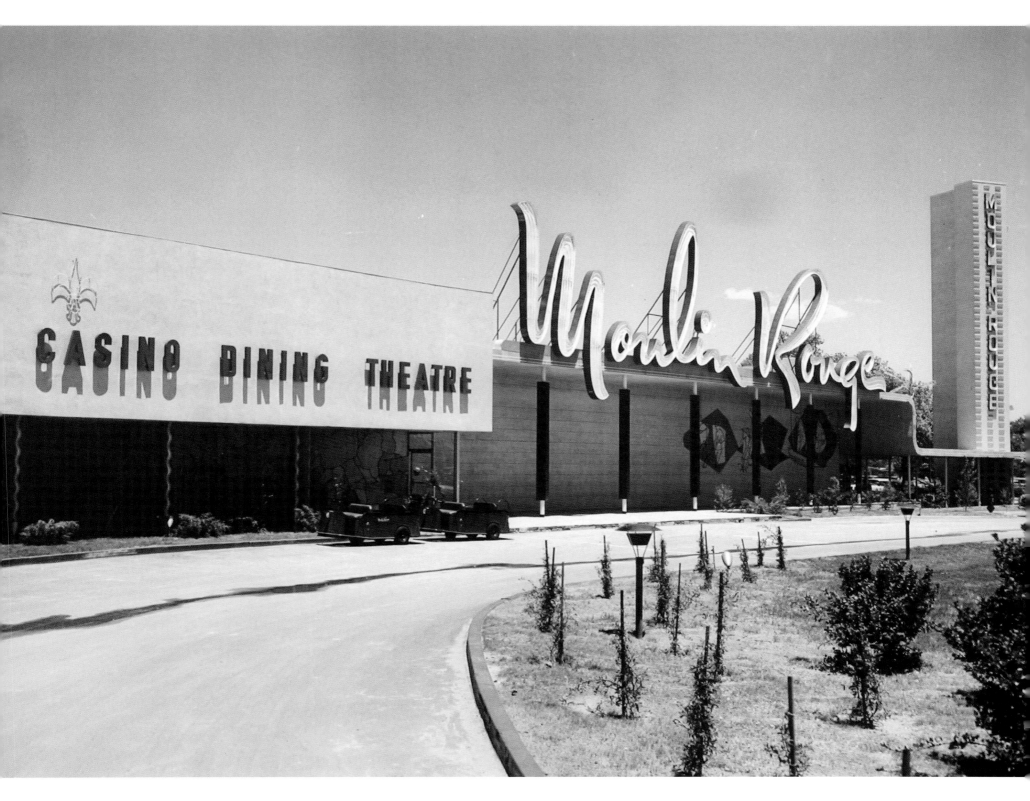

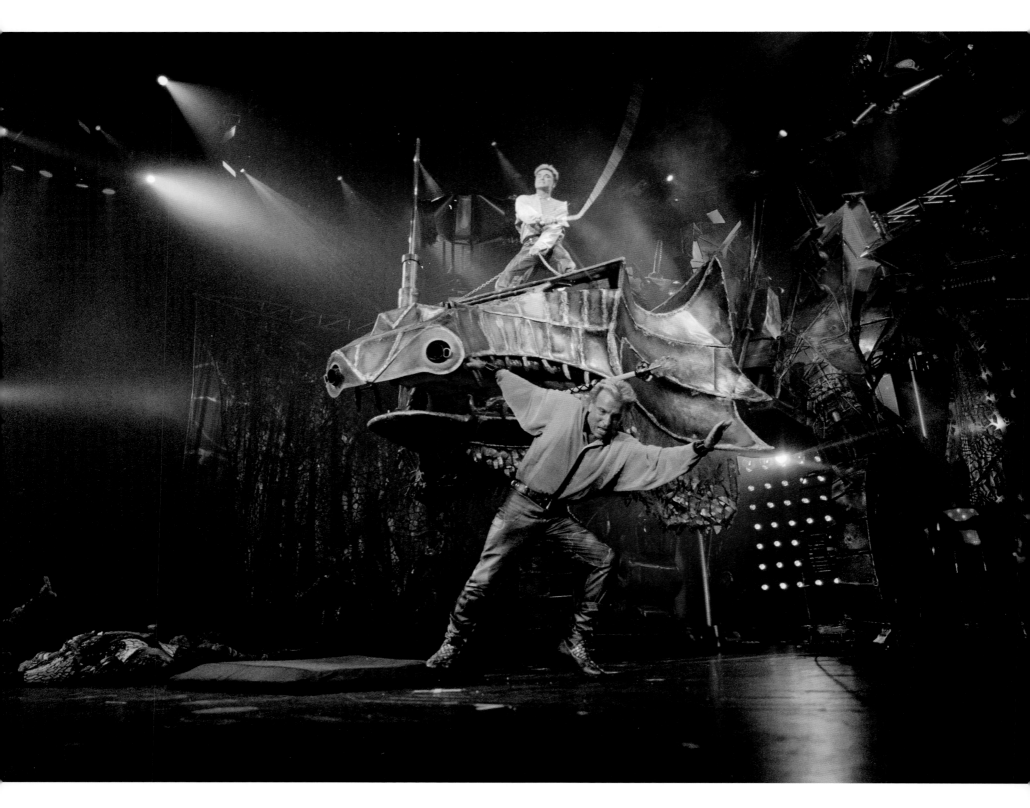

Siegfried & Roy MAGIC ACT ENDED 2003

Siegfried Fischbacher and Uwe Ludwig "Roy" Horn were arguably the best-known entertainers of their time in Las Vegas, certainly among the richest. Their unique show combined magic with a circus act including white Bengal tigers, some the pair raised since birth. The two men were war babies, born in Nazi Germany during the World War II era, Siegfried in 1939 and Horn in 1944. According to Horn, his mother peddled toward her sister's home while nine months pregnant through their town in Nordenham as Allied bombs dropped nearby and gave birth to him within minutes of arriving. After the war, Fischbacher, from the Bavarian town of

LEFT *The illusionist team of Siegfried Fischbacher (below) and Roy Horn (above) during a battle with a giant "dragon" as part of their act at The Mirage Hotel in the 1990s.*

RIGHT *Horn stands beside a white Bengal tiger as Fischbacher looks on during their Mirage show in the 1990s.*

BELOW *An advertisement for the "Beyond Belief" show, which ran at the Frontier Hotel from 1981 to 1988.*

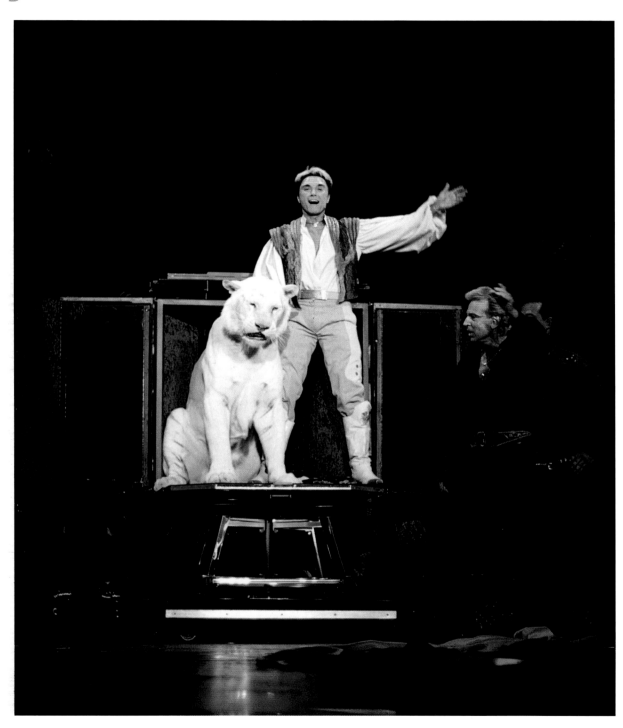

Rosenheim, became a self-taught magician and started performing in 1956 at age 17 in front of audiences while a steward on a cruise ship from Germany to America. Horn, as a boy, developed an affinity for animals while working for his uncle at the Bremen zoo, where he befriended a cheetah named Chico that one day would join the Siegfried & Roy act. In 1957, at age 13, Horn got a steward's job on the same ship where Fischbacher was by then performing a full-fledged magic act with disappearing rabbits and doves. Needing an assistant one day, Fischbacher asked Horn to help him. Horn assisted in the act, then challenged Fischbacher to make a cheetah disappear. Siegfried is said to have replied, "In magic, anything is possible." During a subsequent voyage, Horn knocked on Fischbacher's door and led him to his cabin. Waiting inside was Chico that Horn had smuggled aboard in a laundry bag. They used him at the end of Fischbacher's act that night, and were fired by the ship's captain. But a wealthy married couple in the audience liked the act and hired them to work on an America cruise line to the Caribbean.

Siegfried, the magician, and Roy, the animal expert, then took off as an act. They worked in Monte Carlo and Madrid in the 1960s. In 1967, they were asked by producers of the Paris-based Folies Bergère show to work for the company in Las Vegas for a year and then return to Paris. Their initial performances, for 12 minutes during the Folies Bergère show at the Tropicana hotel in Las Vegas, did not go down well. After a few months, they took an offer from the Lido de Paris show in Paris, stayed for three years and returned to Las Vegas in 1970 to perform their act in the Lido's show at the Stardust hotel. Unlike in the late 1960s, magic acts were being welcomed on the Las Vegas Strip. By 1972, Siegfried & Roy received the Las Vegas Entertainment Award for Best Show Act of the Year. Four years later, the Academy of Magical Arts in Los Angeles gave them the Magicians of the Year Award. They debuted their first marquee sign billing for the Lido show at the Stardust in 1978. Soon, they landed their own show, "Beyond Belief" at a new venue, the Frontier hotel. In 1982, they began the integration of white Bengal tigers into their stage act by importing two tiger cubs from India. One of their white tigers bore a cub for them in Las Vegas in 1986. They were still at the Frontier when casino mogul Steve Wynn dangled a $57 million deal for them to move to his planned $630 million, 3,049-room Mirage hotel-casino. Wynn promised to build a showroom and stage custom-built for

their show. They took the offer. The pair designed a glass-lined habitat, for public display, for their white Bengal tigers at the Mirage, which became a signature attraction after Wynn's new resort opened. On November 2, 1989, minutes before the Mirage's grand opening, with Nevada's Governor Bob Miller watching, Fischbacher and Horn escorted the hotel's first "guests," four white tigers, to the habitat. The pair's Mirage shows were said to be sold out for more than 13 years running. Their stable of white tigers grew to 38, many living outdoors on the grounds of their expansive estate in Las Vegas. In the mid-1990s, they agreed to help a zoo in South Africa raise rare white lions and eventually bred 23 of the lions in captivity. But on October 3, 2003, during a show, one of their white tigers attacked Horn on stage and bit down hard on his head. Horn suffered brain trauma and survived but their act at the Mirage, and their performing careers, came to an end. Despite Horn's injuries, in 2013 the pair traveled to Europe for the exhibition of

a German-produced two-hour documentary, *The Siegfried and Roy Story*. The two presently oversee a foundation that gives grants to people to promote animal conservation and education.

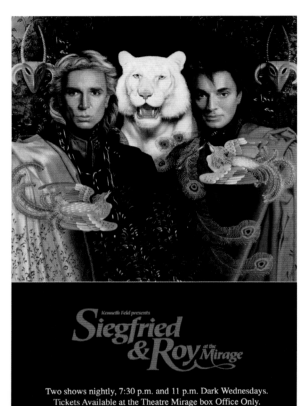

ABOVE *A poster advertising their show at the Mirage, which opened in 1989 and featured a specially built theater.*

LEFT *A bronze sculpture of the heads of Siegfried & Roy and a tiger was installed on the Las Vegas Strip near the Mirage to honor them in 1993.*

RIGHT *Horn and Fischbacher posed with a rare white lion inside their private apartment at the Mirage, prior to Horn's near fatal mauling by a tiger on stage in 2003.*

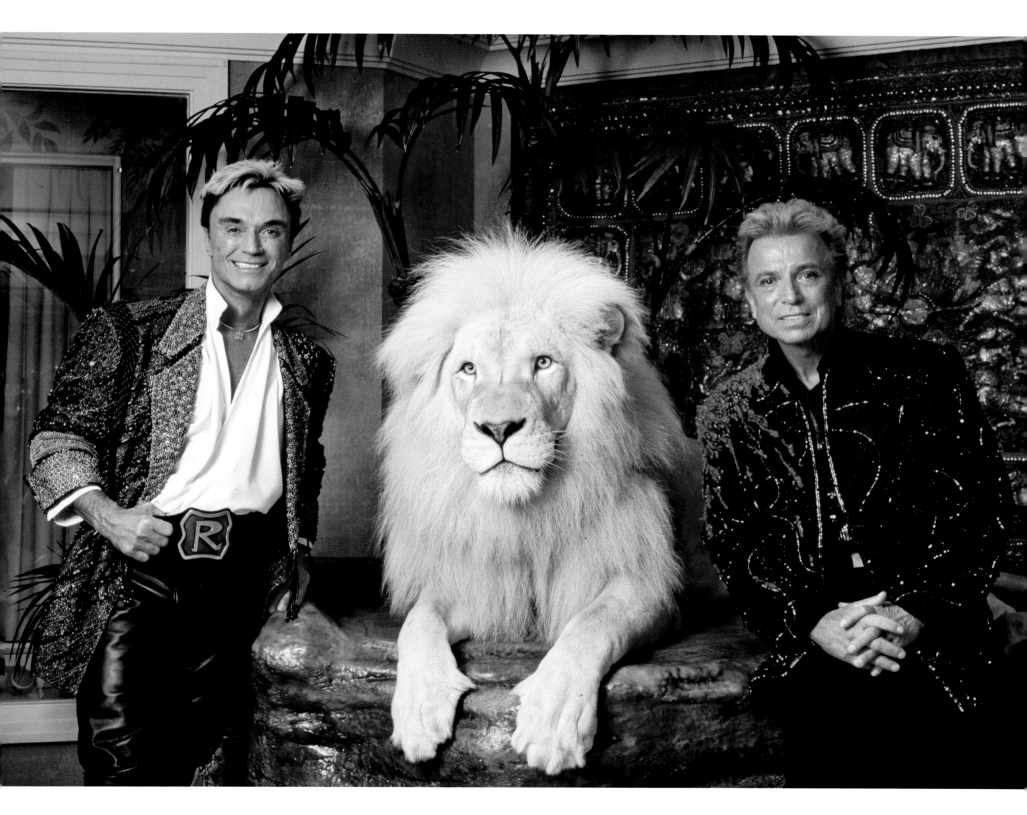

Bourbon Street Hotel and Casino CLOSED 2005

Bourbon Street Hotel and Casino was one of Las Vegas's lesser casino properties, aiming for budget-minded tourists seeking simplicity in accommodations. But the small hotel was well-located, only a long block east of the major intersection of Flamingo Road and the Las Vegas Strip. Its big-name neighbors included the Flamingo and MGM Grand hotels. Still, the Bourbon Street, themed after the boulevard known for jazz clubs in New Orleans, could never get past a series of ownership problems and aborted plans for improving the property to take advantage of its location. The hotel started in 1980 as the Shenandoah, named after a small ranch in Las Vegas, the Casa de Shenandoah, owned by singer Wayne Newton, who had invested in the project. The construction price was a relatively cheap $29 million. But the Shenandoah was troubled from the beginning. State gaming officials learned that the hotel's president had been convicted of securities fraud and made him leave the project. Newton himself left as well and the project fell apart after

losing a fortune. The hotel-casino remained closed for two years. The property's new owner, the Canadian company Carma Developers, obtained a gaming license and opened the place as the Bourbon Street Hotel and Casino in 1985. The hotel had a relatively low 160 rooms and a casino of just 15,000 square feet, about 150 slots and a dozen table games.

The building included red awnings outside mixed with an exterior painted pink and white and a nondescript neon sign. The design lacked distinction and operators tried to compensate with bright lighting. But the hotel was never a good idea—too few hotel rooms and too small a casino to make a decent return. Three years later, Carma sold out, and the hotel changed hands again later that year. Owned by the large lodging investment firm Starwood Hotels, the Bourbon Street continued to operate as a mediocre property while its owner tried to rid itself of the burden. Starwood reached a deal to sell it in 1996 for just under $9 million to an owner from India, who closed the casino with stated plans

to develop a timeshare project there. Those plans fell through, and the owner in turn sold it for $11 million in 2001. The Bourbon Street's casino reopened, but the place was regarded more as a piece of real estate to be sold at a quick profit than a viable hotel-casino. By 2005, property values in Las Vegas ballooned. The hotel's latest owners, Trevor Pearlman and Reagan Silber of the investor group Edge Resorts, eyed replacing Bourbon Street with a Starwood's "W" luxury hotel project. But Edge liked a different location a few blocks away, and sold the Bourbon Street in July, 2005 at a large profit to casino giant Harrah's Entertainment. The price was $60 million. The hotel-casino was far more valuable as land for future development. Harrah's, with plans for a new mega-resort, closed the Bourbon Street on October 18, 2005, and imploded the building four months later.

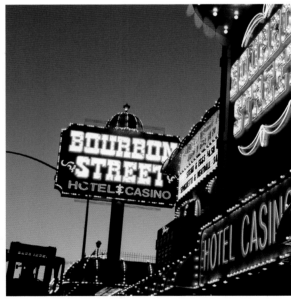

ABOVE *A view looking up from the entrance of the Bourbon Street Hotel and Casino on Flamingo Road.*

LEFT *Another night view of Bourbon Street showing heavy traffic lining Sahara Avenue.*

RIGHT *The hotel tower is shown collapsing behind the casino when the structures were imploded in 2006.*

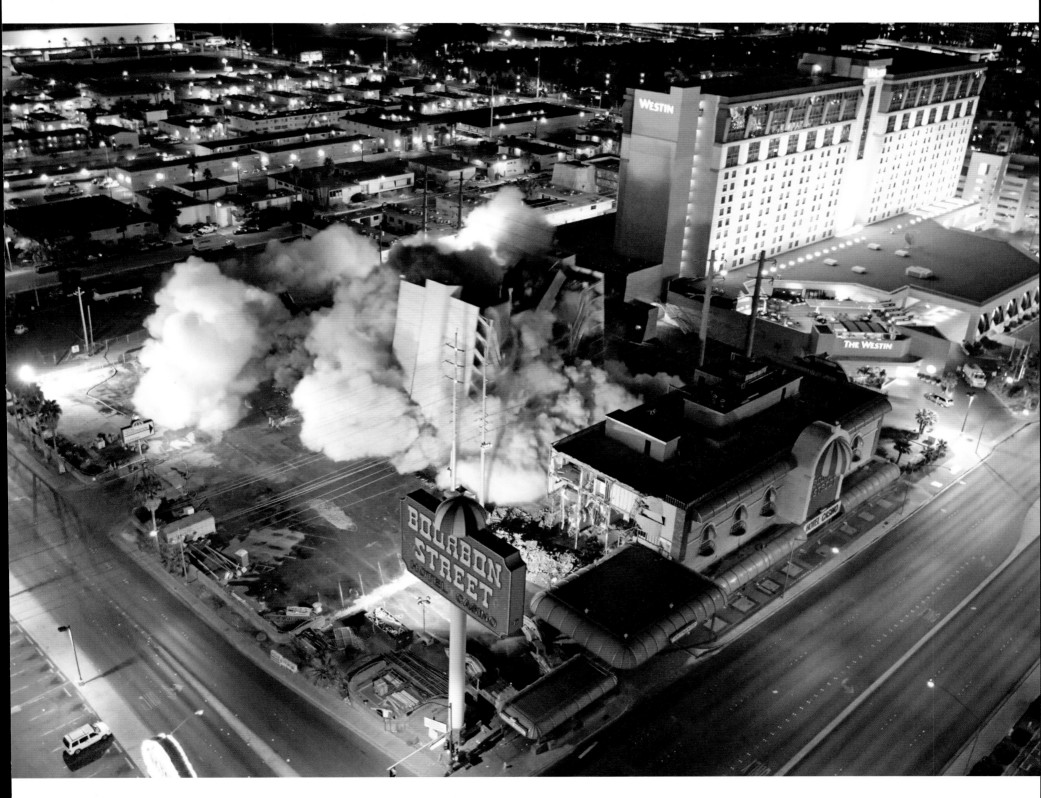

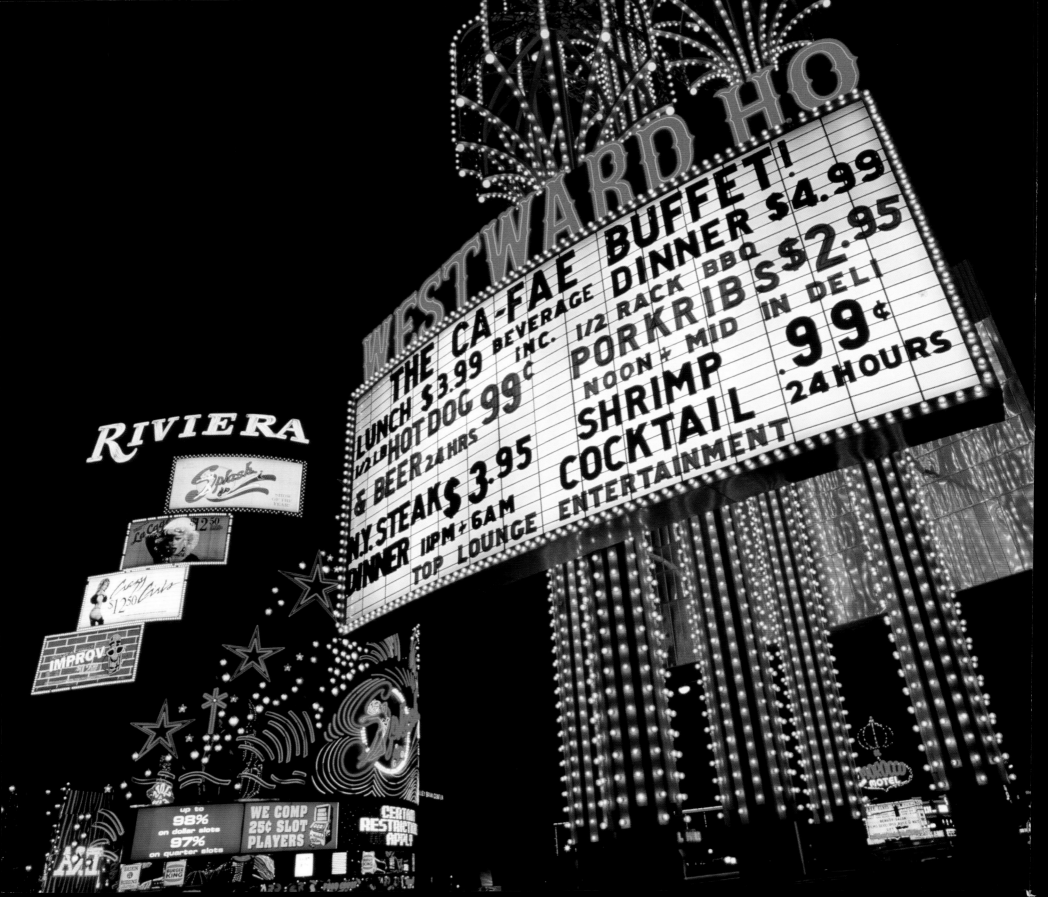

Westward Ho **CLOSED 2005**

Dean Peterson, his sister Faye and brother Murray grew up in the small town of Hyrum in northeastern Utah, a state that did not permit any gambling, period. Dean and Faye moved to Las Vegas in 1954, the capital of legalized gambling. Murray and other family members would follow. The three Peterson siblings, led by Dean, invested in real estate in the growing town, made savvy decisions and a fortune as a result. With their company Roundup Realty they would build many Las Vegas housing projects, including the tallest high-rise apartment building in town in the early 1960s. One of their projects, Central Park Apartments east of the Strip, with a circular pool, became a favored dwelling spot for casino executives. In 1963, they opened the Westward Ho, its name a reference to 19th-century wagon trains headed west. The hotel and casino was located on the northern section of the Las Vegas Strip near the Stardust hotel.

Dean, Faye and Murray ran the Westward Ho as a low-key, friendly place to visit and gamble. The hotel's approximately 700 inexpensive guest rooms were in drive-up, motel-style low-rise buildings beside swimming pools, behind the Westward Ho casino fronting the Strip. Hans Dorweiller managed the property for them for decades. Dean Peterson oversaw the casino and hotel operations. Unlike some of his contemporaries in resort executive offices in Las Vegas, Dean shunned the limelight, granting few interviews with journalists, while contributing to many local charities. In 1983, the

Petersons installed 80-foot-high, bright gold-colored "umbrella" lights attached to the hotel's front sign and other shorter umbrellas with green and orange awnings at the casino's facade. Other casinos took note and would copy their faux umbrellas. Inside, water spilled from a fountain onto champagne glasses stacked in a pyramid. The Petersons quietly enjoyed large profits from the casino. At its height in the 1990s, the Westward Ho had a 56,000-square-foot casino, 744 rooms and three swimming pools.

Dean died in November 1997 at the age of 63. By then, his casino had 1,000 slot machines, a dozen table games and offered a floorshow, "Hurray America," in the upstairs showroom. Faye took over and almost immediately put the resort up for sale. In 1998, she found a buyer, Frank Zarro, a real estate investor from Florida.

Under new management, with remodeled hotel rooms, Westward Ho resumed making profits with its simplicity, cheap food and affordable, cut-rate guest rooms, and loyal repeat customers. Its second-floor showroom offered a Rat Pack impersonation act, called "Tribute to Frank, Sammy, Joey & Dean," and a "Ho-Waiian Luau" and dinner show—for $16.95—on Saturdays. The "Grubsteak Jamboree" barbecue steak dinner show featured imitators of country singers Dolly Parton, Patsy Cline, Reba McIntire and Willie Nelson. Elvis Presley impersonator Michael Kennedy worked the casino lounge in free shows at 2 p.m. and 5 p.m. three days a week. But time ran out in the mid-2000s. The Westward Ho's old customer base was older and getting smaller while younger Las Vegas customers looked for hipper attractions. It finally closed in 2005 and the building was imploded in 2006.

OPPOSITE AND RIGHT *The marquee for the Westward Ho, topped by its unique lighted "umbrellas," in the 1980s.*

LEFT *A fold-out brochure showed the five lodging businesses owned in the 1970s by the Peterson family, who ran the Westward Ho from 1963 to 1998.*

Boardwalk Hotel and Casino IMPLODED 2006

Norbert "Norm" Jensen owned and operated the Pioneer Club, with its famous Vegas Vic cowboy sign, in downtown Las Vegas in the 1960s. Jensen was a former sports book odds man at the old Boulder Club whose knack for business deals would make him a local success story. One of his deals, as the developer of the Riverboat casino, got him a foothold on the Las Vegas Strip. He helped his wife, Avis, open a gift shop at the Riverboat (which later became Harrah's) and she started her own gifts and sundries company. Jensen, constantly involved in various hotel mortgage and real estate transactions, won a lease for another gift shop at the Holiday Inn hotel a couple blocks south on the Strip from the Riverboat. The Jensens' new shop at the Holiday Inn, managed by Avis and her company, did fine and they added some slot machines for greater cash flow.

Together, they would become one of the few couples ever to acquire a Las Vegas Strip casino. By 1977, Norm had enough resources to buy the entire Holiday Inn hotel, with Avis still in charge of the gift shop. He started a public company, Boardwalk Casino, Inc., in 1994, sold shares and raised $80 million to convert the ordinary facade of the Holiday Inn to the Boardwalk—a hotel-casino with an amusement park theme. Jensen bedecked the exterior with a huge clown face, a faux Ferris wheel and roller coaster, and added a 17-story, 450-room hotel tower and 33,000-square-foot casino. Under the Jensens' management, the Boardwalk offered customers traditional, Las Vegas-style discounted perks, such as a $1.29 breakfast, 99-cent boxes of a dozen donuts and an inexpensive 24-hour buffet with 600 seats. As the age of the luxury mega-resort hotels took hold on the Strip in the 1990s, the Boardwalk remained a comfortable, uncomplicated, low-cost spot for visitors.

Norm and Avis bought a home near the ocean in San Diego, California, where Norm loved to bet the horses at the Del Mar racetrack, and they split their time jetting between there and Las Vegas. Meanwhile, the Boardwalk, a profitable business, would become an increasingly valuable, 5-acre piece of property on the Strip. Norm died in 1997, the same year Mirage hotel owner Steve Wynn bought the Boardwalk. Wynn kept the place running for three years before his company was sold and merged into a new corporation, MGM Mirage. The new owner maintained and operated the Boardwalk with far bigger plans ahead. On January 9, 2006, MGM Mirage finally closed the Boardwalk and imploded the building to use the land for part of a $5 billion project, a series of high-rise hotel and condominium buildings known as the CityCenter. Avis Jensen, who continued to run the Boardwalk gift shop after Norm's death and up until the hotel closed, put the Boardwalk's furnishings up for sale at a public auction, retaining a large wooden boardroom table he used for years to talk business.

RIGHT *The Boardwalk Hotel during its mid-1990s redecoration with an amusement park theme.*

BELOW LEFT *The enormous face of a circus clown, above the front doors leading to the Boardwalk Hotel's casino, was added in the mid-1990s by owner Norm Jensen.*

BELOW *The Boardwalk's amusement park exterior included a simulated roller coaster and Ferris wheel.*

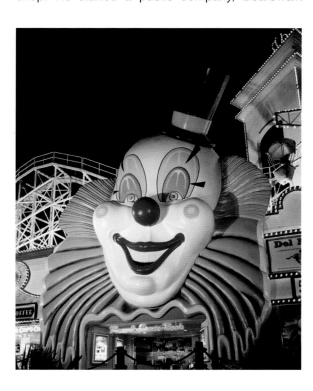

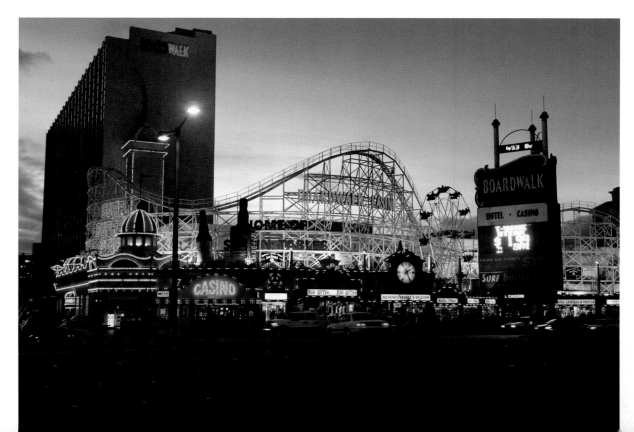

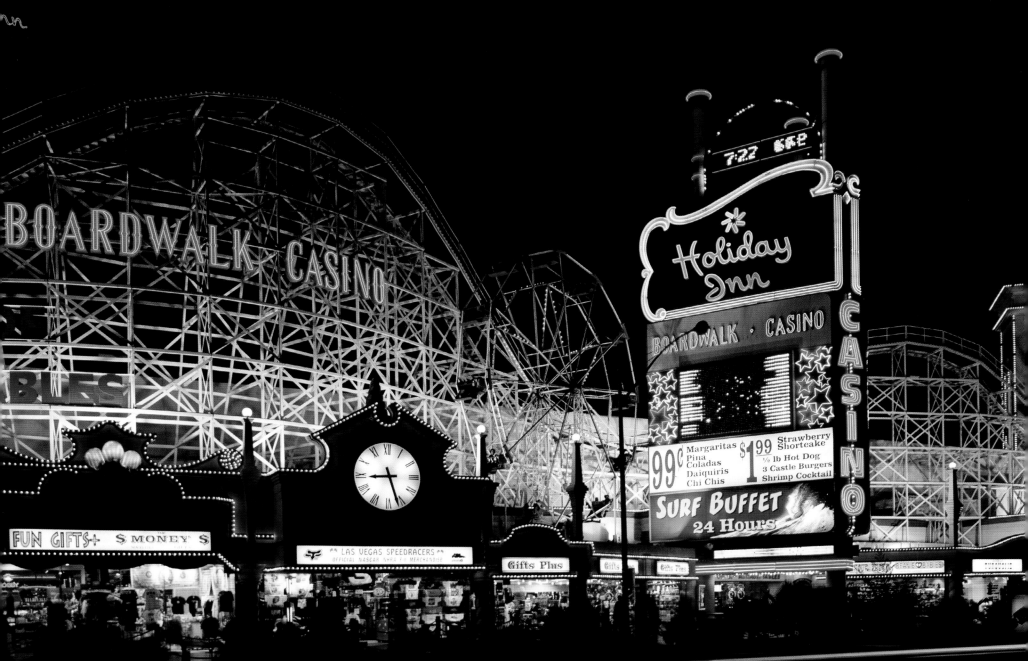

Elvis-A-Rama CLOSED 2006

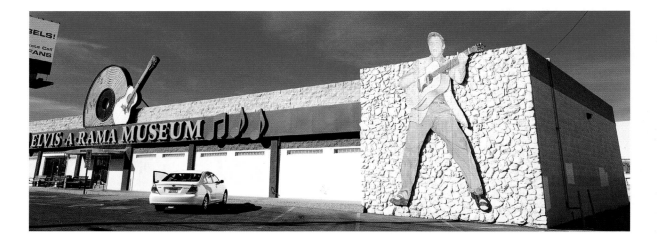

If there is one city other than Memphis, Tennessee, associated with Elvis Presley, then it is Las Vegas. On July 26, 1969, Elvis arrived in a carefully staged motorcade of 20 limousines. His career had been resurrected by the famous 1968 TV special.

The King had been to Las Vegas before in 1956 but the experience had not been a good one. The band had struggled to be heard by diners who didn't want his new rock 'n' roll music. He'd been back briefly in 1963 to star with Ann Margret in *Viva Las Vegas*, but this visit would prove to be a turning point, both for the image of Las Vegas and unknowingly, his career. His appearance at the showroom of the newly built International Hotel brought 10 standing ovations and a long-term contract for two shows a night. The hotel, which was the biggest in the world at the time, started to rake in record box office receipts. Other hotel-casinos up and down the Strip took note. As the world was to learn, his residency would come to an abrupt end in 1977.

Like Elvis, the Elvis-A-Rama Museum had a shorter residency in Las Vegas than managers expected, opening on November 5, 1999 and closing on October 1, 2006. It contained $6 million of Elvis memorabilia collected by *Hot Boat* magazine publisher Chris Davidson. Exhibits included Elvis's 1955 black Cadillac limo, a customized million-dollar Mercedes-Benz, many of his Las Vegas jumpsuits, and a 100-seat showroom to experience an *Elvis in PanoramaVision* film. Elvis impersonators performed tributes from the Presley repertoire three times daily at the stark, industrial-looking building.

The story behind Elvis-A-Rama goes back further than 1999, though. The name was originally given to an 85-foot-long mural painted by country music singer Mitchell Torok and was sited in a small corner of Nashville's Music Row. The mural was a pictorial history of Elvis's 20-year career and fans could sign their names at the side for $3. The aim was to get a million signatures on the mural. It was bought in 1994 by musician and Elvis collector Jimmy Velvet who moved it to Branson Missouri and then sold it on to Chris Davidson.

Once installed in Vegas, fans who had seen the mural in Nashville, noticed that the artwork had lost its "eternal flame" (a gas jet on a wooden stand) somewhere en route to the museum two blocks off the Strip. Now it was installed behind a rope and fans were discouraged from adding their names to the side of what had become a million-strong collection of Elvis fans' autographs, including those of guitarist Chet Atkins and author Maria Shriver. However, Elvis fans could still get close to his original blue suede shoes or his turquoise karate outfit with the eagle rhinestone appliqués or the electric guitar he used for his 1968 comeback special.

Although Elvis-A-Rama had a less-than-prestigious location at 3401 Industrial Road and needed to organize its own shuttle bus to take visitors out from downtown Vegas, it wasn't ultimately visitor numbers that caused it to close in 2006. Elvis Presley Enterprises acquired the assets and trademarks of Elvis-A-Rama and closed it down with the intention of creating a world-class, Elvis-themed hotel-casino closer to the heart of downtown Vegas. The plans are yet to come to fruition.

ABOVE *The exterior of the museum featured a large cut-out picture of a young Elvis Presley performing in the 1950s.*

RIGHT Viva Las Vegas, *released in 1964, was filmed on location in "the fun capital of the world."*

OPPOSITE *A display case of memorabilia in the museum contained some of Elvis's clothing and sheet music, as well as his famous blue suede shoes, which sold at auction in 2013 for $80,000.*

Klondike Hotel CLOSED 2006

In 1976, John Woodrun, a former partner with well-regarded Las Vegas casino operator Bill Boyd, bought the 14-year-old Kona Kai motel from local developer Ralph Engelstad for $1.2 million. The Hawaiian tiki-style motel had a coffee shop, lounge, heated pool and lots of parking on six acres. Its only distinction, aside from being the hotel on the farthest south end of the Las Vegas Strip, was that it was next to the famous "Welcome to Fabulous Las Vegas" neon sign that stood on a median on the Strip. Woodrun renamed the motel the Klondike and reopened on May 12, 1976, with 153 modest rooms and a two-story casino building, painted all in red. Woodrun themed his casino on the Klondike Gold Rush in western Canada of the 1890s. Over the front entrance the owner put up a circular picture of a bearded miner leaping in the air after striking gold. The Klondike was basically a motel with a rather small casino, a simple, uncomplicated place where patrons could literally drive up and park beside the entrance as was once common on the Strip in the 1940s and 1950s. Woodrun held onto the old Kona Kai's tiki facade and two-story A-frame motel buildings.

After the Klondike opened, Woodrun considered the "Fabulous Las Vegas" sign, designed by Betty Willis in 1959, as a kind of beacon for his place. The sign's owner, the Clark County government, had turned off its flashing neon a few years earlier to avoid paying for the electricity. Woodrun decided on his own to hook an electrical cord from his property to power on the sign. That did not sit well with county officials, until Woodrun offered to cover the utility bill himself (the county later took over paying for it).

Woodrun prized the Klondike as a family run, low-key, non-corporate business. Tucked away on the far south Strip, the Klondike was inexpensive and free of the crowds at the big hotels. In the 1980s and 1990s, Woodrun's casino games had old-fashioned low bet limits, such as $2 minimum wagers for blackjack and even 10-cent bets for craps, once associated with the casinos in downtown Las Vegas. His coffee shop served breakfasts (two pancakes and one egg) for 99 cents, which had all but disappeared in Las Vegas. He refurbished the place in 2003, taking down the A-frames. By the mid-2000s, his motel-casino's six acres caught the attention of Florida condominium developer Royal Palm Communities. The offer the firm made, $42 million for his property, was too good to turn down at a time when the price for Las Vegas Strip real estate was at its peak. Woodrun's coffee shop offered the 99-cent breakfasts all the way up to the casino's closing on June 30, 2006. The Klondike was demolished in 2008, but the new owner's plans for a billion-dollar casino and condo project fell through.

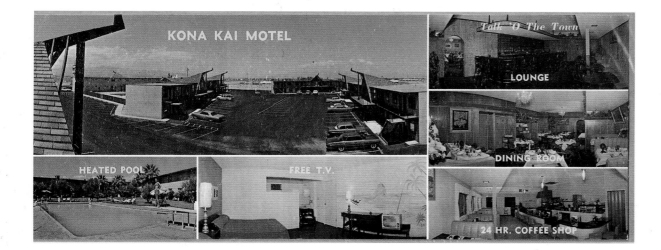

ABOVE *Photos of the Klondike with the old Kona Kai motel's A-frame facade (top) in the 1980s and the later renovated front with "Klondike" spread across it.*

LEFT *A postcard shot of the old Kona Kai, a tiki-style motel that started on the south Las Vegas Strip in 1962, 14 years before John Woodrun bought it to create the Klondike Hotel.*

RIGHT *The driver of a 1950s convertible eases by the front lot of the Klondike at twilight, with the Mandalay Bay Hotel, opened in 1999, in the distance to the left.*

Lady Luck CLOSED 2006

Andrew Tompkins, a native of New York City, arrived in Las Vegas in 1955. After working as general manager at the Nevada Club on Fremont Street, he saved up and in 1963, bought a newsstand called Honest John's. Its tobacco products and six slot machines were at Third and Ogden streets, a block north of Fremont Street. In 1968, he changed the name of the business to Lady Luck and four years later was finally able to afford to tear down the newsstand and build a large gambling club. A decade later, at age 40, he bought a former electrical utility building, ripped it down and put up a 112-room hotel tower to go with the Lady Luck's casino. His success in targeting low-rolling, working-class visitors and gamblers, drove Tompkins to construct a 17-story tower, of 300 rooms, in 1986, and a 25-story second tower with 334 rooms. A windowed bridge above Third Street linked the towers. While others had often failed in the same area of downtown, a block northeast of Fremont Street, Tompkins' Lady Luck was one of the busiest casinos there. Its design was decidedly ordinary, with beige-colored towers and white awnings over an arched entrance with the ceiling lined in reflected gold metal that glowed with neon and incandescent lighting.

A devotee of the arts, Tompkins traveled annually to Austria to attend Mozart festivals and was a generous donor and supporter, with his wife Susan, of the Las Vegas Philharmonic orchestra. The Lady Luck garnered national news attention in 1991, when a teenager from Iowa, under the legal age of 21 to gamble in Nevada, won a $509,000 jackpot in a slot machine with a 50-cent wager. The boy had to give up the jackpot, but when the boy turned 21, Tompkins arranged an all-expenses-paid stay for him and several family members at the Lady Luck to give it another try.

In 1999, as riverboat casinos grew in the Midwestern United States, the riverboat gambling company Isle of Capri convinced Tompkins to sell

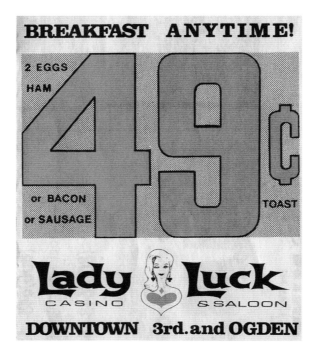

them the Lady Luck. The firm took over in 2000, just before a national recession hit. But the Lady Luck, without Tompkins at the helm, was never the same, and became more of a real estate proposition than a profitable hotel-casino. Isle of Capri sold out in 2002 to Steadfast AMX, a real estate firm from Newport Beach, California, that converted 16 of the hotel's rooms into timeshares. But Steadfast gave up on it and sold the 758-room hotel to the Henry Brent Company for $25 million in 2005. Henry Brent, run by Anthony Donner who owned Timbers cocktail lounges in Las Vegas, announced a major renovation project, with 1,000 new hotel rooms, and closed the Lady Luck in 2006, but the company could not raise enough money. Still closed, the hotel-casino nonetheless drew a large selling price, $100 million, when the CIM Group bought it in 2007. After languishing for years, CIM renamed it the Downtown Grand in 2011 and started to take down the old Lady Luck's main buildings in 2012.

TOP RIGHT *An early 1970s advertisement for the Lady Luck's all-day 49-cent breakfast.*

RIGHT *Cars parked in front of the Lady Luck's entrance, before the property was expanded in the early 1980s.*

OPPOSITE *The Lady Luck's 25-story (left) and 17-story (right) hotel towers loomed over Third and Ogden streets after the business closed without reopening in 2006.*

The Aladdin Hotel CLOSED 2007

Milton Prell, the one-time owner of the Sahara Hotel, bought the shuttered King's Crown hotel property, formerly the Tally Ho, in early 1966. Prell imagined a casino based on the fanciful Arabic legend of Aladdin's lamp and a magical genie granting wishes to lucky strangers. He opened the Aladdin Hotel only three months later, keeping many of the wooden Tudor-style buildings left over from the King's Crown in the rear and spent about $3 million on a casino and other renovations.

The new hotel's most outstanding feature was a faux genie's lamp that Prell had ordered and installed atop the casino's front sign. The unique lamp, covered in golden, glittering lights, shone like a beacon and became an instant classic on the Las Vegas Strip. For a time, Prell's Aladdin boasted of having the largest casino in Nevada, while its 500-seat showroom, the Bagdad Theater, allowed patrons to sit and drink without paying admission fees. He also reopened the nine-hole golf course from the King's Crown behind his resort.

Still, the Aladdin was decidedly middle-brow, at least compared to its better-known neighbors like the Tropicana and Sands. But the place shot to fame with the other Strip carpet joints when megastar Elvis Presley and his fiancée Priscilla Beaulieu chose to get married there on May 1, 1967.

Prell could not enjoy his success for long. He suffered a stroke that year and soon it became clear he could not continue managing his creation. He put the Aladdin up for sale, the first of many future sales transactions that would befall the Aladdin. The Parvin-Dohrmann Company, operator of the Fremont Hotel in downtown Las Vegas, bought it in 1968. Parvin-Dohrmann in turn sold the Aladdin in 1971 to St. Louis investors Peter and Sorkis Webbe and Sam Diamond at a price of $5 million. The new investors would spend a then-fortune of $60 million in improvements, including a 20-story hotel tower and the 8,000-seat Aladdin Performing Arts Center—built over the former nine-hole golf course. The arts center would become the top venue in Southern Nevada for all kinds of traveling shows, from Broadway musicals to ballets, for more than a quarter of a century.

But in the late 1970s, Nevada gaming officials learned that organized crime figures from Detroit had hidden interests in the Aladdin, and forced the St. Louis group out. They sold the Aladdin to famous Las Vegas singer Wayne Newton and casino operator Ed Torres for $85 million in 1980, but neither they nor subsequent owners could turn a profit. Japanese businessman Ginji Yasuda, who bought the Aladdin in 1986 for $50 million, closed it for renovations, reopened in 1987 and went bankrupt in 1988. The Aladdin was operated by a court's bankruptcy trustee until 1994, when a family trust headed by businessman Jack Sommer took over. It was the age of the mega-resorts in Las Vegas, and Sommer would invest $1.2 billion into the Aladdin, holding onto its name and Arabian theme. He tore down the Aladdin's buildings, except for the arts center, in 1998, installed more than 2,500 rooms in two hotel towers and built a massive indoor shopping mall, the Desert Passage. Sommer opened the New Aladdin in 2000 after London Clubs International agreed to become a partner. But Sommer could not make it work either, and he filed for bankruptcy. In 2003, a judge accepted a buy-out bid of $637 million from a group headed by British investor Robert Earl, who ran the Planet Hollywood restaurant company, and the hotel firm Starwood Resorts. Earl renamed the resort Planet Hollywood Resort and Casino, with a theme based on Hollywood movies, which finally opened in 2007.

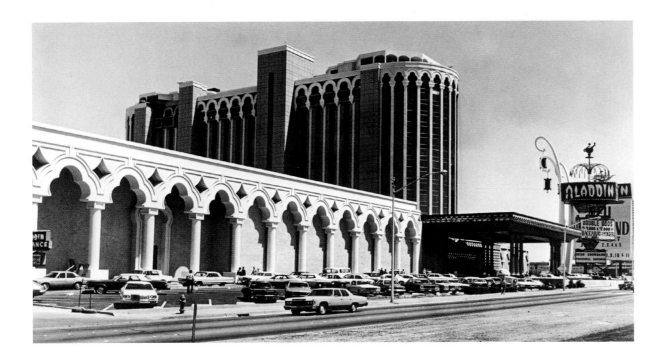

ABOVE *The Aladdin soon after it opened in 1966.*

LEFT *In the early 1970s, the Aladdin's new owners added a 20-story hotel tower (background center) and a performing arts center in the rear.*

OPPOSITE *Renovated and extended in 2000, the new Aladdin featured a faux mountainside facade.*

Last Frontier / New Frontier CLOSED 2007

In mid-1941, R.E. Griffith and his nephew William J. Moore, were driving on Highway 91 outside Las Vegas on the way back to Dallas, Texas. Griffith's family owned a chain of movie theaters in Dallas and he and Moore both had just been in California to order materials to build a theater in the small town of Deming, New Mexico. But the men got to rethink their plan when they stopped by the El Rancho Vegas, which had only opened that April. They reasoned that Southern California, with its growing defense industry supplying America's friends in Europe, would have more people and more money to spend, and so would Southern Nevada. During their overnight stay in Las Vegas, Griffith and Moore canceled their plans for New Mexico and started designing what would soon be their resort on the highway, the Last Frontier. They used their building know-how to act quickly. The well-heeled Griffith laid out the cash to buy Guy McAfee's two-year-old 91 Club nightclub and the

owner's 35 acres on the highway. The site gave them an advantage over the El Rancho—it was a mile farther south on the highway, and motorists driving toward Las Vegas from Los Angeles would encounter their resort first. Moore served as the hotel's architect. By October 1942, Griffith and Moore were in business in what would be the second resort on the Las Vegas Strip, about four miles south of downtown Las Vegas. The theme they selected for the resort was the American Old West.

The pair, who knew American movies, enlisted film actor Leo Carillo, of the popular "Cisco Kid" B-movie series, to be associated with a lounge in the Last Frontier called the Carillo Bar. Griffith and Moore tried to outdo the El Rancho with an elaborate front lobby decorated with large stuffed animals. They decorated the hotel with real horse saddles, guns and other Western relics. They hung up old wagon wheels to serve as ceiling lighting.

They bought the 40-foot-long mahogany Old Western saloon bar from the closed Arizona Club downtown and put it into service. Each guest room had cow horns inside. They installed a large pool and deck in front of the resort to entice drivers on the highway. They even brought in craftsmen from New Mexico's Native American Ute tribe to build sandstone fireplaces and patios. Their banquet hall, the Ramona Room, and their showroom both had seating for 600 people. The resort had perhaps the largest parking lot around, with spaces for 400 autos. After the opening, they offered guests rides in an authentic Western stage coach and on horseback. The Last Frontier was a hit right away and with the equally successful El Rancho nearby, showed that the future of Las Vegas lay on the highway, outside the city limits of Las Vegas, instead of downtown on Fremont Street.

As the resort grew, the pair expanded by building a faux Old West town, designed by Moore,

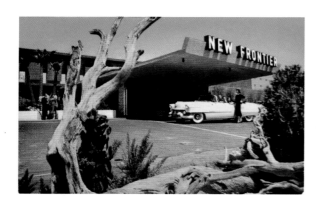

ABOVE *A 1955 promotional shot for the New Frontier.*

RIGHT *A burlesque dancer and group of comedians pose in the early 1950s on the small flood-lit stage of the Frontier's Silver Slipper, among the first showrooms in Las Vegas to host regular shows featuring striptease artists and a touch of vaudevillian humor.*

OPPOSITE *The 15-acre Last Frontier, built in 1942, viewed from the air, looks isolated on Highway 91 (later the Las Vegas Strip) in 1943.*

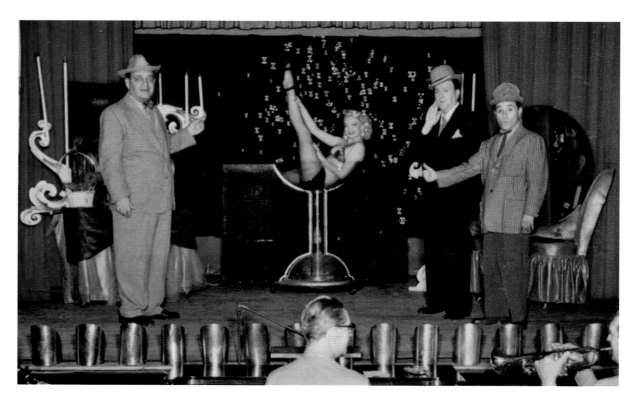

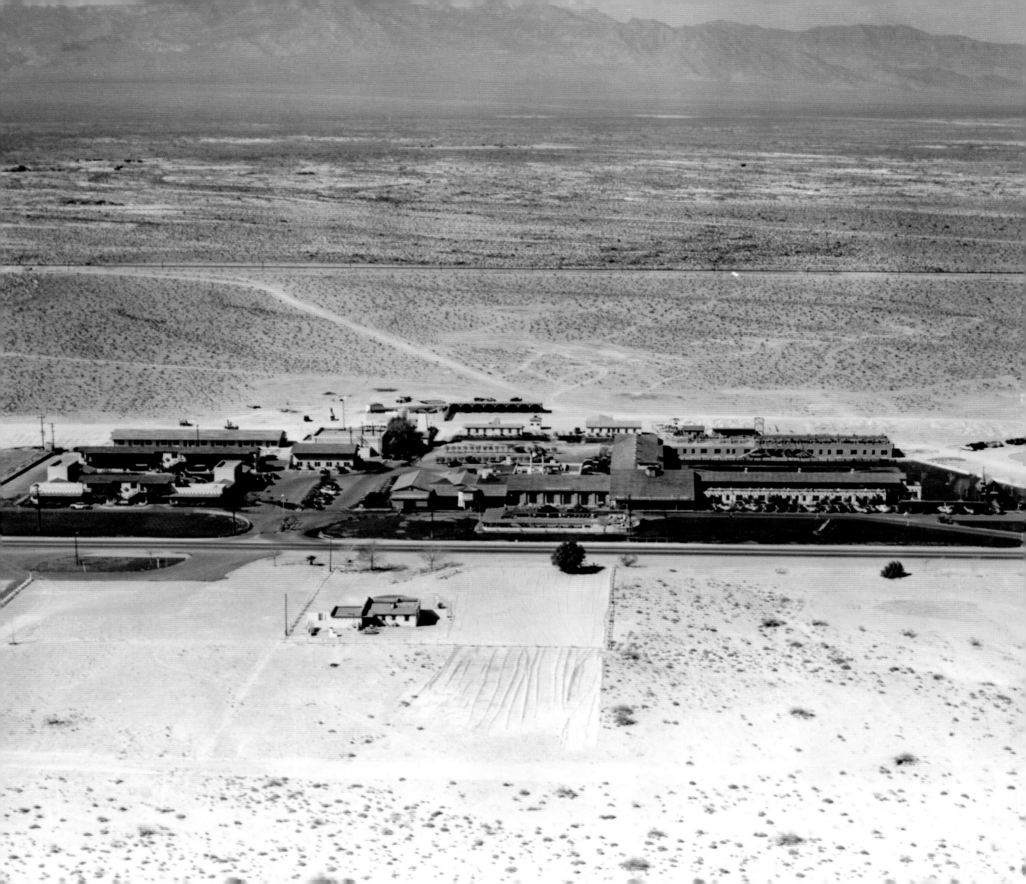

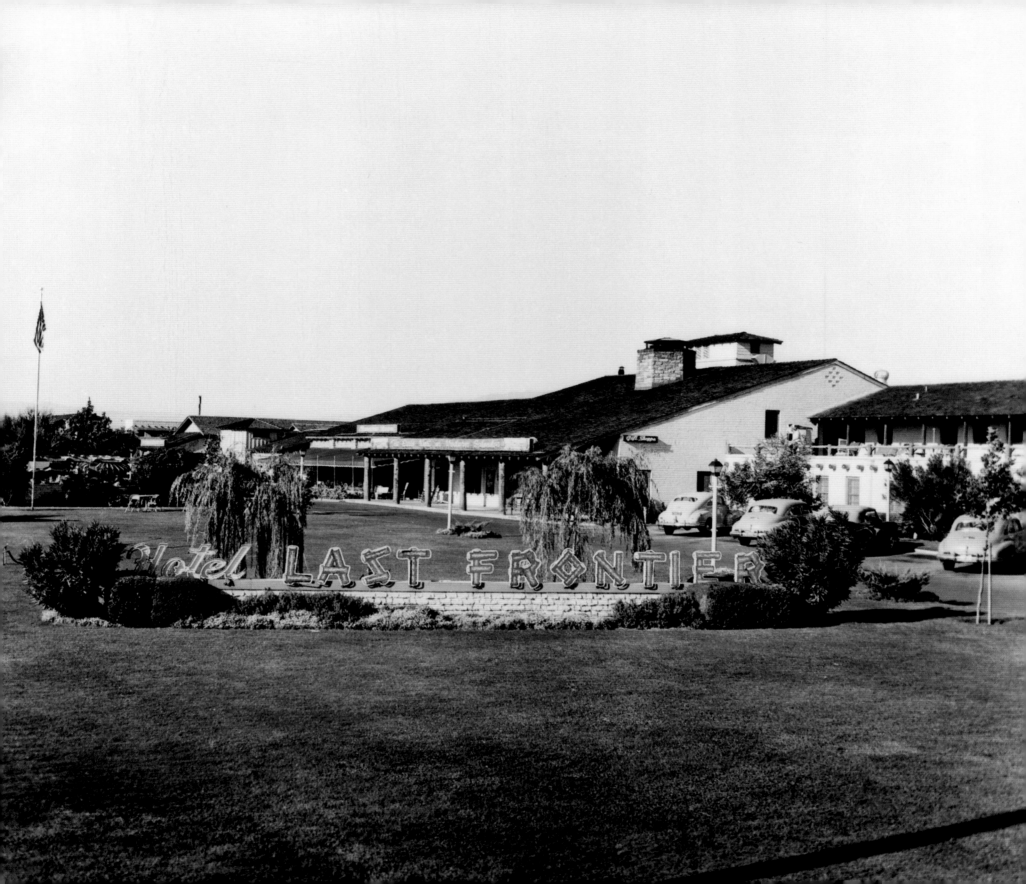

known as the Last Frontier Village, with an arching sign over the front entrance next to the resort. They imported some 900 tons of Western antiques, from a collection owned by Robert "Doby Doc" Caudill in northern Nevada, to embellish the town for resort guests and other patrons. The owners put in a real mining train, a 19th-century Chinese house of worship and an Old West jail, all of which made the Last Frontier Village a popular attraction for tourists and local residents. Also, taking advantage of Nevada's liberal marriage laws, the owners built a wedding chapel, the Little Church of the West that would be the site of hundreds of marriages, including those of many celebrities, for decades.

After 10 years in business, Last Frontier owner Moore was ready to sell. The new owners were Jake Kozloff and Beldon Katleman, who invested in some improvements and renamed the resort the Hotel New Frontier in 1955. Kozloff and Katleman in turn sold out to a new group of investors and the resort changed hands again. In the mid-1960s, an insurance company bought the property, closed it down, razed Griffith and Moore's resort buildings and embarked on building a hotel with 500 rooms. In 1967, the Last Frontier became another Strip

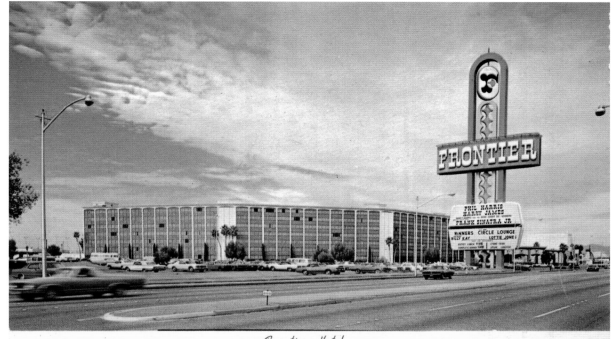

Frontier Hotel

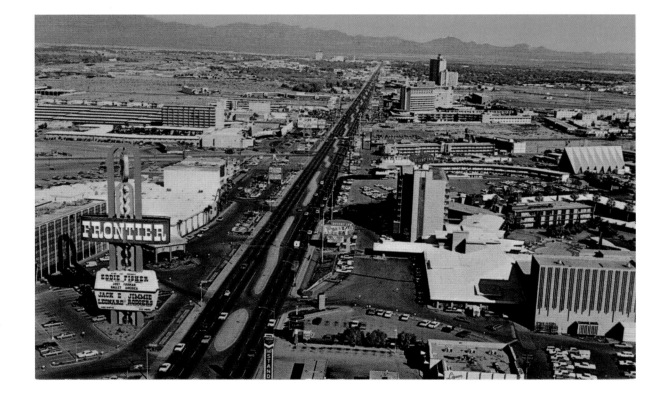

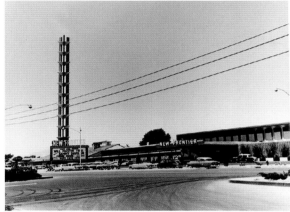

TOP *The front of the simply named Frontier in the 1970s, featuring a turning "F" on top of its marquee sign.*

ABOVE *The New Frontier was renovated by partners Jake Kozloff and Beldon Katleman and another group of investors in 1955.*

LEFT *The Frontier viewed from the air in about 1980. The billionaire Howard Hughes shortened the hotel's name to "Frontier" when he bought it in 1967.*

OPPOSITE *The Last Frontier in its 1940s heyday.*

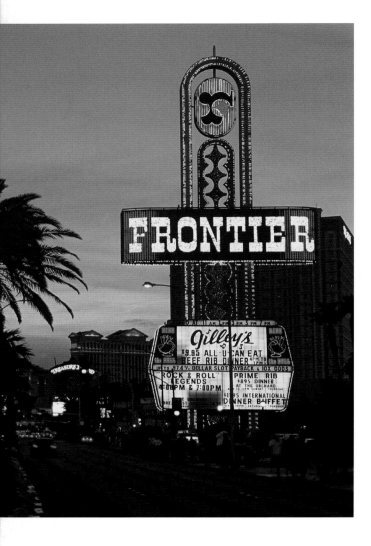

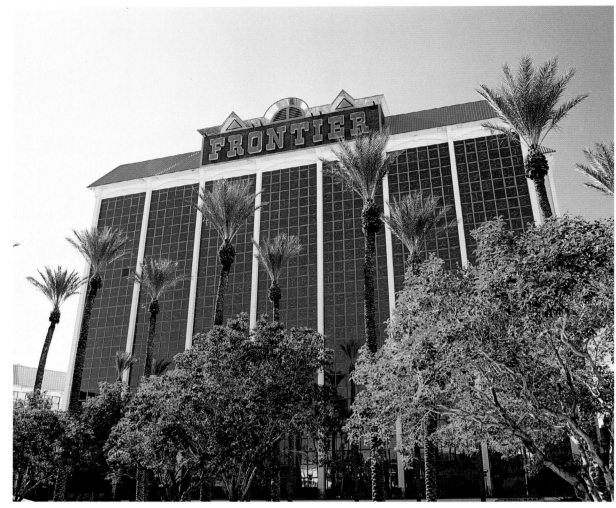

hotel acquisition for the billionaire former airline company owner Howard Hughes. He also bought the Silver Slipper, a burlesque nightclub next to it. Hughes changed the name of the 500-room resort simply to the Frontier and added another 500 rooms. A decade later, the Frontier's showroom was used by magicians Siegfried & Roy.

In 1988, more than a decade after Hughes' death, Margaret Elardi, who once ran the Pioneer Club casino on Fremont Street in Las Vegas, bought the Frontier from Hughes' company. Elardi tore down the Silver Slipper to gain more parking for the Frontier, and refurbished the hotel, giving it a more modern look. But after years of clashes with the local hotel workers' union, she sold out in 1997 to Phil Ruffin, an absentee owner who lived in

Kansas. Ruffin changed the resort's name to the New Frontier and toyed with revamping the place with a theme based on San Francisco, California. In 2005, he sold part of his back parking lot to Donald Trump, the New York–based developer who then built a 64-story tower for condominiums. By then, Ruffin, who had held onto the resort property for years without doing much with it, sold the resort and its 36 acres to the Elad Group that owned the famous luxury hotel, the Plaza in New York. The Elad's investors were not interested in running the Frontier, and demolished it in 2007, 65 years after Griffith and Moore opened their resort at the spot.

ABOVE *Margaret Elardi bought the Frontier from Howard Hughes' company in 1988 and made major changes. She tore down the Silver Slipper and added this 16-story atrium tower.*

ABOVE LEFT *After Elardi sold the Frontier to Phil Ruffin in 1997, Ruffin added Gilley's, a popular country and western lounge that included a mechanical bucking bull and later offered "bikini bull riding" and female mud wrestling. Ruffin announced development plans that never panned out and he sold out to owners of New York's Plaza hotel in 2005.*

RIGHT *A view of the Frontier from the Strip in 2002.*

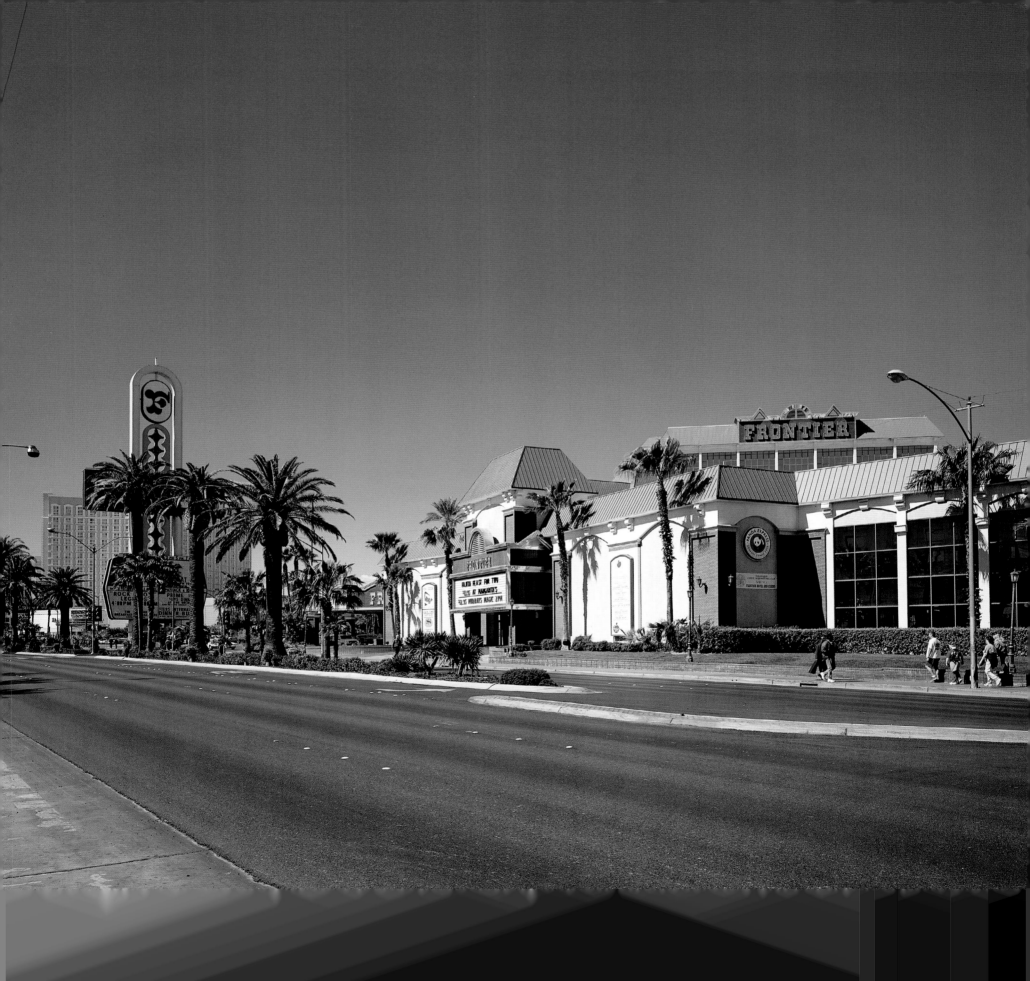

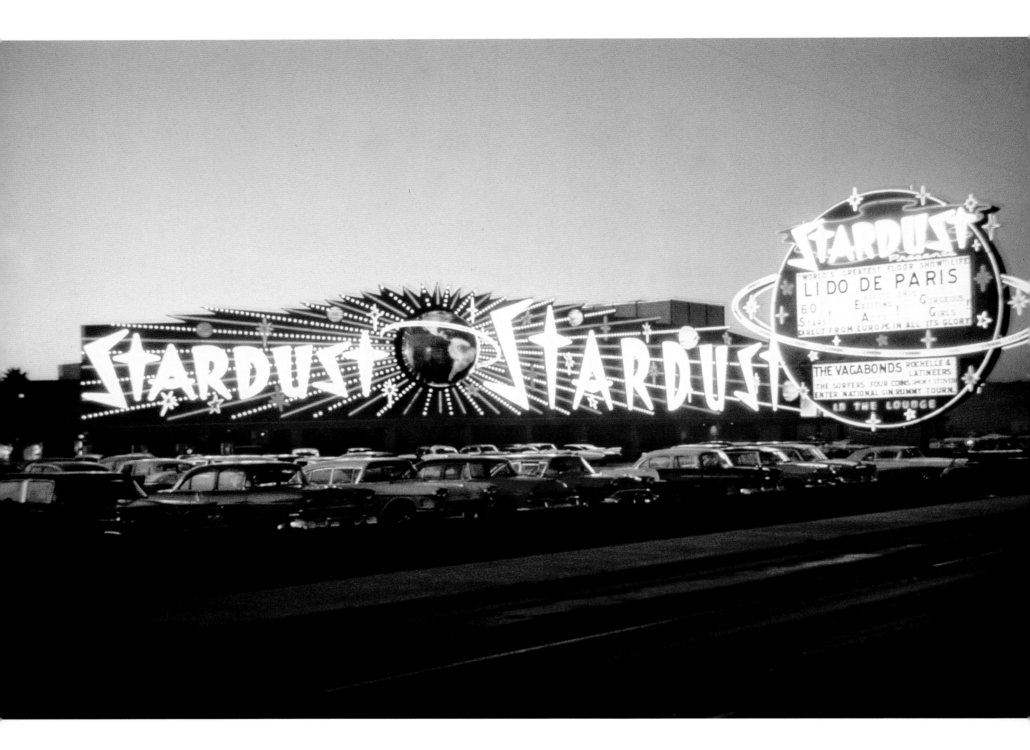

Stardust DEMOLISHED 2007

Tony Cornero had already made a name for himself in Las Vegas in the 1950s as a tenacious casino operator, but with a questionable past. He served time in prison for running illegal liquor in Southern California. He was an early believer in Las Vegas, opening the Meadows hotel-casino with his brothers outside downtown months after Nevada legalized gambling in 1931. After the Meadows failed, he moved back to Southern California to run a gambling ship, the S.S. *Rex*, in international waters. Then it was back to Las Vegas to oversee a small gambling club downtown called the S.S. Rex. Over time, Cornero did succeed in amassing a small fortune.

In 1954, as the town talked about a new wave of resorts planned on the Las Vegas Strip, Cornero regaled his drinking friends at a bar about his own plan. He would outdo all the new places with a resort dubbed the Stardust, with 1,000 guest rooms, more than any hotel in the world. He spent a then-fortune of $650,000 on 36 acres on the Strip, about a half mile south of the El Rancho Vegas. To raise additional money he hatched a unique plan. Instead of lining up partners with cash like many Las Vegas projects, Cornero issued and sold corporate stock. The United States government, however, limited him to selling shares only within Nevada. Cornero nonetheless succeeded in selling an astonishing $6 million in shares. But his past caught up with him. The Nevada state government refused to allow him to partake in the proceeds from the Stardust's

OPPOSITE *An early evening view from 1958.*

RIGHT *The Stardust through the decades. Top: a large sign lured patrons to the hotel's Aku Aku Polynesian restaurant, opened in 1960. Middle: the Stardust's glittering front entrance in 1978. Bottom: In 1980, when the Lido de Paris featured an extended show by Siegfried and Roy.*

BELOW *The Stardust's 32-story hotel tower, built in 1991.*

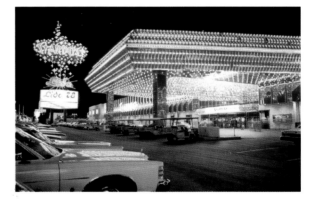

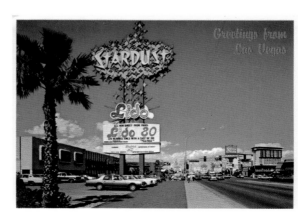

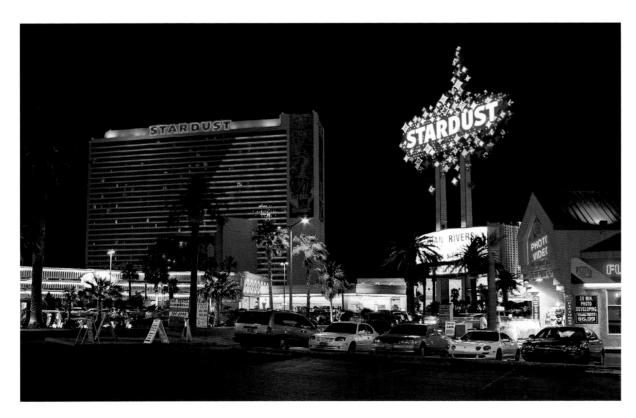

planned casino, so he agreed to let the Desert Inn's gambling manager Moe Dalitz lease the casino from him.

Cornero was on a roll, but he would not see his dream fulfilled. In one of Las Vegas's most publicized true stories, Cornero, while rolling the dice at a craps table at the Desert Inn in 1955, suffered a heart attack and died right on the casino floor. Without Cornero at the helm, the project, about 70 percent complete, was put on hold. It remained unfinished until 1957, when Jake "the Barber" Factor—whose brother ran the Max Factor cosmetics company in New York—took over with a $10-million cash infusion. Organized crime figures in Chicago allegedly invested a few million dollars to receive secret profits from the Stardust. The Factors kept Cornero's contract with Dalitz to lease and manage the casino.

Finally, on July 2, 1958, the Stardust had its gala opening. The hotel impressed locals with 1,032 guest rooms, its 105-foot swimming pool and 16,000-square-foot casino. In the rear, the Stardust had horse stables and a rodeo complex. Its showroom's revue, with a stage utilizing hydraulic lifts, was the Lido de Paris, destined to be an iconic

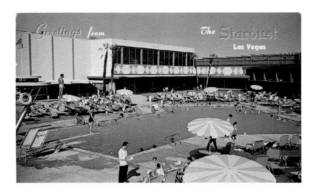

Las Vegas showgirls revue that made a star out of producer Donn Arden. But soon the Factor group ceded the Stardust over to Dalitz.

In the 1960s, the Stardust was sold to a group led by Delbert Coleman, helped by a $12-million loan from the same Teamsters union's pension fund that several other Las Vegas casinos had used. Coleman sold out to Allen Glick, who headed the Argent Corporation, in 1974. Glick also used a far larger loan from the Teamsters pension fund to buy out Coleman. Rumors of organized crime

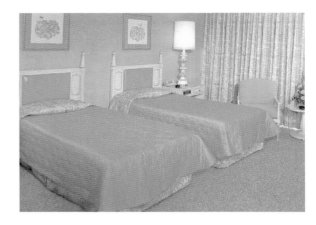

involvement at the Stardust proved true. State gambling agents learned that former Chicago-based gambler, Frank "Lefty" Rosenthal, ran a secret casino skimming operation at the Stardust. Rosenthal's scheme sent perhaps up to $15 million to various top-level mob figures in Chicago, Milwaukee and Kansas City. Rosenthal's rise and eventual fall, involving his mobster friend Anthony Spilotro, later served as the basis for the book and movie *Casino* in the 1990s. Nevada gambling overseers took away Argent's license and in 1984 they approved new owners, Las Vegas men Al Sachs and Herb Tobman, who used to work for Coleman at the Stardust. But hidden mob skimming at the Stardust resumed under their noses and Sachs and Tobman were quickly sent packing by the state. After such a bad run, Nevada officials approached two respected Las Vegas casino operators, the father-and-son team Sam and Bill Boyd, in 1985. The family business, known as the Boyd Group, kept the aging, famous property going into the 2000s. But times changed and the Strip was in the age of modernized mega-resorts. The group tore the Stardust down in 2007 to ready the site for a $4-billion new resort and other developments, although their plans were put on hold for years.

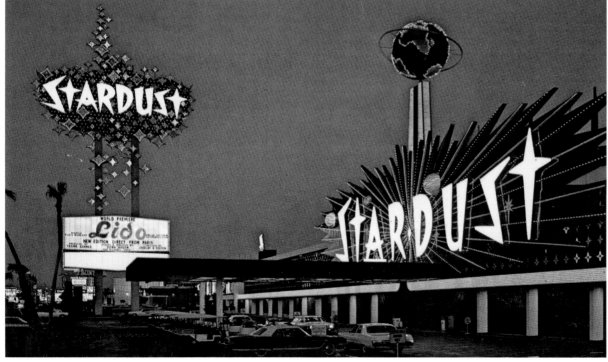

ABOVE *One of the Stardust's deluxe double rooms, decorated in bright orange, in the 1960s.*

ABOVE LEFT *In the early 1970s, the Stardust's casino, bungalows and other hotel buildings surrounded a pair of Olympic-sized pools.*

LEFT *A whirling planet sign served as a beacon in this view of the Stardust, facing south, in the late 1960s.*

RIGHT *The Stardust's 32-story tower in 2006.*

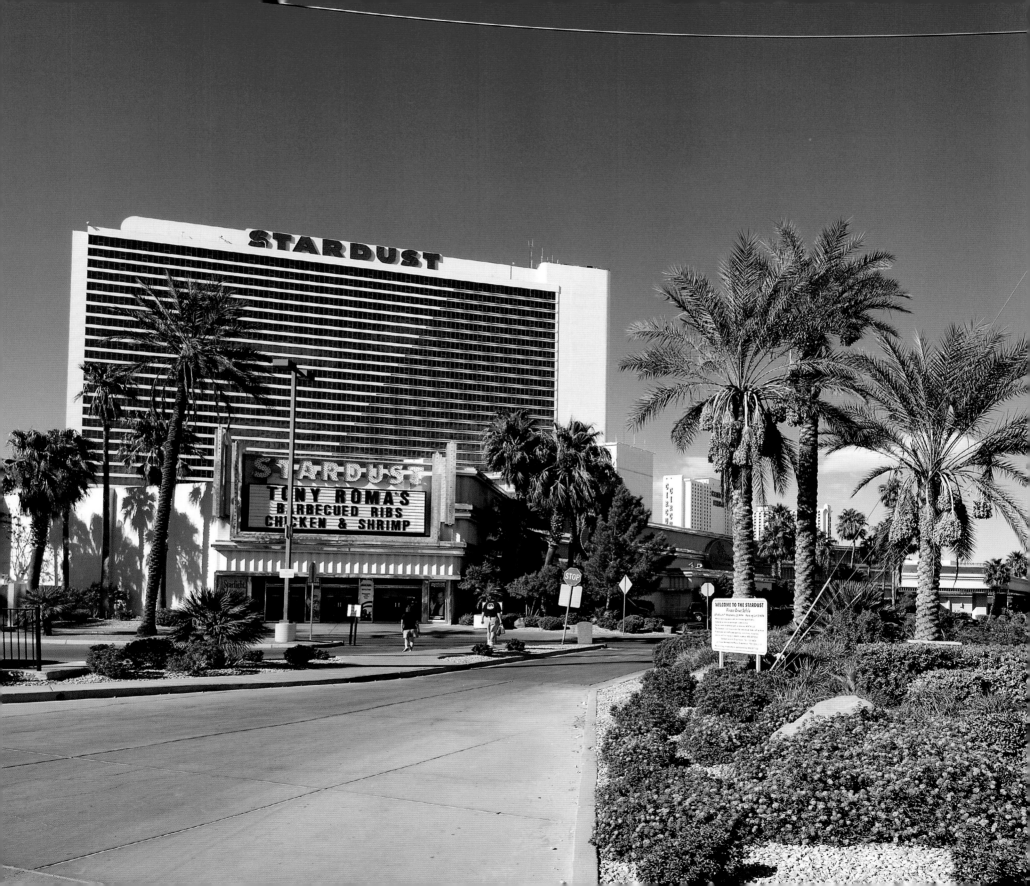

Guggenheim Museum CLOSED 2008

By the year 2000, the venerable Solomon R. Guggenheim Foundation held one of the finest art collections in the world, spread across its museums in New York, Venice, Italy and Bilbao, Spain. Las Vegas had little association with the arts in general for almost its entire history. That began to change in 1998, when Mirage casino owner Steve Wynn introduced parts of his valuable art collection, including works by Picasso, Hopper, Monet and Warhol, to his new Bellagio hotel on the Strip. Sheldon Adelson, a casino-owning rival of Wynn's on the Strip, opened the Venetian Hotel in 1999. Two years later, the Venetian interested Guggenheim foundation director Thomas Krens in bringing a museum to a still culture-starved Las Vegas. Krens hired the architect Rem Koolhaas to design two museums, the Guggenheim Las Vegas and the Guggenheim Hermitage within his Venetian resort. The idea behind the museums was to introduce the Guggenheim's high level of fine arts and master works to the Strip and Las Vegas and perhaps grab the attention and admission fees from the informal, casino-going masses as they walked by.

When they opened in October 2001, the first exhibit at the larger museum, the Guggenheim Las Vegas, was a considerably low-culture collection of motorcycles, called *The Art of the Motorcycle*. Whether it was the choice of the exhibit itself, or the gallery's location among the Venetian's many distractions, it turned out to be a poor call, and the museum shut down within 15 months due to lack of interest. The museum faced the difficulty of operating as a non-profit among commercial spaces. But the foundation persevered, determined to place its rich collection before the masses and seemed to pour effort into maintaining its second museum, the Guggenheim Hermitage—a partnership between the Solomon R. Guggenheim Foundation and the State Hermitage Museum in St. Petersburg, Russia. It succeeded, for a time. The Hermitage featured 10 shows of the Guggenheim's masterworks from such famous artists as Rubens, Picasso, Miro, Degas, Chagall, Klee, Modigliani, Lichtenstein and Rauschenberg. But it did not make people mention Las Vegas in the same breath as New York, Venice and Bilbao.

Las Vegas art watchers felt that the Guggenheim Foundation was not very enthusiastic about its newest location, a contention the foundation denied. Some thought it was too small and too out of place on the Strip. The foundation would counter that it tried, with some of its best works. But the Las Vegas community itself seemed unwilling to follow the independent museum on the touristy Strip with much financial or moral support. Meanwhile, though it had only a small collection, the for-profit Bellagio Gallery of Fine Art across the Strip from the Hermitage Museum enjoyed lines of tourists willing to pay the price of admission to see the works bought by Wynn with millions from his own pocket.

The Hermitage Las Vegas museum operation began to show signs of trouble in 2007, when the Venetian took charge of day-to-day operations. Then in February 2008, Krens resigned as director of the foundation. When the leasing contract for the museum's space at the Venetian was coming to an end, the casino decided it had a better use for it and chose not to renew. But Elizabeth Herridge, the managing director, would proudly state that the Guggenheim attracted a million visitors over its nearly seven years and about 4,500 local school children walked inside each year to view the museum's masterpieces.

ABOVE AND RIGHT *The Guggenheim's maiden exhibit, The Art of the Motorcycle, ran from 2001 to 2003. The exhibition's stainless steel backdrop was designed by architect Frank Gehry.*

LEFT *A building with a facade modeled after a palace in Venice, Italy served as the home for the Guggenheim Hermitage Museum at the Venetian hotel.*

Star Trek: The Experience CLOSED 2008

Star Trek: The Experience opened in 1998 at the Las Vegas Hilton, which up to then was a hotel oriented mainly toward the convention trade, with the Las Vegas Convention Center its connected next-door neighbor. The off-Strip Hilton, the old International Hotel built in 1966, sought an attraction to match what was happening on the Strip at the new mega-resorts of the 1990s. Convinced by the millions of fans of the original *Star Trek* and spin-offs *The Next Generation*, *Deep Space Nine* and *Voyager* TV series, Hilton figured the Experience would bring in a new set, and new generation, of customers. To publicize the attraction, the Hilton slapped on part of its outer wall a smallish facade that looked like the side of a spaceship with the Star Trek Federation's arrowhead symbol on it. When the place opened that January 3, the Paramount and Landmark companies brought in actors to perform in character as starship Federation personnel, as well as alien Klingons in full costume and makeup to chat with the news media and customers. Inside, the attraction included a thrill ride for about 25, where patrons who thought they were on their way to "The Klingon Encounter" were given a televised safety lesson for riding a shuttlecraft. Suddenly the

lights went out, a burst of air was pumped in, the lights went back on and riders found they were in the transporter room of USS *Enterprise*-D ship from *The Next Generation*. Riders were then informed that they had been put into a "time-rift" by an evil Klingon that removed an ancestor of *Enterprise* Captain Picard and so prevented Picard from being transported. The group was then retransported to the *Enterprise*'s shuttlecraft for a faux battle with a Klingon warship, then back to the Hilton, where Picard appeared on a television and thanked the riders for restoring him to life.

On the way to the thrill ride, patrons walked by the History of the Future Museum, a collection of many actual costumes and props from the *Star Trek* programs, running video clips from the different series and a timeline of episodes. The "Quark Bar" was a full cocktail lounge similar to the space bar in *Deep Space Nine*. In 2004, the *Star Trek* attraction added "The Borg Invasion 4-D," a second thrill ride for about 50 people at once, inside a simulated starship space station. Live actors mixed with videos of crew members for a battle with a Borg Queen that included riders being squirted with water and air. Former *Voyager* stars Kate Mulgrew (the Admiral), Robert Picardo (the Doctor) and Alice

Krige (the Borg Queen) appeared in the video. At one point, operators of the ride offered guided backstage tours of the ride. But interest in the attraction started to fall. Negotiations between Hilton and the ride's latest owner, Cedar Fair Entertainment, to save the Experience fell through. On September 1, 2008, Cedar Fair gave the ride a respectable send off with a ceremony, including the appearances of a few *Star Trek* spin-off actors. The ride was symbolically awarded a banner from the United Federation of Planets. That October, Las Vegas Mayor Oscar Goodman tried to help a downtown Las Vegas shopping center owner transfer the Experience there, but the deal fizzled. Many items from the Experience's interior were sold off in 2010.

OPPOSITE *Models of the Starship* Enterprise *hang above the Star Trek: The Experience attraction, which opened at the Las Vegas Hilton in 1998.*

BELOW LEFT *Actors in full costume appear as alien characters from the Star Trek series at the Experience.*

BELOW *A sign meant to attract fans to the exhibit was installed on the western side of the Las Vegas Hilton.*

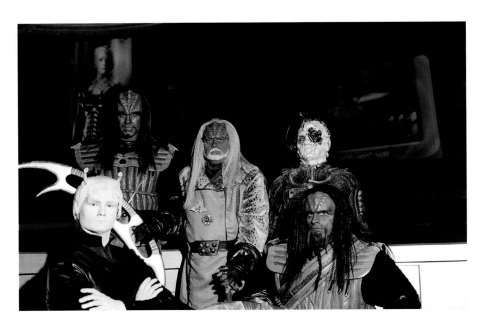

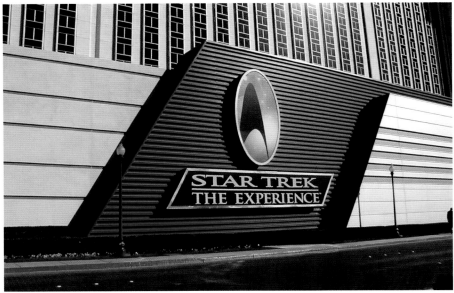

Liberace Museum CLOSED 2010

When it closed after 31 years in 2010, the Liberace Museum had already suffered from a lack of paying customers for a number of years. Many of the people coming to Las Vegas were in their 20s and did not know or care who Liberace was. But their grandparents surely did. In the 1950s, Liberace (his full name was Wladziu Valentino Liberace) was one of the most popular musicians in America. His *The Liberace Show* was a hit weekly variety program with a national television audience of tens of millions from 1952 to 1955. He sold millions of recordings of his virtuoso piano numbers. His fame, movie appearances, unique personality and humor made him a household name.

Born in Wisconsin in 1919, Liberace was a gifted pianist; a prodigy who performed solo for the Chicago Symphony when he was only 16. He first played in Las Vegas in 1944, for the princely sum of $750 a week, at the two-year-old Last Frontier hotel, the second resort built on the Las Vegas Strip. He would later recall how organized crime member, and killer, Benjamin "Bugsy" Siegel tried

ABOVE *A portrait of Liberace tops a sign for a shopping mall anchored by the Liberace Museum in the 2000s.*
ABOVE LEFT *Liberace's rhinestone-encrusted Baldwin grand piano.*
LEFT *The front entrance of the Liberace Museum.*
RIGHT *Liberace wore this "Hot Pink" turkey feather costume for a 1985 Radio City Music Hall Easter show as he emerged from a 12-foot Fabergé egg.*

to recruit him to play at Siegel's Flamingo resort in early 1947, not long before Siegel was shot to death in June of that year. Liberace toured throughout the country and Canada and while on his way to national stardom, continued to play in Las Vegas. In 1955, the new Riviera hotel on the Strip booked him to open the showroom for the hotel's debut on April 29, 1955. From the 1960s to the 1990s, Liberace

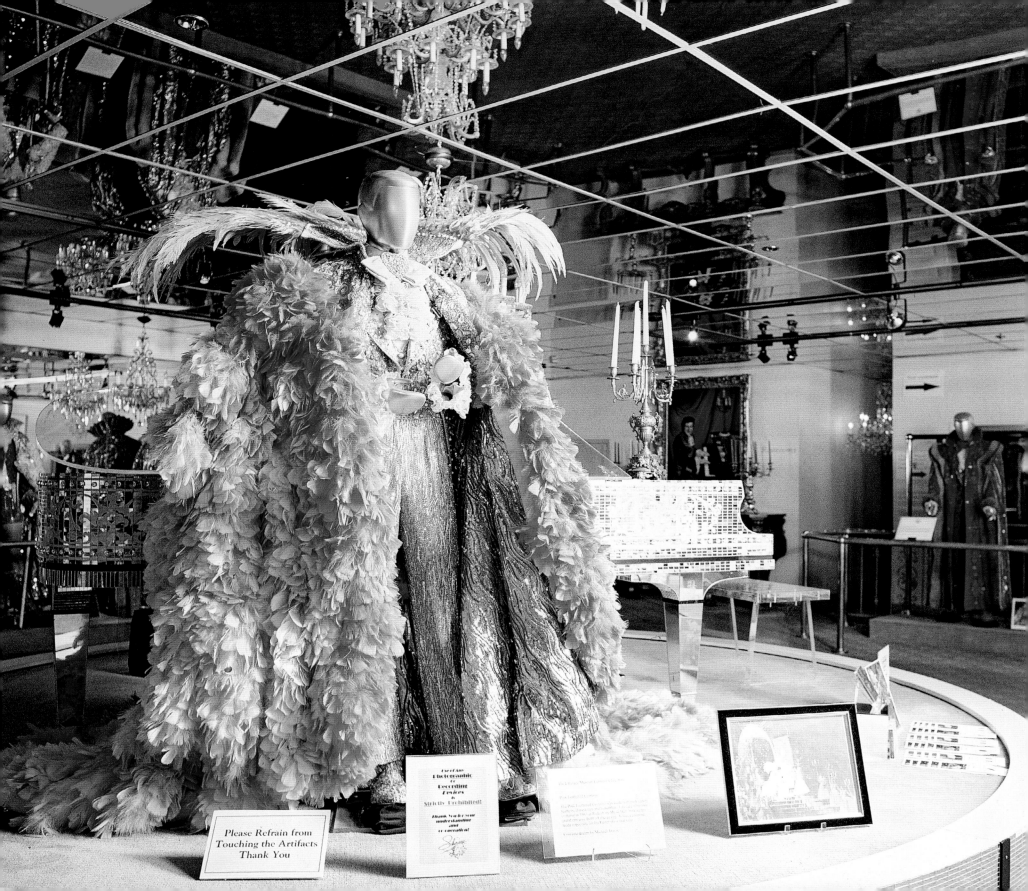

Please Refrain from
Touching the Artifacts
Thank You

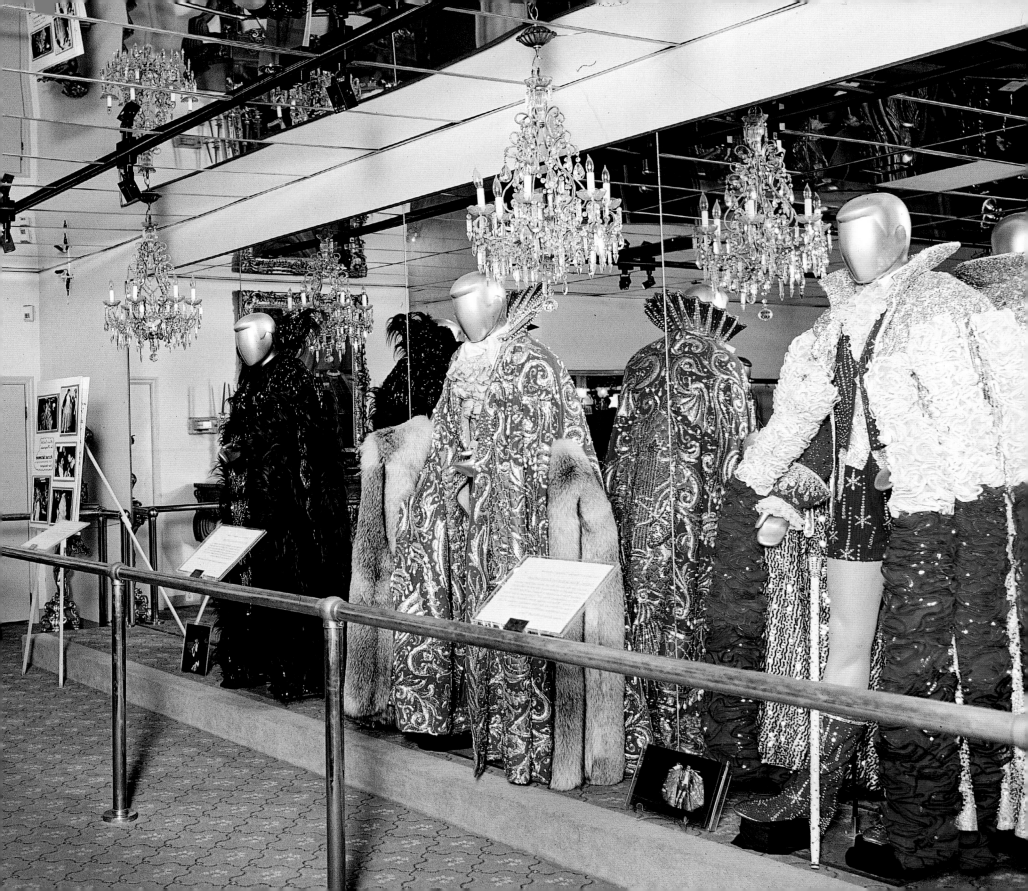

was one of the major stars, and draws, for Strip resorts. His appeal lay with women and men who liked his outrageous on-stage antics and famous garish costumes, such as when he wore hot pants while performing at Caesars Palace in 1971. In the mid-1970s, while a mainstay on the Strip, Liberace bought a house in Las Vegas and allowed people inside to view his career memorabilia. In 1976, he started the Liberace Foundation for the Performing and Creative Arts to fund scholarships for music students. Then in 1979, he moved his things to the Liberace Museum on Tropicana Avenue east of the Strip. The museum housed some of his elaborate outfits—flowing furred capes and feather boas arranged on faceless manikins—his silver Rolls Royce, pink and silver convertible Rolls Royce, light green Chevrolet Corvette, a 1972 custom Bradley GT with candelabras on each side (Liberace drove it while visiting his Palm Springs home), red sequinned sneakers, his two Emmy Awards, some of the garish rings he wore, and a collection of brightly decorated and mirrored pianos.

Liberace died in his Palm Springs home in 1987 from pneumonia as a complication of AIDS. In the last years before the museum closed, Liberace's foundation redecorated the staid facade of the museum to include wall-sized faux sheet music, swirling piano keyboards and neon fashioned into the shape of a piano above the entrance. When it closed its doors on October 17, 2010, foundation officers blamed "the economic downturn and the decline in the number of visitors." The museum's contents were set to go on tour as a traveling exhibit. The foundation announced that in accordance with Liberace's wishes, it had awarded scholarships amounting to $6 million to more than 2,700 students of 120 educational institutions.

OPPOSITE *More over-the-top costumes worn by Liberace. He wore his famous American flag costume (right) while stepping out of a matching Rolls-Royce during a stage performance to celebrate America's bicentennial in 1976*
BELOW *Two of Liberace's decorated Rolls-Royce cars.*

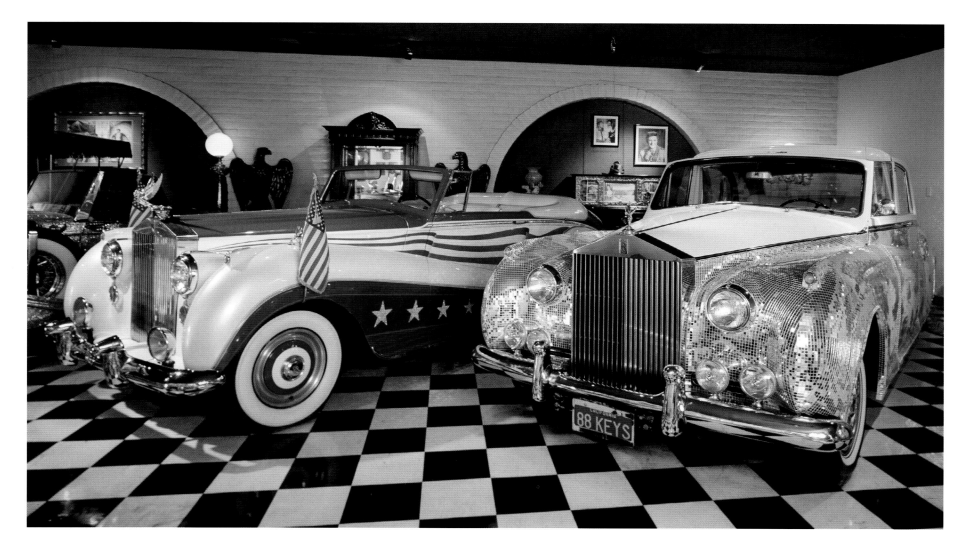

Sahara Hotel CLOSED 2011

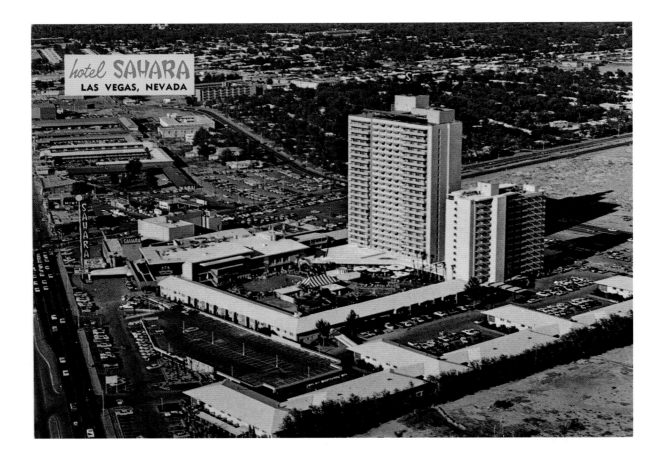

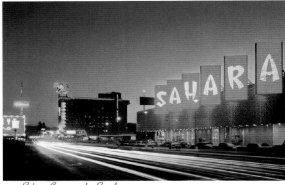

Sahara Casino at the Stateline

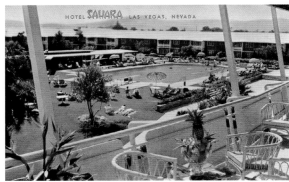

Milton Prell grew up in Los Angeles, where he sold luggage and cars and finally made a small fortune in jewelry in the 1930s. But he would later tell a journalist that his dream was to run the best luxury hotel in the country. In 1945, he moved to Las Vegas and soon invested in Club Bingo, which clicked for a while with its more popular neighbors the Flamingo, Last Frontier and El Rancho Vegas, but not for long. It fell into bankruptcy in 1950. But Prell, at age 45, was ready to take a bigger plunge—with investors who believed in him—in a new major resort. In 1951 he planned his Sahara hotel, to be built at the Club Bingo site, convincing investors A. Pollard Simon and Flamingo hotel builder Del Webb—who earned a share of the action for constructing it—to join the project.

Prell's $5.5-million Sahara, with 276 rooms and themed after the North African desert, opened on October 7, 1952, a golden time for Strip resorts— the Sands opened to the south on the Strip that December. His Sahara soon became one of the all-time classic Strip hotels, setting high standards for showroom and lounge entertainment. Prell, who called the place "The Jewel in the Desert," put in two large camel statues at the entrance. He insisted on having the largest swimming pool (the Garden of Allah) and showroom (the Congo Room) in the Las Vegas area. He hired 48-year-old film actor Ray Bolger, an unlikely but agreeable choice, to be the showroom's opening and post-opening act for the huge sum of $20,000 per week. Prell assembled some of the best casino and hotel people in town: Sam Boyd in the casino, Herb McDonald in publicity, and Bill Miller and Club Bingo's Stan Irwin

ABOVE *Postcards from the Sahara in the 1960s with the letters of its name stretching along the Strip and a view from a second-floor terrace of its Olympic-sized pool.*

ABOVE LEFT *This postcard from the mid-1960s shows the Sahara hotel's 14-story tower (1960), 24-story tower (1963) and its low-rise bungalow rooms next to the pool.*

RIGHT *The Sahara seen from the Strip in the early 1960s.*

to manage the competition for pricey headline entertainers in the Congo Room. Las Vegas was winning more and more attention from the national media as hotel publicists made the most of the antics of their celebrity showroom idols. The Sahara was no exception, such as when actress Marlene Dietrich, being paid $30,000 a week, made national

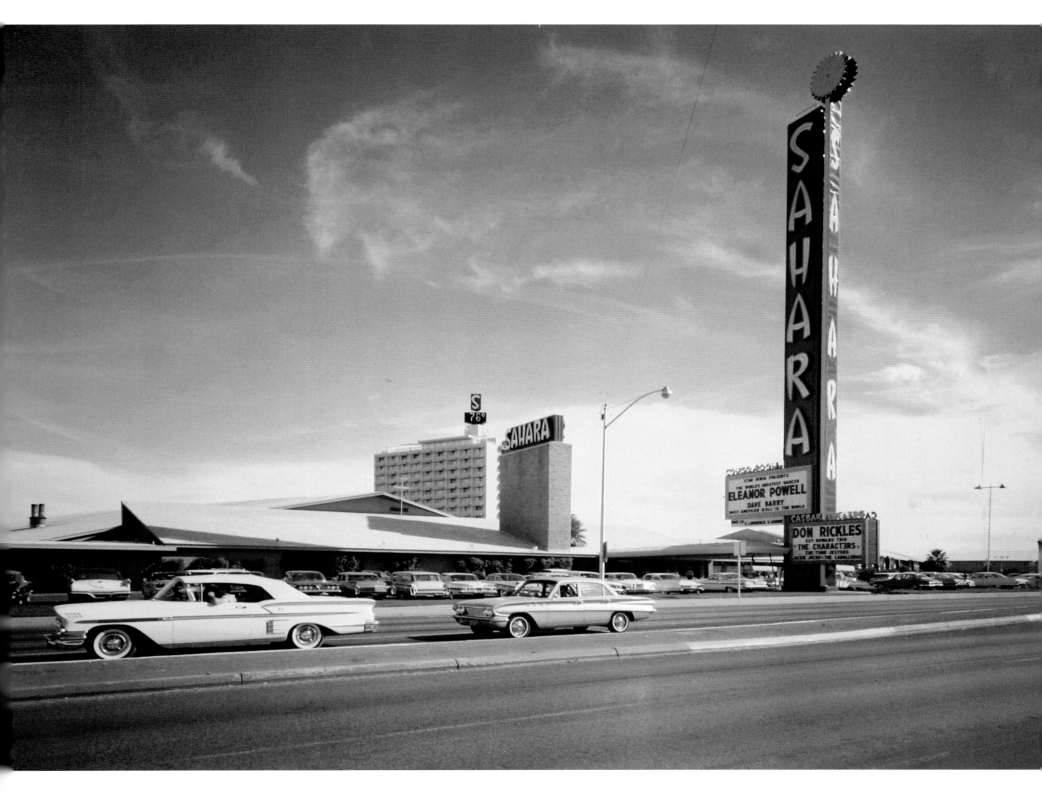

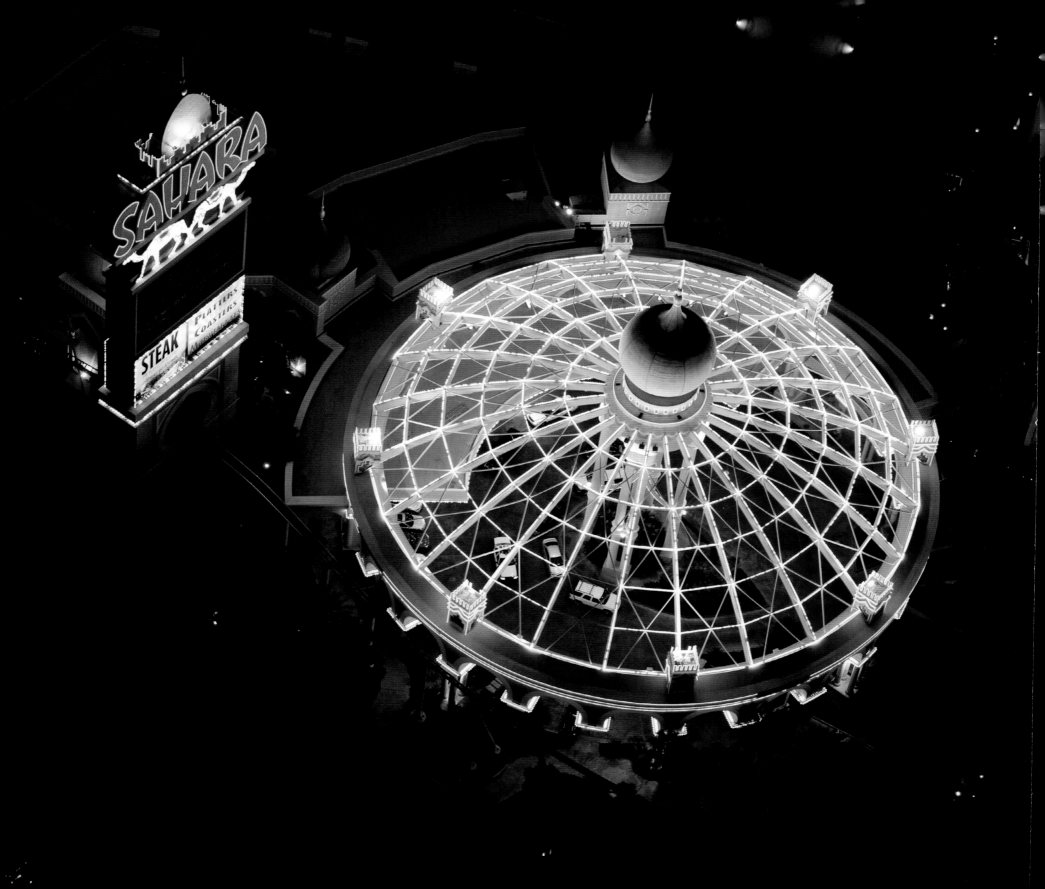

news for the hotel while performing in a sheer dress that made her appear to be nude.

The competition also affected late-night lounge entertainment, and there the Sahara made great strides when Miller booked Louis Prima and Keely Smith, later with sax player Sam Butera, in the Casbah Lounge in 1954. Musicians and comics in the Casbah would rotate in shows running all night. By the mid-1950s, the Sahara would have one of the best gourmet restaurants on the Strip, the House of Lords, that stayed with the resort into the 1990s. In 1959, Irwin brought in comic Shecky Green and brash, "put down" comedian Don Rickles who became a must-see between Prima-Smith shows at the Casbah for his spontaneous ribbing of celebrities who came to watch his late-night shows.

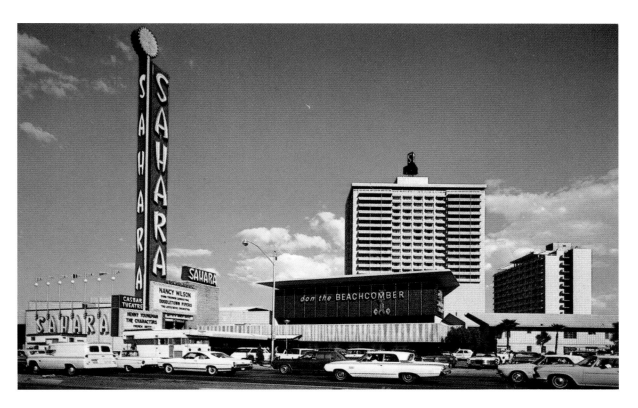

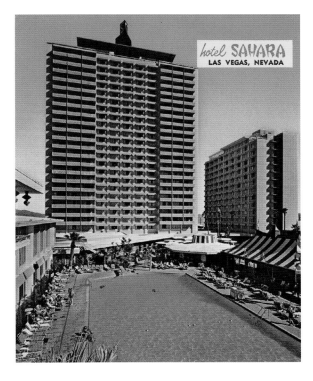

ABOVE AND TOP RIGHT *Two mid-1960s postcard views showing the Sahara's Olympic-sized pool and its vertical neon sign on the Strip. The Beatles stayed in the top-floor penthouse suite while performing in Las Vegas in 1964.*

LEFT *The Sahara's circular porte-cochère, topped by an Islamic Mosque-style dome, was added in 1997.*

RIGHT *The lobby of the Sahara hotel in about 1960.*

Prell added a 14-story high-rise and convention area a year later. But after nearly a decade at the helm, Prell opted to cash out, and sold the Sahara to Webb's Sahara-Nevada Corporation, the first such company to own a Las Vegas casino. A prolific builder, Webb opened a new 24-floor, 400-room hotel tower in 1963. Months later, the tower hosted the Beatles—booked by Irwin—in a top-floor suite, during the pop group's swing into Las Vegas in 1964. Comedian Jerry Lewis used the Sahara's convention area to hold his celebrity fundraiser telethons for muscular dystrophy from the late 1960s into the 1990s.

The Sahara's next owner in the 1980s was Paul Lowden, a former Las Vegas bandleader turned casino operator, who sold out to the cash-rich former Circus Circus Enterprises executive William Bennett in 1995, during the Strip's mega-resort boom period. The Sahara was then at a disadvantage, as many of the new tourist-attracting resorts were located far to the south on the Strip. Bennett pumped about $100 million into the aging icon, later building a $50-million NASCAR exhibit for the new demographic of fans in town to watch races at the Las Vegas Motor Speedway. Bennett also

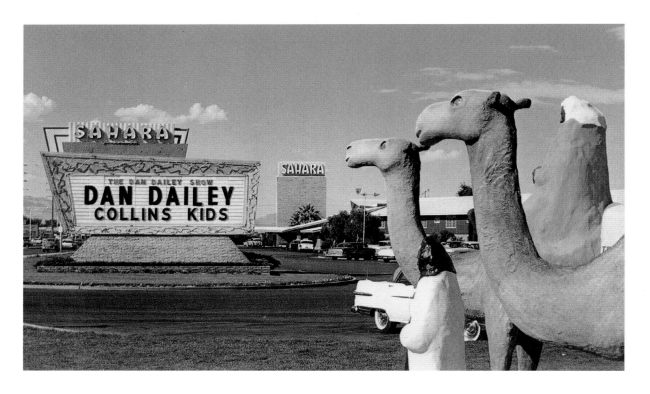

introduced rides on a roller coaster that ran outside along the Strip and back into the exhibit.

But by the 2000s, with billion-dollar resorts on the other side of the Strip and too far away for most visitors to walk over, the Sahara, with 1,750 rooms, was unable to compete. The venerable Sahara, its time behind it, closed on May 14, 2011, although its front neon sign—featuring faux camels—remained until it came down on March 12, 2013 to make space for a $750-million hotel planned by Los Angeles hotelier Sam Nazarian.

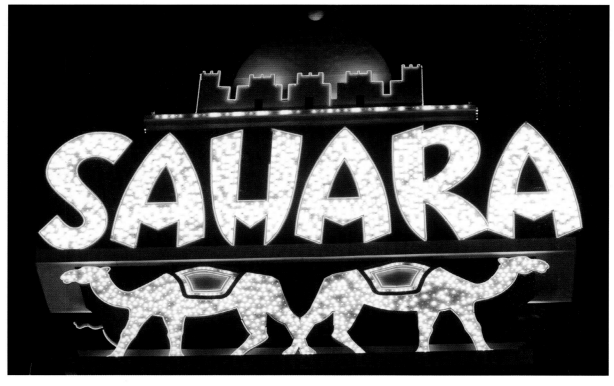

ABOVE *A 1958 photo showing the Sahara's camel sculpures.*

LEFT *The Sahara's marquee neon sign on the Strip in the late-1990s.*

RIGHT *The bright new exterior of the Sahara included a new entrance from the Strip and a domed, Arabian-themed porte-cochère constructed in 1997.*

Imperial Palace CLOSED 2012

Ralph Engelstad grew up in North Dakota in the 1930s and 1940s. He worked in construction in Grand Fork, North Dakota, and eventually started his own building company. In the early 1960s, Engelstad heard about construction opportunities in Las Vegas, where new residents needed housing, and moved there while in his early 30s. He soon made big money building housing tracts. In the mid-1960s, he bought a 145-acre property in the city of North Las Vegas called the Thunderbird Airport. In 1967, the property caught the eye of billionaire and famed aviator Howard Hughes, who moved to Las Vegas in 1966. Hughes, who wanted his own airport, made an offer and Engelstad accepted—$2 million. Engelstad used the money to buy a small casino, the Kona Kai, on the far south end of the Las Vegas Strip, and then sold it.

In 1971, Engelstad bought the nine-acre site of a closed motel, the Flamingo Capri, on the Strip across from Caesars Palace. On that small site he would build the Imperial Palace, which opened in 1979 and was modeled after the pagoda-style house of the Emperor of Japan. It was an almost ideal location for a hotel-casino, with the famous Flamingo his next-door neighbor. One problem, however, was its vulnerability to flooding. When water from rains flooded the hotel site, Engelstad rebuilt atop pillars dug deep into the earth. He put much of the riches he earned as the casino's sole proprietor into expanding the Imperial Palace. He would build a series of joined, high-rise towers that had 2,600 rooms. His property at one time was said to be the world's largest privately owned hotel. He invested in an on-site medical clinic, another first, for his employees, and reached out toward disabled people to become guests at the hotel.

By 1981, Englestad's personal worth was estimated at $100 million. He was a classic car enthusiast and would amass one of the largest collections in the world. He had more than 250 cars and showed many of them in a 125,000-square -foot showroom on the hotel's fifth floor. He had each car rebuilt to drivable condition. He owned a 1934

Rolls-Royce Phantom II, a 1931 12-cylinder Cadillac, separate cars once used by Howard Hughes, Marilyn Monroe, John F. Kennedy and talkshow host Johnny Carson, along with 43 Duesenbergs. In 1984, Engelstad also began collecting vehicles from the Axis Powers of World War II, including a 1939 Mercedes-Benz owned by Adolf Hitler. He placed the Hitler car and Axis vehicles in a private "war room" with a collection of Nazi flags and memorabilia. He also held two parties on Hitler's birthday in the war room, which Engelstad said later were not meant to glorify the Nazi dictator. When news of the Hitler parties and Axis collection emerged, Engelstad ran afoul of state casino regulators, who had the authority to punish casino owners who made the industry look bad in the eyes of the public. Engelstad was fined $1.5 million, one of the highest fines in Nevada history.

With the war room scandal behind him, Engelstad would invest in building a major car racetrack outside Las Vegas, the Las Vegas Auto Speedway that opened in 2000 for NASCAR and other races. Having succeeded in so many venues, Engelstad told people he was ready to start selling his assets. He donated $100 million to his alma mater in North Dakota. He sold 300 of his cars. But he never let on if he intended to sell the Imperial Palace. Suffering from lung cancer, he died in his sleep in 2002, at age 72. Harrah's Entertainment (later known as Caesars Entertainment) bought the Imperial Palace for $370 million in 2005, refurbished it and renamed it the Quad Resort in 2012.

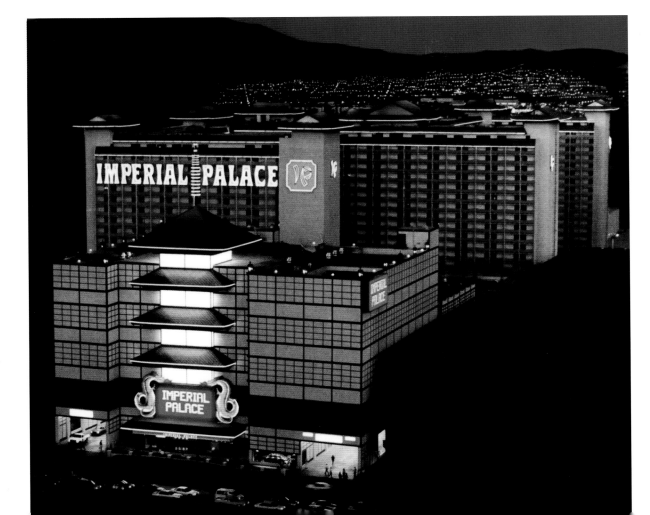

LEFT *The Imperial Palace's facade was patterned after the Emperor of Japan's residence in Tokyo. This photo from 2006 includes a marquee sign advertising the hotel's celebrity impersonation stage show, "Legends in Concert."*

RIGHT *A nighttime shot of the Imperial Palace in the 1990s. The hotel at its peak offered 2,600 guest rooms.*

Showgirls WANED 1990S TO PRESENT

When the "Les Folies Bergère" closed at the Tropicana in 2009, it left just "Jubilee!" at Bally's as the only original, traditional showgirls show in a Las Vegas hotel. The showgirl became an archetype for Las Vegas, born from the "Les Folies Bergère" cabaret music stage show in Paris, France of 1869 with sexy dancing girls. Over the decades, the dancing girl revues went through various incarnations in the United States—cancan, burlesque, vaudeville, and Busby Berkeley–style Hollywood movie routines.

In Las Vegas, showgirls, themed after Old West chorus line revues, started showing up on hotel stages in the 1940s. One of the earliest French-style chorus lines was at the Old West–themed Hotel Last Frontier on the young Las Vegas Strip of 1945. The chorus girls wore feathery headdresses and ruffled dresses pulled up to display their nyloned legs and garter belts, like something out of a Western film. The Frontier's rival Old West–style hotel on the Strip, the El Rancho Vegas, in the 1940s and 1950s employed the George Moro Dancers, whose 1949 show included bare-legged women kicking while wearing hats and sleeves fashioned after craps dice.

St. Louis native Donn Arden, who would be the most famous of all Las Vegas showgirl—and showboy—choreographers, first came to town in 1950. He added his dancers to show headliners Edgar Bergin and Vivian Blaine during opening night for Wilbur Clark's Desert Inn, the newest hotel on the Strip. Two years later, former New York nightclub manager Jack Entratter, who was entertainment chief of the Sands hotel, introduced the Copa Girls, 15 women dancers for the hotel's Copa Room stage. Entratter handpicked the dancers himself, based on their beauty, at auditions in Los Angeles. For Las Vegas, the Copa Girls, with dazzling, colorful and very expensive costumes—everything from formal gowns to skimpy South Seas islands garb—were a great leap forward for Las Vegas, more like modern dancers than preening showgirls. In 1954, Entratter introduced a Copa Girls review, with 20 dancers, based on the old 1920s Ziegfeld Follies of New York, with Sands headliner Frank Sinatra as host. As dancers, the Copa Girls were the best known and a must-see in Las Vegas throughout the 1950s. The standard

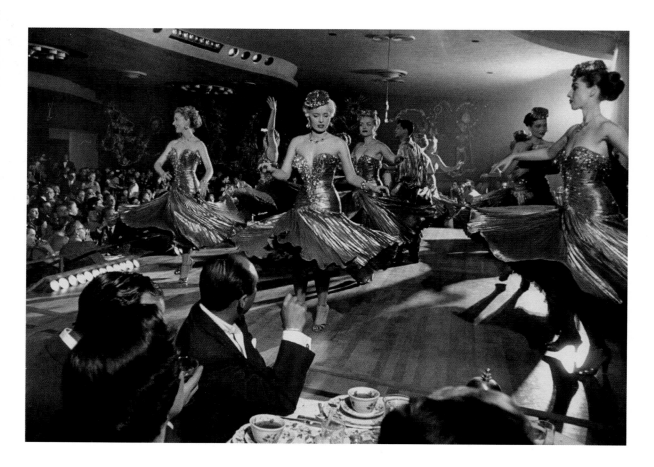

ABOVE *A late-1960s postcard advertising the French-style Casino de Paris show at the Dunes Hotel.*

RIGHT *A Copa Girls show at the Sands in 1952.*

OPPOSITE *A 1978 photo of the principal dancer for the opening number of the Stardust's Allez Lido.*

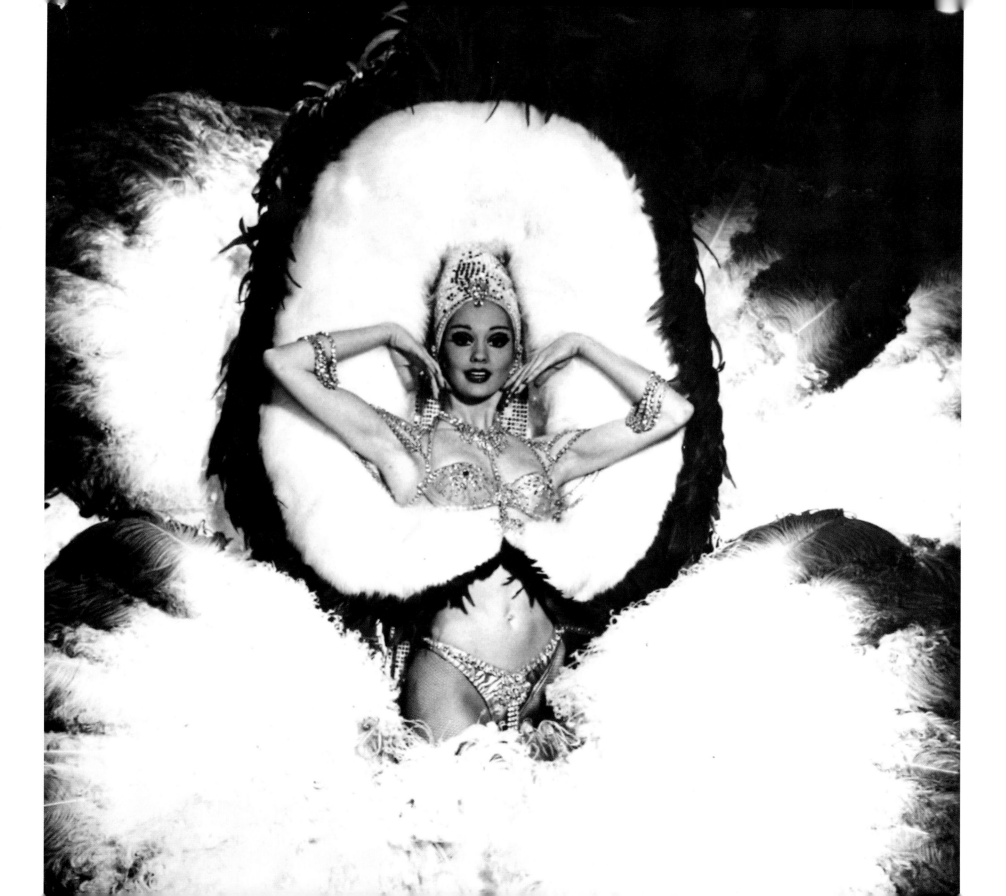

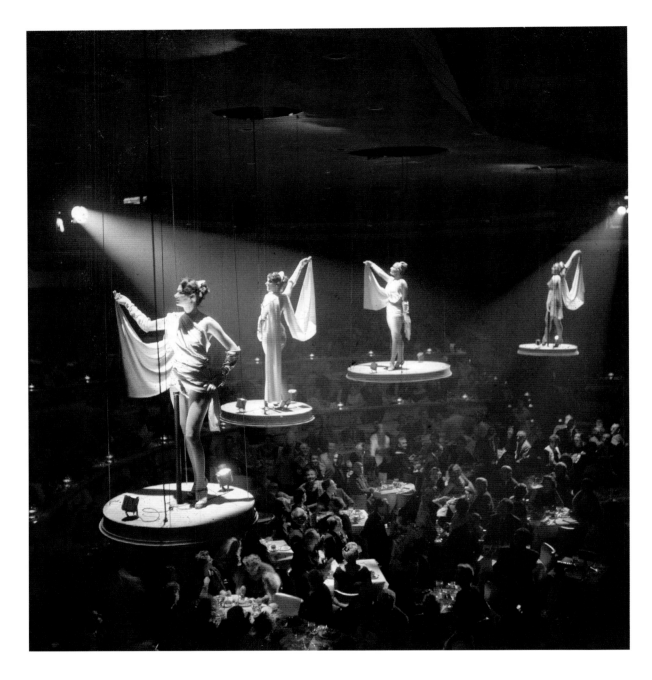

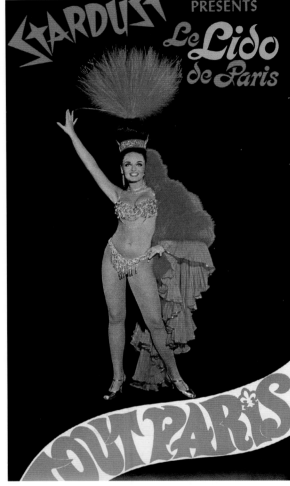

ABOVE *"Tout Paris." A full-color program for the Lido de Paris at the Stardust.*

LEFT *Bluebell Girls from the Lido de Paris revue perform above diners at the Stardust's Café Continental in 1958.*

Entratter set was high. What he did not do was have the women dance topless. Thus the challenge to outdo the Sands was met in 1957, when Harold Minsky, who produced a tame showgirls revue, Minksy's Follies, at the Showboat hotel in 1955, took a more controversial, and far more profitable turn at the Dunes. His revised "Follies" show, with the full support of new Dunes owner Major Riddle, included topless dancers and became a sensation. It set a Las Vegas record with 16,000 ticket sales a week and lasted at the Dunes until 1961.

The biggest advance in showgirl history in Las Vegas happened in 1958, when Arden and famous Paris dance producer Madame Bluebell (aka Margaret Kelly) introduced the Parisian female and male dance revue "Lido de Paris" at the recently opened Stardust hotel. Arden had topless (or at times fully clothed in early shows) female dancers cavort and swing across the stage in a sexy manner, or "showgirl walk" that he taught his dancers to do. The image of Arden's beautiful,

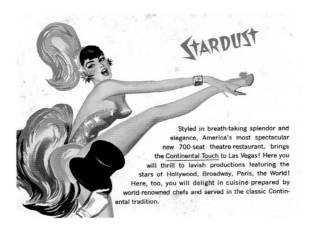

Styled in breath-taking splendor and elegance, America's most spectacular new 700-seat theatre-restaurant, brings the Continental Touch to Las Vegas! Here you will thrill to lavish productions featuring the stars of Hollywood, Broadway, Paris, the World! Here, too, you will delight in cuisine prepared by world-renowned chefs and served in the classic Continental tradition.

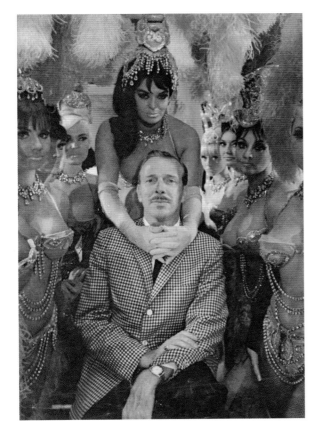

statuesque female dancers, barelegged with enormous feathered headdresses, in Lido de Paris would come to symbolize Las Vegas for visitors worldwide. The Lido shows of the 1960s included the Les Bluebell Girls, the Bluebell Dancing Nudes, Arden Boy Dancers and Singers, dances themed after France, 19th-century Russia, Mexican Aztecs, Turkey and South America. A break featured Chinese acrobats.

On Christmas Eve, 1959, Les Folies Bergère, another French import, arrived at the Tropicana on the Strip. One of the imported French dancers in 1960 was Claudine Longet, who would catch the eye of singer Andy Williams and later launch her acting career. In 1962, the Last Frontier's Bill Miller booked producer Steve Parker to put on "Holiday in Japan," an all-Japanese cast of women who at one point shed their traditional costumes on stage. The next year, the Dunes hotel's Riddle spent a then-fortune of $2 million on a Paris-themed revue, "Casino de Paris," managed by Frederic Apcar, with 100 female and male dancers, various acrobatic acts and comedians. Riddle sought to surpass the Tropicana's Folies Bergère with a so-called "Octuramic" stage that spread out into the audience. The Dunes show was a smash and continued there for the next two decades.

In 1981, Arden moved on to the new MGM Grand hotel, where he staged a new show, "Jubilee!" The show remained after the MGM Grand was renamed Bally's. Arden died in 1994, but "Jubilee!" continued, adding an on-stage reenactment of the sinking of the *Titanic*. Les Folies Bergère, with its cast of 80 performers, closed in 2009. By then, there was only "Jubilee!" at Bally's, the French and frankly nude dance show "Crazy Horse Paris" at the MGM Grand, and the Riviera hotel's lounge-like "Crazy Girls" naughty dance show. But "Jubilee!" was the only one to still feature the classic Las Vegas showgirl dancer.

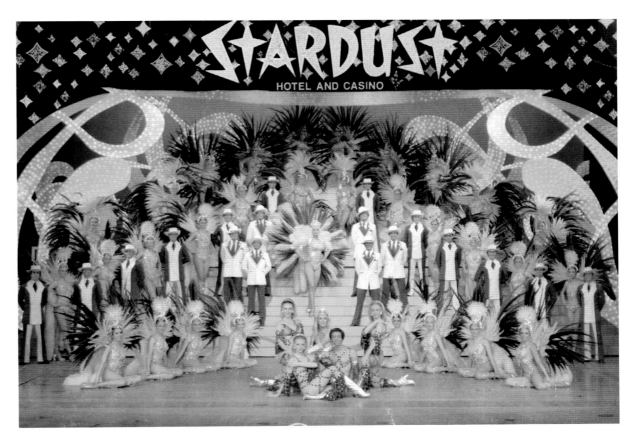

TOP *A drawing of a showgirl as part of a poster touting Lido de Paris at the Stardust's 700-seat showroom bringing "the Continental touch to Las Vegas."*

ABOVE *Folies Bergère showgirl Felicia Atkins drapes her arms around entertainment director Dave Johnson.*

RIGHT *A late-1970s postcard shows the cast of Lido de Paris on the Stardust's stage.*

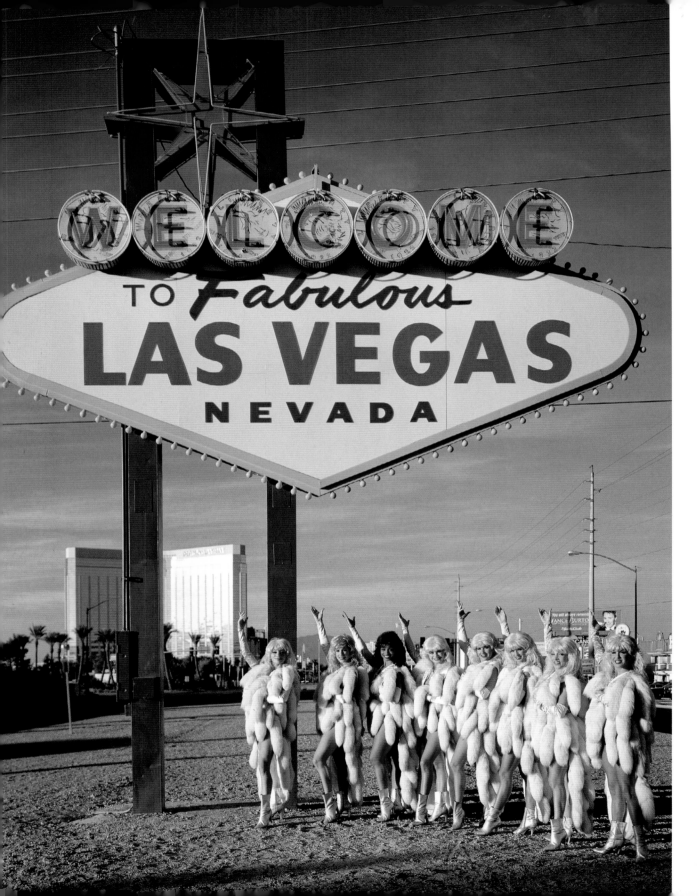

ABOVE *Showgirls from Donn Arden's "Jubilee!" performing at Bally's in the early 2000s.*

LEFT *Fur-draped showgirls pose beside the "Welcome to Las Vegas" sign at the south end of the Strip in 2005.*

RIGHT *Glamorously dressed showgirls entertain the crowds at the Dunes Hotel in 1955.*

BELOW *An early 1980s ad for Las Vegas choreographer Donn Arden's "Jubilee!" show, which began at the MGM Grand Hotel in 1981.*

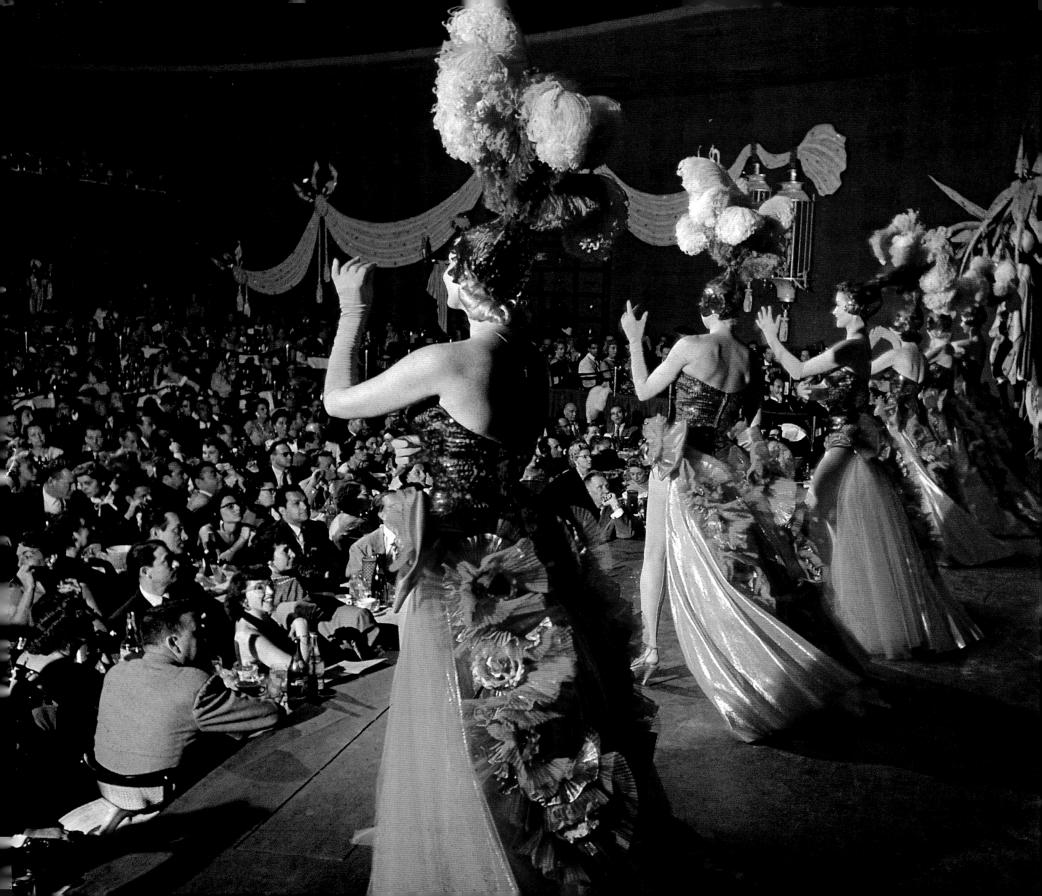

INDEX

91 Club 112
Addison, Chuck 69
Adelson, Sheldon 78, 122
Adrian Wilson & Associates 47
Airdome Movie Theater 37
Aladdin Center for the
 Performing Arts 47, 111
Aladdin Hotel 110–111
Alpine Village Inn 80–81
Apache Hotel 6, 21, 30–31, 58,
 61, 62
Arden, Donn 138, 140, 141
Arizona Club 8–9
Atkins, Felicia 141
Basic Magnesium Inc. plant
 10–11
Basic Townsite 11
Bayley, Judy 73–75
Bayley, Warren "Doc" 73–75
Beatles, The 47, 133, 134
Bellagio Gallery of Fine Art 122
Bellagio Hotel 57, 122
Bennett, William 134
Bergen, Edgar 85, 138
Bernstein, Monte 31
Binion, Benny 6, 31, 62
Binion's Horseshoe 31, 43
Bird Cage Casino 43
Bishop, Joey 77–78
Bismo, Alexander 92
Blaine, Vivian 138
Block 16 6, 8, 58
Block 17 8
Bluebell, Madame 140
Boardwalk Hotel and Casino
 102–103
Bolger, Ray 130
Bonanza Hotel 38
Bond Road 80
Boulder Club 20–21, 61
Boulder Highway 11, 82
Bourbon Street Hotel and
 Casino 98–99
Boyd, Bill 120
Boyd, Sam 43, 120, 130
Bramlett, Al 81
Brown, Joe 31
Brown, William 30
Busy Bee Café and Lido Bar
 43
Caesars Palace Hotel 38, 56,
 57, 78, 129, 137
Carillo, Leo 112
Carma Developers 98
Carousel Casino 63
Carroll, Frank 65, 66
Carver Park 11
Cashman, James "Big Jim" 22
Casino de Paris 141
Castaways Hotel and Casino
 40–41
Caudill, Robert "Doby Doc"
 115
Central Park Apartment 101
CIM Group 108

Circus Circus Enterprises
 75, 134
CityCenter 6, 102
Clark, Wilbur 25, 85
Clark, William 6, 33, 58
Clark County Courthouse
 16–17
Clark County Museum 33
Club Bingo 12–13, 62, 130
Cohen, Burton 86
Cole, Nat King 78
Coleman, Delbert 120
Copa Girls 138, 140
Cornero, Tony 31, 119–120
Coward, Noël 85
Cox, Wally 54
Cragin, E.W. 30, 37
Cragin, Marleau 37
Curland, Bill 69
Dalitz, Moe 18, 82, 85, 120
Davidson, Chris 104
Davis Jr., Sammy 37, 77–78,
 92
Del Webb Corporation 52
DeLongchamps, Frederick 17
Desert Inn Hotel 6, 25, 38, 40,
 62, 77, 78, 84–7, 138
Desert Passage Shopping Mall
 111
Desert Showboat Motor-Hotel
 82
Diamond, Sam 111
Dietrich, Marlene 133
Donner, Anthony 108
Dorweiller, Hans 101
Doumani, Lorenzo 91
Downtown Grand Casino 108
Doyle, Jack 31
Dunes Hotel and Casino 6, 18,
 54–57, 140, 141, 143
Durante, Al 35
Durante, Jimmy 78
Earl, Robert 111
Edge Resorts 98
Edwards, E.H. 8
El Cortez Hotel 61
El Dorado Club 6
El Morocco Motel 91
El Portal Theater 36–37
El Rancho Hotel and Casino
 52–53
El Rancho Vegas Hotel and
 Casino 6, 22–27, 61, 85,
 112, 138
Elad Group 116
Elardi, Margaret 44, 116
Ellen, Vera 54
Elvis-A-Rama Museum
 104–105
Engelstad, Ralph 137
Entratter, Jack 77, 78, 138
Exber, Mel 29
Factor, Jake "the Barber" 120
Ferron, William E. 15
Fifth Street 58
Fiorito, Dan 35
First Street 8, 15, 43, 69
Fischbacher, Siegfried 94–97
Fishman, Frank 18

Flamingo Capri Hotel 56, 57,
 137
Flamingo Hotel 6, 38, 56, 57,
 62, 126
Flamingo Road 38, 98
Fourth Street 15
Foxx, Redd 40
Foxy's Firehouse Casino 89
Fremont, John C. 58
Fremont Hotel 62
Fremont Street 6, 7, 8, 15, 21,
 29, 30, 31, 33, 35, 37, 43,
 58–63, 69, 108, 116
Fremont Street Experience 62,
 69
Friedman, Bill 40
Friedman, Jake 77
Friedman, Maurice 18
Frontier Hotel 96, 112–117
Fry, Leo 92
Gable, Clark 21
Gambler's Hall of Fame 15
Garces Avenue 33
Gaughan, Jackie 21, 29
Gem Club 8
Genther, Ethel Wisner 29
George Moro Dancers 138
Ghelfi, Italo 35
Glick, Allen 75, 120
Golden Gate Hotel and Casino
 35
Golden Nugget Casino 6, 40,
 60, 61, 62
Goodman, Oscar 125
Gottesman, Al 54, 57
Gottlieb, Jake 57
Goumond, Gertrude 21
Goumond, Prosper Jacob 21
Griffith, Edward W. 37, 58
Griffith, Robert 22, 112
Guggenheim museums
 122–123
Hacienda Hotel 72–75
Hanley, Gramley 81
Hanley, Tom 81
Harris, Bucky 18
Hatch, Clyde 21
Helldorado Rodeo and Parade
 61
Henderson, Charles 11
Herridge, Elizabeth 122
Hicks, Marian 50, 61
Highway 91 6, 18, 22, 61, 81,
 85, 112
Hoffa, Jimmy 57
Holiday Inn Hotel 102
Holy Cow! 88–89
Hoover Dam 6, 11, 31, 61
Horn, Uwe Ludwig "Roy"
 94–97
Horseshoe Club 6, 21, 43, 60,
 61, 62
Hotel Nevada 34–35, 58
Houssels, J. Kell 21, 29, 61, 82
Hughes, Howard 6, 40, 44, 65–
 66, 78, 85, 115, 116, 137
Hull, Thomas 22, 25
Ice Palace 47

Imperial Palace Hotel and
 Casino 136–137
Industrial Road 104
International Hotel 6, 38, 65,
 104
Irwin, Stan 130, 134
Isis Theater 37
Isle of Capri 108
James, Al 8
Jamieson, John W. 65
Jensen, Avis 102
Jensen, Norbert "Norm" 102
Jewell Drug Store 15
Johnson, Dave 141
Jones, Clifford 50
"Jubilee!" 141, 142
Katleman, Beldon 25, 26, 44,
 115
Katleman, Jake 25, 26
Kefauver, Estes 77
Kelly, Joseph 82
Kelly, Margaret 140
Kennedy, John F. 47, 77
Kerkorian, Kirk 38, 65, 78, 86,
 89
King's Crown Hotel 111
Klondike Hotel and Casino
 106–107
Knight-Preddy, Sarann 92
Koolhaas, Rem 122
Kozloff, Jake 18, 73–74, 115
Krens, Thomas 122
La Concha Hotel 11, 90–91
La Rue Restaurant 77
Lady Luck Casino 108–109
Lake Mead 11, 31
Landmark Hotel 64–67
Langham, Ria 21
Lansky, Jake 50
Lansky, Meyer 50
Larsen, Jack 44
LaRue, Ike 40
Last Frontier Hotel and Casino
 6, 8, 61, 112–117, 126,
 138
Last Frontier Village 44
Las Vegas Boulevard 15, 44,
 91, 70, 81
Las Vegas Club 21, 29, 61
Las Vegas Convention Center
 46–47, 65, 70, 125
Las Vegas Hilton Hotel 125
Las Vegas Pharmacy 14–15
Las Vegas Ranch 58
Las Vegas Rancho 33
Las Vegas Springs Preserve 33
Lawford, Peter 77–78
Les Folies Bergère 138, 141
Leverton, Hershel 80, 81
Levinson, Edward 43, 62
Lewis, Jerry 134
Liberace, Museum 126–129
Liberace, Wladziu Valentino
 126–129
Lido de Paris 140–141
Lincoln Hotel 58
Little Chapel of the West 75
Longet, Claudine 141
Lowden, Paul 75, 134

Lucky Strike Club 43, 61
MacLaine, Shirley 86
MacNelledge, Charles
 Alexander 37
Magestic Theater 37
Main Street 29, 33, 35, 58, 62
Majestic Theater 58
Mandalay Bay Hotel 107
Mandalay Bay Resort 75
Mansfield, Jayne 57
Marie, Rose 30
Marina Hotel 89
Martin, Dean 77–78, 86
Marvin, Lee 43
Mason, Charles 31
Massaro, Leo 35
McAfee, Guy 6, 31, 61, 62, 112
McAlister and McAlister 22
McCarren, Pat 11
McDonald, Herb 12, 130
McIntosh, James 8
Meadows Hotel and Casino
 29, 119
Merlin, Lee 48
Mermaids Club 15
MGM Grand Hotel 38–39, 89,
 141
Miller, Bill 18, 130, 133, 141
Miller, Bob 96
Miller, John F. 35, 58
Million Dollar Historic
 Gambling Museum 70
Minnelli, Liza 86
Minsky, Harold 140
Minsky's Follies 140
Mint Hotel 42–43, 65
Mirage Hotel and Casino 6, 40,
 94, 96
Mitzell, George 40
Moll, Albert 18
Monte Carlo Hotel 57
Moore, William 8, 82, 112, 115
Morris, William "Wildcat" 66
Moulin Rouge Hotel and
 Casino 6, 92–93
Murphy, J.V. 21
Nangaku, Masao 57
National Museum of Organized
 Crime and Law
 Enforcement 6
Neon Museum 91
Nevada Club 108
Nevada Test Site 6, 18, 48–49
New Frontier Hotel and Casino
 8, 18, 112–117
New Pioneer Club 69
New York-New York Hotel 57
Newton, Wayne 62, 98, 111
Northern Club 21, 58
Ogden Street 8, 108
Overland Hotel 28–29, 58, 61
Page, Farmer 69
Paradise Road 47, 81
Parker, Steve 141
Parvin-Dohrmann Company
 111
Patriarca, Ray 54
Pearlman, Trevor 98
Peterson, Dean 101

Peterson, Faye 101
Peterson, Murray 101
Picardo, Roberto 35
Pike, William 37
Pioneer Club 15, 61, 62,
 68–69, 102, 116
Pioneer Club Hotel 69
Planet Hollywood Resort and
 Casino 111
Plaza Hotel 63
Prell, Milton 12, 43, 69, 111,
 130, 134
Presley, Elvis 104, 111
Presley, Priscilla 111
Prima, Louisa 78
Quad Resort 137
Rand, Sally 44
Red Onion Club 8
Red Roosters Club 40
Replogle, John 18
Reuben, Louis 92
Rice, Bob 54, 57
Richardson, Rich 18
Riddle, Major 52, 57, 140, 141
Riviera Hotel and Casino 6, 18,
 91, 126, 129
Rosenthal, Frank "Lefty" 120
Roundup Realty 101
Royal Nevada Hotel and
 Casino 6, 18–19
Ruffin, Phil 116
Russel, Robert R. 30–31
S. S. Rex Club 119
Sachs, Al 120
Sahara Avenue 98
Sahara Hotel and Casino 6,
 18, 43, 62, 77, 130–135
Sal Sagev Hotel 34–35
San Pedro, Los Angeles and
 Salt Lake Railroad 6, 33,
 58
Sands Hotel and Casino 6, 18,
 38, 62, 76–79, 140
Sans Souci Motel 40
Sassy Sally's Club 15
Scherer, Tutor 69
Schiro, Frank 12
Schwartz, Will 92
Second Street 30
Sedway, Moe 31
Shenker, Morris 57
Showboat Hotel and Casino 6,
 82–83, 140
showgirls 138–43
Siegel, Bugsy 31, 61, 126
Siegfried & Roy 94–97, 116,
 119
Silber, Reagan 98
Silvagni, Pietro O. 30, 31
Silver Palace Casino 15
Silver Slipper Club 44–45, 116
Silverbird Hotel and Casino 52,
 53
Simon, A. Pollard 130
Sinatra, Frank 44, 77–78, 86,
 92, 138
Smith, Sydney 30
Smith Center for the
 Performing Arts 6

Sommer, Jack 111
Spilotro, Anthony 120
Star Trek: The Experience
 124–125
Stardust Hotel 6, 96, 101,
 118–121, 140–141
Steadfast AMX 108
Stewart, Helen 6
Stocker, Mayme V. 58
Stratosphere Tower 71
Strode, Woody 43
Stupak, Bob 70–71
Sullivan, Jo 54, 57
Summa Corporation 85, 86
Thomas, Danny 65, 77
Thompson, Hunter S. 43
Thunderbird Airport 137
Thunderbird Hotel and Casino
 6, 50–52, 62
Tobman, Herb 120
Tompkins, Andrew 108
Tompkins, Susan 108
Torok, Mitchell 104
Torres, Ed 52–53, 111
Traubel, Helen 18
Treasure Island Hotel and
 Casino 40
Tropicana Avenue 81, 129
Tropicana Hotel 6, 96, 138
Truman, Harry 78
Trump, Donald 57, 116
Union Pacific Station 32–33
Union Plaza Hotel 33
Vegas Vic 6, 15, 43, 63, 68, 69,
 102
Vegas Vicky 15
Vegas World Hotel and Casino
 70–71
Velvet, Jimmy 104
Venetian Hotel 122
Watson, Walter 21
Webb, Del 43, 130, 134
Webbe, Peter 111
Webbe, Sorkis 111
Westside 92
Westward Ho 101–102
Wiesner, Tom "Big Dog" 89
Williams, Andy 141
Williams, Paul Revere 11, 18,
 91
Willis, Betty 92
Wisner, John Stewart 29, 58
Woodrun, John 106
Wyman, Sid 18
Wynn, Steve 6, 40, 57, 62, 86,
 96, 102, 122
Wynn Las Vegas Resort 86
Yasuda, Ginji 111
Zarro, Frank 101

OTHER TITLES IN THE SERIES

ISBN 9781862059344

ISBN 9781862059924

ISBN 9781862059931

ISBN 9781909815049

ISBN 9781909108714

ISBN 9781909108448

ISBN 9781909108431

ISBN 9781909108639

ISBN 9781862059351